GUY ROSE

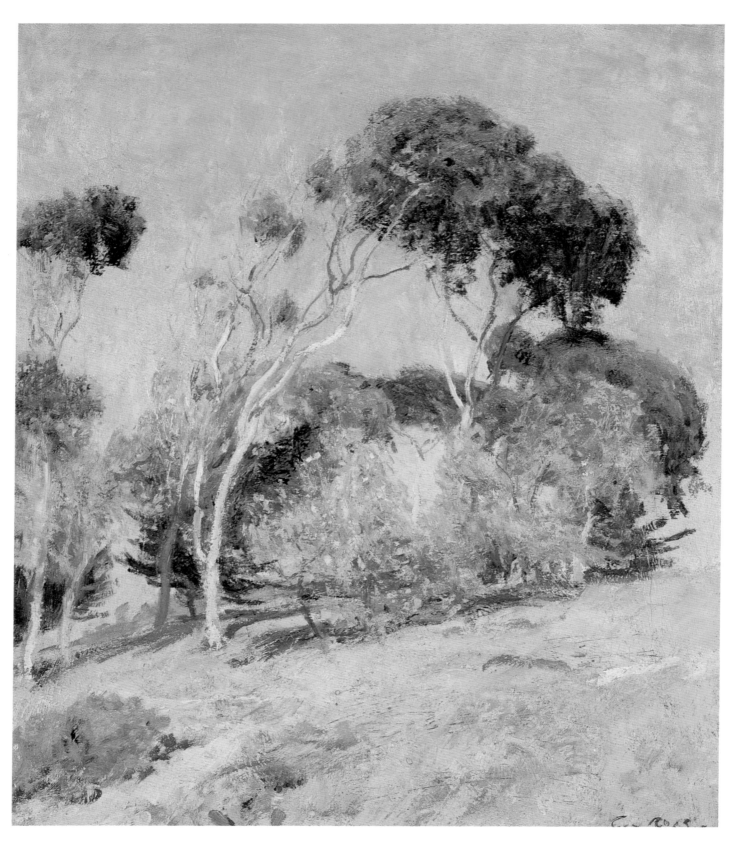

Windswept Trees, Laguna. Oil on canvas, 18 x 15 in. Private collection.

GUY ROSE

AMERICAN IMPRESSIONIST

BY

WILL SOUTH

INTRODUCTION BY

WILLIAM H. GERDTS

ESSAY BY

JEAN STERN

The Oakland Museum

and

The Irvine Museum

Library of Congress Catalog Card No. 95-069077

ISBN 1-882140-06-0 Hardback
ISBN 1-882140-07-9 Paperback

The Oakland Museum
Art Department
1000 Oak Street
Oakland, California 94607-4892

The Irvine Museum
Twelfth Floor
18881 Von Karman Avenue
Irvine, California 92715

Catalogue design by Gordon Chun Design,
Berkeley, California

Printed in Hong Kong through Overseas Printing,
San Francisco, California

CONTENTS

Lifting Fog, Laguna. Oil on canvas, 24 x 29 in. The Irvine Museum, Gift of James and Linda Ries.

FOREWORD

IT IS WITH GREAT PRIDE and satisfaction that The Oakland Museum and The Irvine Museum present this magnificent book and exhibition of the life and works of Guy Rose.

The mission of The Irvine Museum is to preserve and display California art of the Impressionist period, and it has always been our goal to present the best work by the best artists, and Guy Rose is certainly one of the very best.

Soon after its founding in 1992, our museum joined forces with The Oakland Museum in a concerted effort to bring to fruition the long-awaited Guy Rose retrospective exhibition. On a memorable afternoon meeting at the Oaks, my equestrian training facility in San Juan Capistrano, Harvey Jones, Senior Curator of The Oakland Museum, presented his plan for the exhibition. Among the attendees were Roy Rose, grandnephew of the artist, and Jean Stern, art historian and recently appointed director of The Irvine Museum. Roy has long been regarded as the leading authority on the artist, and he and Jean had been planning a major retrospective for nearly three years prior to signing on with Harvey and The Oakland Museum. In short order, we approved Harvey's plan and agreed to sponsor the exhibition, book, and video on Guy Rose.

Now, three years later, we are opening this major exhibition with a sense of exhilaration that we have achieved our goal: to honor and memorialize the life and work of this great California Impressionist in a manner befitting his stature. The paintings you will see in this book reflect the highest standard of American art. Furthermore, they encapsulate the unique qualities of California Impressionism by combining great beauty with historical significance and, most of all, a deep reverence for nature. These paintings testify in a most eloquent manner to the need for enlightened environmental management. The ageless beauty of our land was present a century ago for Guy Rose and his colleagues and it is present here today for us. We must strive to preserve what remains of that beauty, not only for ourselves but also for generations to come.

Joan Irvine Smith
President of the Board of Directors
THE IRVINE MUSEUM

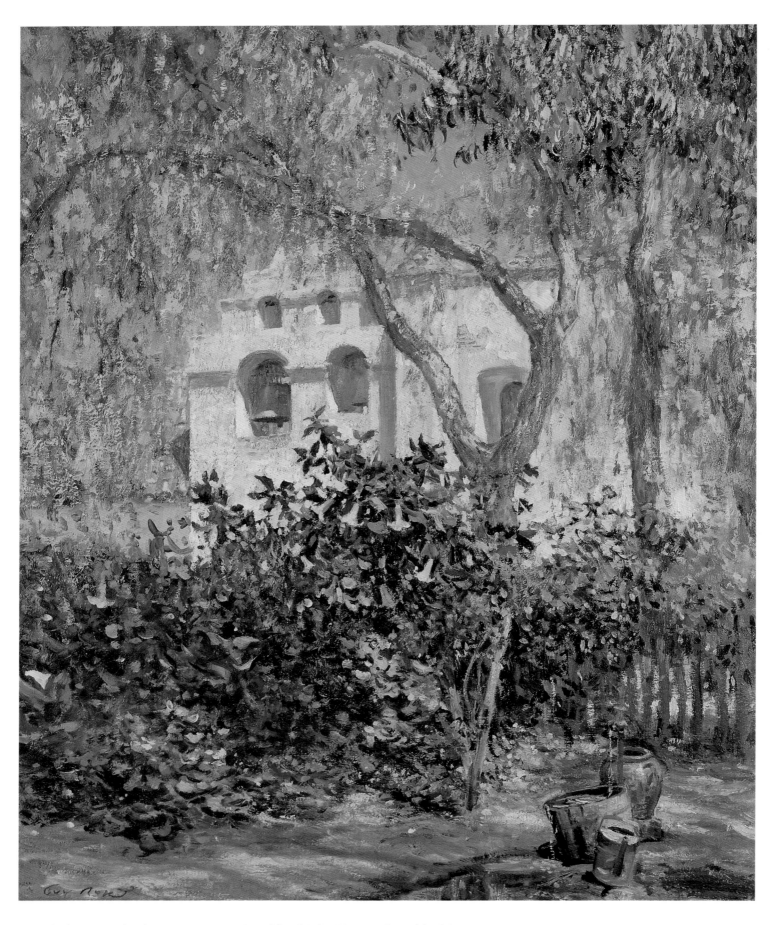

San Gabriel Mission, n.d. Oil on canvas, 28¾ x 23¾ in. The Fleischer Museum, Scottsdale, Arizona.

PREFACE

GUY ROSE: AMERICAN IMPRESSIONIST represents the continuing efforts of The Oakland Museum of California and The Irvine Museum to establish the achievements of California artists within the broader context of American art. The story of a California-born painter who enjoyed a privileged upbringing in a prominent pioneer family and made a reputation in the world of art far from his Southern California birthplace, to which he eventually returned to great local acclaim, is a true American success story. The story of Guy Rose is not, however, without the challenges of adversity. His death at the age of fifty-eight, attributed to lead poisoning, no doubt limited the number of beautiful Impressionist paintings he left behind. For many years it was assumed that the known paintings of Guy Rose were even fewer in number and more limited in their range of subject matter than we have since learned. Recent research has identified increased numbers of the extant paintings and has greatly broadened our knowledge of the themes and scope of his artworks.

The public's fascination with Impressionist-style painting in recent years has resulted in extensive surveys of French Impressionism and its originators, most particularly Claude Monet. The numerous artists who were inspired by Monet and other French Impressionists quickly made it an international style. Monet's residence in the village of Giverny, not far from Paris, became a major attraction to young American painters after 1890, and, despite his resistance to direct involvement with the international set in Giverny, Monet's influence was evident and crucial to the developing variants of the Impressionist style. The colony of artists in Giverny at that time included several of those who have become America's best-known painters in the Impressionist style. Among them was Guy Rose, less well known but arguably their artistic equal. The fact that Guy Rose spent his most productive years in California, at a distance from the eastern art centers where his Giverny colleagues settled, and where much of art history was written, has delayed the national recognition his work deserves.

The preparation of this book involved the contributions of several dedicated individuals who accepted an invitation to participate in the shared goal of this project—to garner for Rose the recognition due him. William H. Gerdts, a leading authority on American art, in general and on American Impressionism in particular, has provided the Introduction to the book. He sets out to place the California painter Guy Rose in a context that is international, national, and regional. Dr. Gerdts discusses the artistic climate of Paris during Rose's impressionable student years, his standing among his American colleagues in Giverny, and ultimately his impact on a generation of painters back in his native California.

The art historian Will South, a curator at the Utah Museum of Fine Arts, University of Utah, has provided the first comprehensive biographical investigation of the life and works of Guy Rose. His highly detailed and well-documented account of the artist's background and the people and events that shaped his artistic career incorporate new information and heretofore unpublished material relating to Rose's professional and private life. South had expressed his interest in the paintings of Guy Rose while working on a book about James Harwood. South's research had revealed a connection between Harwood and Rose during their student days in Paris. In addition to South's own extensive research into the subject, he made use of copious materials and images gathered by Roy Rose, a descendant of the artist's brother.

Roy Rose, himself a longtime researcher, avidly collected California painting and owned works by many artists. Among them he of course counted paintings by his grand-uncle Guy Rose as well as those by Elmer Wachtel and Marian Kavanagh Wachtel, who were related to Rose by marriage. Eventually, his research efforts and ultimately his collection too centered on Guy Rose almost exclusively. The gathering of material for the family archives provided the authors of this book with an invaluable source of new information; further, Mr. Rose's compilation of a list of known works by the artist was indispensable. Roy Rose kindly consented to provide a written account of his involvement titled *A Rose Family Perspective: Building a Collection.*

Jean Stern, art historian and acknowledged authority on the art and artists of Southern California in the early twentieth century, has contributed an essay that discusses Guy Rose's return to California, where he participated as a teacher and exhibiting member of a community of plein-air painters that sprang up around Los Angeles, Pasadena, and Laguna Beach during the years Rose was in France.

An important contribution to this comprehensive biography of Guy Rose is the intensely researched and carefully detailed Chronology of the artist's professional life prepared by Marian Yoshiki-Kovinick. With the assistance of her husband, Philip, she consulted numerous directories, catalogues, and newspaper articles to reconstruct an accurate timeline of Guy Rose's activities. Mrs. Kovinick also made a thorough investigation of the artist's exhibition record that spanned thirty years of his life as a painter.

The realization of the *Guy Rose: American Impressionist* book and its accompanying exhibition are a direct result of the participation of a particular individual. Joan Irvine Smith's passion for the California plein-air landscapes depicting the natural beauty of the region in which she was born and reared are the heart of the museum she founded to display them. The prominence of Guy Rose among those artists prompted her commitment to the production of an in-depth art-historical investigation into the life and work of the artist. Mrs. Smith's Foreword addresses the concern of all participants in the project—that Guy Rose achieve his well-deserved recognition as one of America's finest Impressionist painters.

Harvey L. Jones
Project Director

Senior Curator of Art
THE OAKLAND MUSEUM

ACKNOWLEDGMENTS

ON BEHALF OF THE OAKLAND MUSEUM, the organizing institution for *Guy Rose: American Impressionist,* and its Executive Director, Dennis M. Power, I would like to acknowledge the contributions of many individuals whose efforts toward realization of the various facets of the Guy Rose project—the book, the exhibition, and the video biography in particular—transcend the notion of "merely doing their job."

First, I want to express my gratitude to Joan Irvine Smith for her unstinting commitment to the creation of *Guy Rose: American Impressionist,* including the book, its accompanying exhibition, and all related programs. This project was made possible by the support of the Joan Irvine Smith and Athalie R. Clark Foundation. Additional thanks go to James Irvine Swinden and Russell G. Allen for their valuable assistance.

When I first proposed the idea of an exhibition and catalogue based upon the paintings of Guy Rose it was with the knowledge that a proper mounting of such a project was not possible without the cooperation and "blessing" of Roy Rose, whose personal commitment of many years researching the subject went well beyond a curiosity about his antecedent. I was able to convince him that The Oakland Museum would make a sincere effort to produce the kind of exhibition and publication that would bring credit to one of America's most deserving painters.

This project benefited greatly from the direct assistance in the form of information, contacts, resources, and personal encouragement that I received from Jean Stern. Mr. Stern contributed an essay to the book and pledged his continued help for the duration of the project for which I am most grateful.

Special thanks go to the contributing authors of essays in this book. First, to Will South whose assignment of the major essay was accomplished with the highest standards of scholarship and professionalism intact. His hard work, cooperative spirit, and enthusiasm for the project made him the perfect colleague. To William H. Gerdts goes my sincere appreciation for his highly informed perspective in the Introduction and for the honor his participation brings to the project.

Although Guy Rose was a well-known and respected painter, at least in Giverny, France, and Southern California almost a hundred years ago, much of the published information about the artist since that time raised as many questions about the life of the painter as there were known facts. Much material conflicted in details of time and place. We are indebted to Roy Rose, Marian and Phil Kovinick, Jean Stern, and Will South for cooperating on the gathering and sharing of new facts about Guy Rose. Their efforts benefited from the generous assistance of many other individuals, including Dr. Denise E. Beaudoin, Amy J. Coleman, James Coran, Vivian Gill, Dorothy Greenland, Barbara Mellin, Myron Patterson, Walter Nelson-Rees, E. Francesco B. Raneri, Claire Toulgouat, and Deedee Wigmore.

Museum personnel and collections administrators have given special attention to requests for information useful to this project. I express thanks to Susan Anderson, Curator, Laguna Art Museum, Laguna Beach; D. Scott Atkinson, Curator, Terra Museum of American Art, Chicago; Gerald Buck, The Buck Collection, Laguna Hills, California; Donna H. Fleischer, Director, Fleischer Museum, Scottsdale, Arizona; Ilene Susan Fort, Curator, Los Angeles County Museum of Art; Robert Korengold, Administrator, Musée d'Art Américain, Giverny, France; Armand Labbe, Director of Collections, Bowers Museum and Cultural Center, Santa Ana, California; Mary MacIntyre, Administrator, The Fieldstone Collection, Newport Beach, California; Martin Peterson, Curator, San Diego Museum of Art; E. Frank Sanguinetti, Director, Utah Museum of Fine Arts, University of Utah; Allison Frame South, Assistant Director, Utah Museum of Fine Arts, University of Utah; Patricia Trenton, Curator, The Los Angeles Athletic Club.

I am pleased to acknowledge the generous assistance provided by several individuals connected with art galleries who provided photographs or helped to locate works by Guy Rose for use in the book or exhibition: Patrick Kraft, William A. Karges Fine Art, Carmel and Los Angeles, California; Scott

Leavit, Butterfield and Butterfield, Los Angeles; The Ray Redfern Gallery, Laguna Beach, California; George Stern Fine Arts, Los Angeles; Jason Schoen, New Orleans, Louisiana; Trotter Galleries, Carmel, California.

We are particularly indebted to the collectors of paintings by Guy Rose who allowed their paintings to be illustrated in this book or made them available for exhibition. Those collectors who did not wish to remain anonymous are given credit elsewhere in the book. We thank them all.

A huge debt of thanks must go to Fronia W. Simpson for editing the text for this book. Her careful attention to consistency and style was invaluable. The graphic design and production of this book are the artful products of Gordon Chun, whose wife, Suzanne, greatly aided in the process. Thanks also to M. Lee Fatherree for his photographs of some of the paintings used in this book. Many thanks are owed to Robert Boudreaux for directing the video production and for providing additional photographic services.

Finally, and far from least important, goes my deepest appreciation to Kathy L. Borgogno, who assisted me and all of the writers of this book with her diligent work in preparation of the texts for editing. Kathy's efforts to maintain a schedule of deadlines was crucial to the project. Other members of The Oakland Museum staff who contributed to this project are Janice Capecci, Arthur Monroe, and Karen Nelson.

H.L.J.

La Jolla Arbor. Oil on canvas, 18 x 15 in. Private collection.

My Sister Maud. Oil on canvas, 5¾ x 4½ in. Rose Family Collection.

A Rose Family Perspective:

BUILDING A COLLECTION

Roy Rose

GUY ROSE LEFT THIS LIFE, which had been plagued with illness and affliction, on 17 November 1925. He left behind a legacy of fine artworks, and a family that appreciated them.

Some fifty years after his death, I, a grand-nephew of the artist, set about to collect a representative sampling of Guy's work. The Rose Family Collection today contains works from his youth, student days, early academic paintings, and Impressionist paintings from France and America. Subjects include still lifes, figures, and various land- and seascape paintings of his favorite locales. A collection of this type takes a great deal of research and effort, which has been helped along by tremendous contributions from my family and friends.

From early on, Guy's family collected his paintings, and by the time of his death, there were several considerable accumulations within the family. Guy's sister Nina had married John Wachtel, brother of the California artist Elmer. With Guy Rose, Elmer Wachtel, and Elmer's wife, Marian, in the family, it was natural that other family members would be interested and supportive. Sisters Maud, Mabel, Daisy, and brother Leon also had nice collections. My parents were given and inherited paintings. I was fortunate in that I grew up surrounded by this fine art and early on took a keen interest in it.

My aunt, Maud Easton, was a tremendous influence on my life. She lived in Westwood Village in Los Angeles, where I attended UCLA. Already in her eighties, she fascinated me with her stories of family and with her love of art and fine things. She vividly recalled a trip to Europe with her mother and two sisters, and of the experience of visiting Guy in Giverny. When she decided to retire to a senior resident community years later, she gave me my first painting by Guy, as well as Guy's portfolio of photographs of many of his other works.

Never serious about painting myself, my artistic interests centered on collecting, and I felt it was a challenge to assemble a comprehensive and important group of works. In that pursuit, which has lasted more than thirty years, I have had much help and support, particularly from my parents, Leonard and Phyllis Rose, who have been generous with their encouragement, enthusiasm, and full participation. My father's remembrances added greatly to the wealth of oral history I was accumulating. In addition, about 1980 I met George Stern, Jean Stern, and De McCall, and my special friend Ray Redfern, all of whom have been most helpful in developing my collection, sharing information, and encouraging me in my effort.

In 1986 an advertisement appeared in the Sunday classified section of the *Los Angeles Times:* "Wanted, Information of Ethel Rose, wife of deceased American Impressionist Guy Rose." Responding, I was astounded to find out that the advertiser, Lyman Allen, was a grand-nephew of Ethel, as I am a grand-nephew of Guy. Neither of us knew of the existence of the other, and it seemed an incredible coincidence that out of 250 million people in the United States we would discover one another in this way. Lyman came to California later that year and brought with him a wealth of photographs and articles Ethel had left to her sister, Lyman's grandmother. He has been extremely generous in sharing this material, and many of his photographs appear in this book.

Gathering information has not all been as easy as this. If Guy kept a journal or ledgers, they do not seem to exist today. If he was a letter writer, we have not found many. He did not have children, and his widow lived another twenty-one active years after his death, which included an unsuccessful second marriage, worldwide travels, and a busy career as an artist and journalist, which involved many moves, and it appears unlikely that Guy's materials would have been saved.

Complementing what we have found—plus the oral histories from my father, Aunt Maud, another second cousin, Markel Gallagher, and other relatives and family friends—have been the enormous contributions of Will South and Marian and Phil Kovinic. Will South, as an art history student at the University of Utah, wrote his master's thesis on the Utah artist James T. Harwood and discovered that Harwood and Rose had been close friends and fellow art students in both San Francisco and Paris. Harwood left letters with numerous references to Rose. From Will's work on Harwood it was but a short step to his full involvement in our effort to document the life and

career of Guy Rose. Marian and Phil Kovinic were initially hired to do research in archival materials for me, and in the process have become very good friends. Their interest in Guy and in the Rose family has led them to many invaluable discoveries. Numerous others, in doing research on other subjects, have run across references to Guy and Ethel and have unselfishly shared that information, notably Nancy Moure, Walter Nelson-Rees, and Ilene Susan Fort.

From the process of collecting a representative selection of Guy Rose's paintings grew the idea of sharing this information with the wider public in the form of a book or a museum exhibition. It was not until I met Harvey Jones, Senior Curator of Art at The Oakland Museum, that plans for a book and an exhibition were set in motion. Harvey was impressed with what we had done and supervised the project. With the timely and tremendous generosity of Joan Irvine Smith, we are finally and proudly able to present *Guy Rose: American Impressionist.*

Avalon, California
October 1994

GUY ROSE: AN INTRODUCTION

Guy Rose

AN INTRODUCTION

William H. Gerdts

THE ANNALS OF CALIFORNIA ART, while abbreviated compared to those of states along the Atlantic coast, are replete with artists of tremendous ability—painters, sculptors, and printmakers whose works are characterized by great power, great beauty, and often great individuality. Figures such as William Keith, Arthur Mathews, Joseph Raphael, Helen Lundeberg, Henrietta Shore, and Richard Diebenkorn take a back seat to no one in the chronicles of American art. Others, such as Thomas Hill, Raymond Yelland, Samuel Brookes, Seldon Gile, Paul de Longpré, Edgar Payne, Jules Pages, and Maurice Braun, are not far behind, in my estimation, at least when their finest works are considered. Still others, William John McCloskey, Theodore Wores, and Henry Alexander among them, might well be singled out for their unique if somewhat idiosyncratic achievements, unlike those painted by artists anywhere else. And that's not taking into account eastern artist-visitors, those who worked for a while in California and there produced some of their finest pictures—one thinks easily of Albert Bierstadt, James Hamilton, and Emil Carlsen, among the numerous candidates in this category. No other state beyond the Northeast offers such a distinguished and exciting roster of artists in a consideration of American cultural accomplishment.

And yet, the bifurcation of appreciation of American regional artistic achievement is such that, with the exception of the aforementioned "visitors" and more recent painters such as Diebenkorn, these superb painters are generally not included in histories of American art, or in exhibitions organized outside the state, whether surveys or more specialized conceptions, while their works appear only seldom on the eastern art market or in major collections in the East and Midwest. I sincerely hope this will change as collectors, dealers, and museums become more aware of regional achievements and regional variants. And I must admit that despite some severe reservations on my part, the current methodological directions of cultural investigation, wherein, for good or ill, the sociological, economic, political, and even psychological implications of works of art dominate scholarly analysis, often to the exclusion of the qualitative considerations, have at times encouraged the investigation of nontraditional aspects of our art history.

Among the historical—as distinct from the contemporary—figures prominent in California's artistic history, Guy Rose has probably best achieved some measure of appreciation beyond the confines of his native state. This is probably due to a number of factors. First and simplest is the combination of sheer beauty and unequivocal professionalism in his art, this at all periods and in all aspects of his career. Equally significant are his mainstream artistic affiliations. Following upon his early mastery of still-life painting at the California School of Design, where he trained under the noted specialist of that genre, Emil Carlsen, in 1887–88, Rose, among the earliest Californians to study at the Académie Julian in Paris, in 1888–90, created such works as his *Plums* of 1889. Such a picture, reflecting the softening, more atmospheric impact, firsthand, of the works of the great French still-life painter Jean-Baptiste-Siméon Chardin, not only signifies his speedy attainment of greater professional authority but also documents his engagement with one of the essential themes of advanced student practice. Rose's early works in this genre are comparable to the still lifes by such contemporaries as his future fellow-Givernois John Leslie Breck, and it is surprising that such a painting was not exhibited when it was created. As Lois Fink perceptively observed in her important 1990 study, *American Art at the Nineteenth-Century Paris Salons,* still lifes "sometimes served young artists as a first Salon entry."

Rose's early French peasant paintings, *The End of the Day* and *The Potato Gatherers,* both of 1891, and probably painted in Crécy-en-Brie, thirty miles northeast of Paris, are archetypical of the American involvement in that extremely popular artistic theme—think alternatively of the work of Daniel Ridgeway Knight, Charles Sprague Pearce, Gari Melchers, George Hitchcock, and a good many other such specialists, once tremendously favored and patronized. Yet, in some ways at least, Rose was more original than these colleagues. Rose achieved national attention when he joined those other authorities in peasant genre with these two paintings, along with a third peasant subject, *Food for the Laborers* (private collection), at the Columbian International exposition held in Chicago in 1893. Other typical subjects which Rose exhibited at the Salon were religious works such as *St. Joseph Asking Shelter for Mary* and *The Annunciation,* and his fascinating nude Symbolist study, *The Moth,* both themes prevalent in Parisian exhibitions of the late nineteenth century. *St. Joseph Asking for Shelter* also appeared at the prestigious Cotton States and International Exposition held in Atlanta, Georgia, in 1895, and *The Moth* at the Pan-American Exposition in Buffalo in 1901. Rose's connection at this time with another young American art student and artist, Frank Vincent DuMond, is explored in Will South's essay in this book. DuMond also specialized early in religious subjects, and

it may have been he who led Rose to Crécy-en-Brie; he was exhibiting Crécy subjects at the Salon as early as 1889, and four years later DuMond established the first summer class in outdoor paintings for American students in Europe in that village. At about that time, DuMond also owned Rose's *November Morning*, which he exhibited in New York City, and he remained a champion of Rose's long after both had returned to the United States.

At the same time he was showing in the Salon, Rose was in the vanguard of more adventuresome young American painters in seeking out the modernist artistic environment that developed in the small peasant village of Giverny, halfway between Paris and Rouen on the Seine River, and the home of Claude Monet since 1883. Early writers on Rose's work, such as C. F. Sloane in 1891, even suggested that Rose was almost able to establish a master-student relationship with Monet, an association that later writers such as S. Fred Hogue in 1925 further romanticized, having them traveling together, but in actuality Monet became close to extremely few of the American colonists. The initial group of American and Canadian artists and art students settled there in 1887; Rose joined them for six months in July 1890 and returned in the spring of 1891, remaining until 1 July. He was not the first California painter there; the very young Frederick L. "Eric" Pape, who lived with Rose in Paris in 1888–89, first ventured to Giverny in the spring of 1889, and he may well have advertised the advantages of Giverny to his friends back in the French capital. But it was in Giverny that Rose first explored, if at first somewhat tentatively, the strategies of Impressionism.

Rose's major French paintings—the pictures designed for exhibition in the Paris Salon, whether they were actually shown there or not—partook of both traditional themes and traditional strategies. But his work of this period reveals a dichotomy which, again, he shared with a great many other young American painters who were fascinated by avant-garde artistic directions and yet were hesitant to embrace them completely, a dichotomy that took two interrelated forms. First, his large exhibition pieces tended to be more academic, while his smaller paintings revealed more expressive use of color, light, and brushwork—the formal devices of Impressionism. Second, the more traditional subjects were, by and large, figural, while his more experimental paintings were landscapes (Rose exhibited *no* landscapes at the Salon). This is not surprising, since his training in San Francisco and then certainly at the Académie Julian in Paris tended to focus almost exclusively on the study of the figure. In other words, Rose had far less to unlearn when, in his landscape work, he began to follow, perhaps hesitantly at first, in the footsteps of the French Impressionists and their American followers, nor need he have felt that he was betraying all the craftsmanship that he had worked so laboriously to master in art schools. And in that division, Rose would have gained great comfort in the example of other young Americans of the time whose art also separated similarly into academic figurative paintings and experimental landscapes, sometimes radically. This is the case, for instance, of Robert Vonnoh, active in the art community of Gréz-sur-Loing in France, or more subtly in the painting of Theodore Robinson, Philip Leslie Hale, Lilla Cabot Perry, the English artist Dawson Dawson-Watson, and the Canadian William Blair Bruce, all of whom were among the founders and early members of the Giverny art colony where Rose was later active. It may, in fact, be more than coincidental that Rose's major peasant subjects may *not* have been painted in Giverny, or, if they had been, he might have been tempted to follow Robinson in utilizing the advanced strategies of Impressionism in interpreting this theme, strategies that Rose may have viewed as potentially detrimental to Salon acceptance.

It was the commitment to landscape that remained with Rose when he returned to work and teach in the United States during the 1890s. The attraction of Giverny was sufficient to draw him back there in March 1894 for a fairly extended visit, now without the presence of his friend Robinson. Rose was there with his fellow Californian Ernest Peixotto, also a chum of Robinson's, and the artists who may have induced Peixotto to visit Giverny first in 1889, a year earlier than Rose; Peixotto was there frequently through 1895, and returned in the twentieth century. Peixotto would soon afterwards become an illustrator-colleague in New York City and a neighbor of Rose's on Washington Square. The two were recalled together in contemporary San Francisco literature as prominent graduates of the School of Design; their friendship during the later 1880s, the 1890s, and even much later—they were together in Giverny in 1908—would probably offer fruitful investigation. If most of the other early Giverny colonists were no longer in residence there in 1894, Monet remained of course, as did his step-son-in-law, Theodore Butler, who was also a friend of Rose's, and who much later succeeded in gaining Rose further international representation outside of France when he arranged for some of the Giverny painters to exhibit their work in Italy at the Turin International Exposition of Fine Arts in 1911; Rose

was also included in the International Exposition held in Rome that same year. Though due both to his commitment to illustration and then to his debilitating illness from lead poisoning, Rose appears to have painted very little during the later 1890s. Nonetheless, his landscape work remained pretty much in the Impressionist orbit, and certainly his experiences in Giverny could only have supported this chosen artistic direction.

Rose's early years in New York City in the last decade of the century, when he was living first at 939 Eighth Avenue in 1892 and then, after his brief return to France in 1894, for a longer period at 62 Washington Square, deserve to be better known, but the major scholars on the artist, such as Will South and Ilene Fort, have been hampered by the disappearance of most of the pictures he painted then. His illustration work during this decade was outstanding, but it has often been neglected until now in favor of his earlier and especially his later oil paintings. During these periods he continued to exhibit his major French pictures, both those that appeared at the Salon and also scenes painted during his early visits to Giverny, but he also painted American views, both rural scenes and at least one rendering of the arch in Washington Square, and their relationship to the work of American landscape specialists of the period needs further investigation. The titles of some of these, scenes of late autumn along with evening and night views, suggest his adherence to some of the favorite strategies of the Tonalist aesthetic so popular in the period, one, in fact, at odds with the Impressionist movement that was becoming dominant in America at the time. Rose may have been assisted securing his teaching position at Pratt Institute through his fellow painter Henry Prellwitz, who was already an instructor there and had been a friend in Giverny of Frederick Pape and probably Ernest Peixotto, both colleagues of Rose's from San Francisco. As a teacher of art at Pratt from 1896 to 1898, which also included at least one summer term teaching outdoor classes, Rose could not have helped exerting influence on young tyros at the school, who in turn must have recognized his affiliation with the then modernist movement of Impressionism. That this association was stressed at the time is likely, since it was then that he wrote and published about the art colony that had sprung up around Claude Monet in Giverny, France.

It may be, too, that we do a disservice to Rose by overemphasizing his California regional allegiance. It is true that during his early years in France, he associated with fellow art students from San Francisco—in 1891, for instance, both he

Guy Rose, Giverny, 1905. Photograph courtesy of the Rose Family Collection.

and Evelyn McCormick had studios at 29 avenue des Batignolles, and the two were in Giverny at the same time both in 1890 and again in 1891. But despite his California origin and early training, as well as brief return visits—in 1891–92, when he exhibited primarily French pictures at Sanborn, Vail & Company in Los Angeles in October 1891 and in San Francisco at the Art Association; in 1895, when he returned for a few months to Los Angeles with his new wife, the former Ethel Boardman, whom he had met in Venice in 1894 and married the following January in Paris, lecturing on Parisian art for the local Los Angeles Association; and in 1902, when he was living in Los Angeles while again exhibiting with the San Francisco Art Association—he was really active in that state only for seven years at the end of his career, extremely productive though that period was.

When Rose went back to Europe in 1899, he and Ethel visited Giverny again that May, and by the following winter, during a stay in Algeria, he had resumed painting on a limited scale, resulting in a series of figural subjects created in Biskra. He and Ethel appear to have been based subsequently in Paris; by the summer of 1903 they had certainly established a relationship with some of the members of what came to be known as the Giverny Group, a coterie of primarily Chicago-trained painters, for Rose joined Frederick Frieseke, Lawton Parker, and Alson Clark on an extended painting trip through Brittany, before returning to Paris that winter. The following year he and Ethel settled in Giverny, purchasing and enlarging a home in the village, and he seems to have fully resumed his artistic career there in 1905, remaining until 1912, for what amounted to the longest residence of his artistic career. In fact, given his new friendships with Frieseke and his associates, and the lessening of his physical disability, Rose's move to the established art community of Giverny may be identified as a reassertion of his commitment to painting. And now his involvement with

3

The Bridge at Vernon. Oil on canvas, 23 x 28 in. Mr. and Mrs. Thomas B. Stiles II.

the Impressionist aesthetic was total, encompassing both his figural and landscape work; some of the latter concentrated upon architectural monuments in Giverny, such as the Church of Saint Radegonde, the Blue House, as well as the Bridge at Vernon. This commitment may have been due, in part, to the increasing acceptance and even dominance of Impressionism throughout much of the world, East and West, but also to the evolution in Giverny of a figural aesthetic, which easily encompassed the sensual components of light and color so essential to Impressionism, one that obviously appealed to Rose. Though several of his early Giverny colleagues such as Robinson and Dawson-Watson had successfully painted the older, traditional themes of peasant and religious subject matter utilizing Impressionist, or quasi-Impressionist, strategies, these may have seemed inappropriate to Rose when investigating those motifs. But by the beginning of the twentieth century, those themes were no longer in vogue, and Rose joined the other American members of the Giverny colony in concentrating upon the images of lovely ladies dressed in gaily patterned robes and kimonos and situated either in colorful indoor settings or lush gardens. These were very decorative pictures, both in subject and strategies, with a concentration on appealing loveliness, a fantasy world sometimes with gentle

overtones of eroticism (though Rose seldom depicted the nude figure, favored by a number of his colleagues). Of the contingent of American artists who specialized in this subject matter, Rose was the earliest Giverny resident, but given his affliction, which allowed him to resume full-time painting only in the middle of the first decade of the century, he must be counted as one of a number of painters following the lead of Frederick Frieseke, the acknowledged master of this genre.

This group of painters was extremely gemütlich, though it seems that all of them, Rose included, were also very friendly with the older resident American artists remaining in Giverny, such as Butler and the sculptor-painter Frederick MacMonnies. The younger men shared not only artistic themes and ideas but also private locations for painting, props, and probably models, and their social lives were extremely intertwined, within a middle-class and familial pattern that was far different from that enjoyed by the mostly independent young men and women who had first appeared in Giverny in the late 1880s. As an illustrator as well as a painter, Rose formed a natural kinship with Arthur Burdett Frost, one of the most renowned of American illustrators of the period, who took a house in Giverny in 1908. The two artists hunted and fished together, along with Frost's son, the budding artist Jack Frost, and then

4

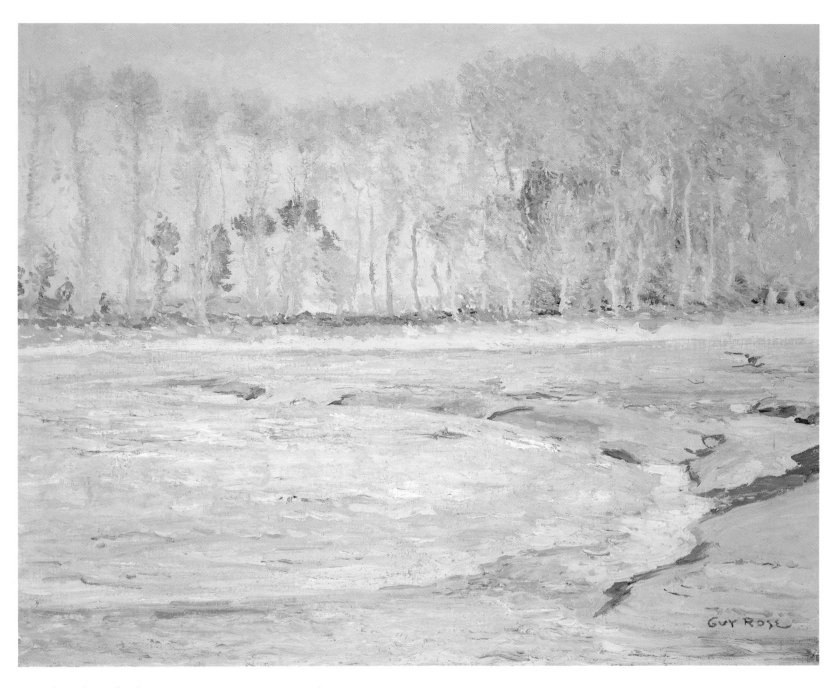

Low Tide Honfleur, n.d. Oil on canvas, 24 x 29 in. Joan Irvine Smith.

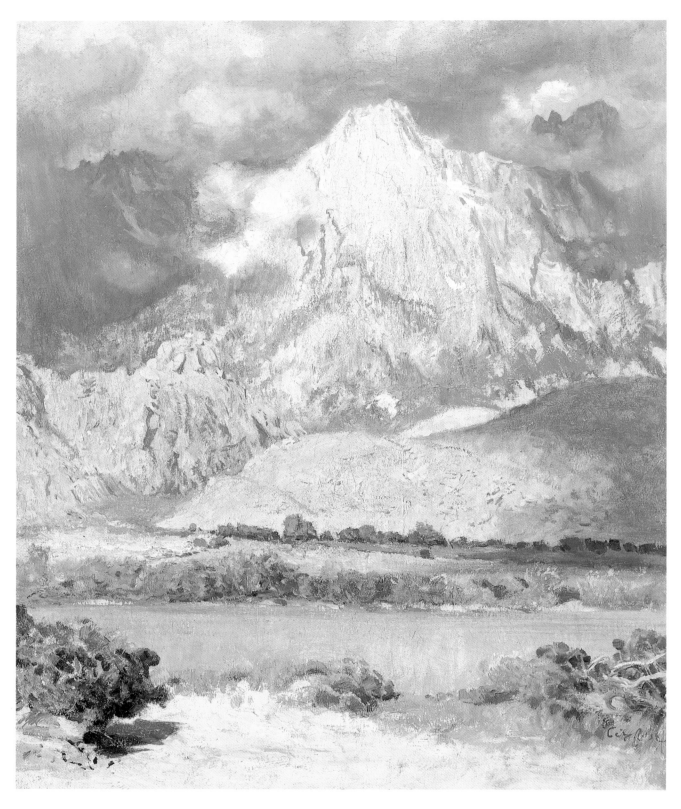

Gathering Storm, High Sierra. Oil on canvas, 28 x 24 in. Wendy Webster Collection.

jointly illustrated several articles together on the subject, authored by Guy's wife, Ethel. Rose and Frieseke were also especially close, although Rose's pictorial identification with his colleague was probably no greater than that shared by Lawton Parker, Richard Miller, Edmund Greacen, Karl Anderson, Karl Buehr, Louis Ritman, and George Biddle, each also with his own pictorial distinctiveness. Rose, in fact, differed from all the rest of these painters except perhaps Greacen, in that his Giverny practice was at least equally as devoted to landscape as to figure painting; contemporary writers emphasized his poetic seasonal interpretations of the broad fields and the willows along the river Epte. And it may be that Rose's involvement with the Giverny colony has led scholars to overlook the paintings he created elsewhere in France, during what may be called his "holidays" away from Giverny—coastal scenes painted at Honfleur and Veules on France's northeast shore and at Antibes, Cagnes, and Toulon along the French Riviera on the Mediterranean.

It may be significant that unlike the previous waves of American artists in Giverny whose origins were in the Northeast, especially New England, this final group derived almost exclusively from the Midwest or, in Rose's case, the Far West, lacking to some degree a long tradition of cultural baggage and artistic legacy. Buehr, Ritman, and Biddle were later residents in Giverny, only arriving in 1909, 1911, and 1915 respectively, but the other six, Rose included, were much touted as the Giverny Group when their work appeared in two shows in New York City in 1910 at the Madison Art Gallery—Greacen's and Anderson's together in January, and that of the other four in December. Though Rose had exhibited previously with the Macbeth Gallery in New York, it was through his association with that group of "Luminists," as they were denoted, that he seems to have gained his greatest national reputation.

Within two years, however, Rose had returned to New York City in 1912, living once more on Washington Square and then nearby in the old Tenth Street Studio Building. It is not known how active he was as a painter in this period, since the works he exhibited in various institutions were either French subjects or landscapes with generic—primarily autumnal—titles, which may also have been painted abroad. A number of his paintings also were shown in 1913 at the Macbeth Gallery in New York, where one critic compared his achievements to those of the much-lamented American Impressionist John Twachtman, an artist with whom Rose was again paired at the time of his 1926 memorial show at the Stendahl Galleries in

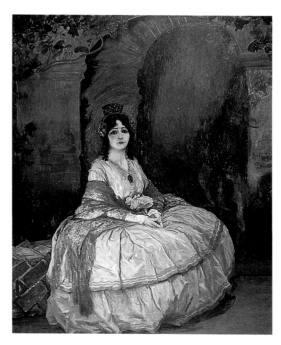

The Leading Lady (Miss Lucretia del Valle as Señora Josefa Yorba), 1915. Oil on canvas, 72⅛ x 60¾ in. The Buck Collection.

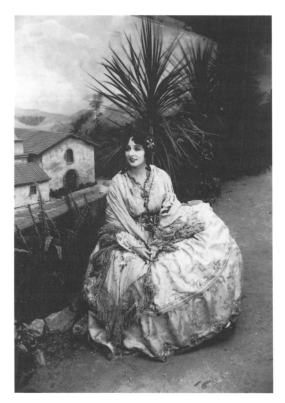

Miss Lucretia del Valle as Señora Josefa Yorba in John McGroarty's *Mission Play*. Photograph courtesy of the Rose Family Collection.

Los Angeles. He also taught again, this time two seasons of summer classes in Narragansett, in Ethel's native state of Rhode Island, while painting the local landscape there, and we would wish to know something of the impact he had upon those students. Only in late 1914 did he settle permanently back in California. Incapacitated by a stroke early in 1921, he was active there for less than seven years, but they constituted not only his most productive period but also his most influential. This was due in part to his tremendous artistic authority, primarily in landscape painting, which he devoted to rendering the appearance of historic buildings, such as the San Gabriel Mission, and especially of many of the picturesque or dramatic regions of the state—the Sierra, the Mojave Desert, and the dunes at Monterey, as well as around his home area of Pasadena. He was perhaps most consistently successful with his coastal scenes, first at La Jolla and Laguna, and then, from 1918, on the Monterey Peninsula at Carmel, works that had precedent in his art in the pictures he painted at Honfleur and Antibes. But allied to these pictorial achievements was his identification with Impressionism itself, an almost universally acceptable aesthetic by the mid-1910s, which was still excitingly avant-garde in Southern California when Rose settled in Pasadena in 1914. If Impressionism needed validation in California, it received it at just this time, first with the appearance there that year of Childe Hassam, the country's most archetypical and most successful practitioner of the mode, and then the enshrinement of Impressionism at the Panama-Pacific International Exposition in San Francisco the following year, where many of the nation's leading Impressionist painters, including Frieseke, were honored with extensive one-artist displays. Rose himself displayed two landscapes there, winning a silver medal. The following year, an unusual venture into theatrical portraiture by Rose, his 1915 likeness of the actress Lucretia del Valle as Señora Josefa Yorba as she appeared in John McGroarty's *Mission Play,* was shown in San Diego at the Panama-California International Exposition and won a gold medal.

Rose's significance for the art world of Southern California was not confined to his painting. In 1915 he accepted a teaching position at the Stickney Memorial School of Art in Pasadena, the art school of greatest repute in the region, and in 1918 succeeded Channel Pickering Townsley to the directorship there. Rose's impact upon the students is yet to be calculated, but it may well have been formidable. In line with both his own artistry and his previous experience, the school's effectiveness vis-à-vis the Impressionist aesthetic was only further enhanced by the addition to the Stickney faculty of two former residents of Giverny—Richard Miller, who joined the school for a two-year stint in 1916, and then Alson Clark, who joined the faculty in January 1921 at Rose's invitation, and took Rose's place as director at the end of the year, after the latter's stroke. Jack Frost, too, settled first in Palm Springs in 1919 and then joined his parents in Pasadena, his work developing along Impressionist modes often quite similar to those practiced by Rose, his father's great friend from their Giverny days. Rose, Frost, and Clark were sufficiently associated that they were included in a show together with two other painters at the Maryland Hotel Art Galleries, Pasadena, in May 1923. Rose was active with the California Art Club, with which he showed regularly from 1915 and where he won the first Black Prize for *A Sierra Trout Stream;* with the Ten Painters Club of California; and with the Laguna Beach Art Association, though he did not exhibit with the latter in their first exhibition held in July 1918, perhaps because he was turning his attention at that time to the scenery of Northern California. Rose was also an annual exhibitor with the Painters and Sculptors of Southern California at the Los Angeles Museum of History, Science and Art, where he won the Preston Harrison Prize in 1921 for *In Arcadia.*

Thus, though relatively brief in his number of active years in the region, Rose was California's premier Impressionist. In 1929, the well-known Los Angeles art critic and talented etcher, Arthur Millier, not only praised Rose as having been the finest artist of the region for the sheer beauty of his painting but also spoke of his great influence upon younger painters. Rather than establishing a new Giverny on the Pacific, Rose advanced the interpretation of the California landscape in Impressionist terms, perhaps more fully than any other artist, and certainly with the most impressive credentials.

GUY ROSE (1867–1925)
AN AMERICAN IMPRESSIONIST

Guy Rose (1867–1925)

AN AMERICAN IMPRESSIONIST

Will South

It is good for the disquieted soul to meet a painter who is an artist by every instinct in his nature, who is a thoroughly trained craftsman in his work, and who is modern without wild vagaries.

ANTONY ANDERSON, "Guy Rose: An Appreciation," in *Guy Rose: Paintings of France and America*

BEFORE HE WAS A CALIFORNIAN, an American, or an expatriate, Guy Rose was a painter. He understood color before politics, and composition before rhetoric. Like most painters, he was compelled by and fascinated by images without a driving need to articulate the reason in some language other than the imagistic one. Pictures provide their own kind of truth, and seeing is its own form of knowledge.

The circumstances of Rose's life ensured that his art would reveal something about being a Californian, an American, and an expatriate. As an expatriate in Europe, he participated in international art movements and contributed to the dissemination of these movements in his own country. As an American, his art partakes of a larger romantic dialogue in painting, stretching back to the Hudson River school, that understood and visually confirmed America as the new Eden, replete with natural resources commensurate with its power and destiny. As a Californian, he recorded his native state by blending the expatriate experience with a western variant of the America-as-Eden ideology, a view characterized by an expanded sense of space and mobility. He thus contributed to the early and lasting definition of California as both a land of great natural riches and the locus of individual freedom, a paradigm of the American Dream. But his essential choice to define himself as a painter, as an image maker, made certain that his art would reflect experiences as personal as they were cultural, phenomena intuited as well as observed, and sensations so fundamental as to be abstract.

Guy Rose was called a modern in his own lifetime, a term he did not apply to himself and that he condemned when applied to early-twentieth-century movements. In our time, when Rose and his entire generation have come under intense scholarly scrutiny, he has variously been called a Regional Impressionist and a cosmopolitan painter. Such terms, we know, would have had little or no meaning for him, and have meaning for us only inasmuch as we define them and mutually agree on what these labels describe. Yet, as useless as words sometimes seem, we continue to discuss him precisely because his

art continues to capture our imagination. What he desired and what he achieved are part of our complex cultural heritage.

Drawn to his deceptively simple, usually elegant, and sometimes iconic paintings, we wish we knew more about him. Unfortunately, Rose left little either in the way of personal writing or articles, and few statements in the press. He left no children, and no personal friends survive. But we do have his most important and telling legacy—the paintings themselves. The following text relies heavily on these images and the historical context in which they were made, with the awareness that the act of painting continues to resist absolute definition. Another hundred years from now, this same group of paintings may survive to tell a very different story to an entirely new world of Californians, Americans, and expatriates of all kinds.

IN THIS LAND OF PLENTY

The artist's father, Leonhard Johannes Rose (which he changed to Leonard John Rose), was born in 1827 in the medieval town of Rothenburg-on-the-Tauber near Nuremberg, in what was then the kingdom of Bavaria. At eleven years of age, "L. J." (as he was later most often called), his mother, and one of his two sisters immigrated to America and joined his father, who operated a small merchandise store in New Orleans. Shortly after their reunion, the family relocated to Illinois, where, again, a retail business was established.

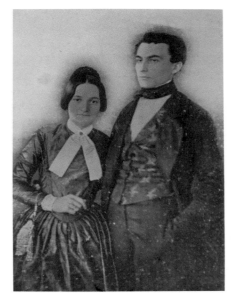

FIG. 1. L. J. Rose and Amanda Jones at the time of their wedding in 1851. Photograph courtesy of the Rose Family Collection.

9

As a young man, L. J. studied for a year at Shurtleff College in Alton, Illinois. He married Amanda Jones (1834–1905) in 1851 (fig. 1), and they had three children before going west: William Ferdinand (b. 1851), who died at three years of age; Nina (b. 1856); and Annie (b. 1857).[1]

L. J.'s earliest business ventures, like those of his father, were mercantile. However, L. J. was far more gifted in the art of money making. He enjoyed success early with selling both produce and livestock. After college, he moved to Van Buren County, Iowa, where he eventually ran his own general store. In 1857 L. J. sold his store for the then enormous sum of thirty thousand dollars. This money made possible the pursuit of an even greater ambition—a move to California, where he could pursue large-scale citrus farming and wine production, and use the profits to finance the breeding of thoroughbred horses.

Aggressive, industrious, and opportunistic, L. J. Rose decided to invest the bulk of his capital in his personal California dream. He later recalled first hearing about his future home: "In 1858, some miners, who had returned from California, so fired my imagination with their description of its glorious climate, wealth of flowers and luscious fruits, that I was inspired with an irresistible desire to experience in person the delights to be found in this land of plenty."[2] That same year, L. J. Rose organized a group of about twenty young men and their families to make the trek across the country, a group that included his wife, Amanda, their two daughters, and Amanda's parents. In addition, he had with him "the finest herd of short-horns and drove of trotting-bred horses that had ever been driven over the plains,"[3] testaments to his early success in business. The bottle of "eight dollar brandy" he packed for the trip, while not specifically evidence of business acumen, signaled his taste for worldly pleasures and prefigured his role as a major producer of fine wines and brandies.

The Rose Party, as it became known, allegedly decided to bypass Utah because of "the Mormon troubles"[4] and take a more southerly route. Though the trip was initially enjoyable, the party soon discovered and suffered the grueling difficulties well known to those who had crossed this vast and magnificent, yet often brutal, terrain. They moved west from Albuquerque along a trail known then as the "Thirty-fifth Parallel Route," which had previously been used only by the army. Grass, game, and water gave way to rock, weed, and strength-draining obstacles. By the time the Rose Party reached the mountain range bounding the valley of the Colorado River, the travelers as well as their stock were weakened by heat and relentless struggle. This terrible fatigue was not to be the last of their problems.

The Rose Party, too, had increasingly problematic encounters with Native Americans. Attempts at communication were confounded by obvious language barriers. The Indians did know some English and Spanish, and with what little sign language the immigrants contrived, a few trilingual meetings were held with various tribes. Goods were traded, and promises exchanged. Old West diplomacy unfortunately fell apart near the banks of the Colorado, where the Rose Party planned to make its crossing. It was at the river's edge that they encountered Mojave Indians, and a fierce battle ensued.[5] Many in the Rose party were injured, some fatally. Their cattle and horses were cut loose and the majority of wagons destroyed. When the fight was over, the immigrants decided not to try to ford the river in their tired, injured, and demoralized state. They agreed to return to Albuquerque, retracing the tracks they had so recently made.

L. J. Rose and his family stayed in Albuquerque for the rest of 1858 and into 1859, then moved to Santa Fe, where they remained for the next two years. Retaining what was described as his "faculty for accumulation,"[6] L. J. undertook a new venture: the hotel business. With what little money he had left and some that he borrowed, he purchased La Fonda, a picturesque hostelry with a colorful clientele. He reportedly saved fourteen thousand dollars from hotel proceeds,[7] easily enough to make the long-awaited trip to California and to have funds left over for the purchase of land. Gambling was a legal and legendary affair at La Fonda and accounted for the sizable profit.

Later in life, Rose indulged a penchant for artistic expression when he recalled his arrival near the site that would become his famous ranch and beloved home:

In 1861, I arrived at El Monte, lying at no great distance from Los Angeles, on one of those delightful evenings that so frequently occur in that part of California, bringing peace to the wanderer's soul. The willows threw dancing shadows on the road; bloom greeting eye on all sides; sweet-scented flowers and new-mown hay charged the air with delicious perfumes; and nature and mankind seemed to take their repose, so quiet was the world, as the sun was sinking to his rest. Presently the bell of San Gabriel Mission rung the vespers protesting, as it were, against nature's silence, and arousing the indolent to activity. On every hand was plenty; surely we had reached the promised land.[8]

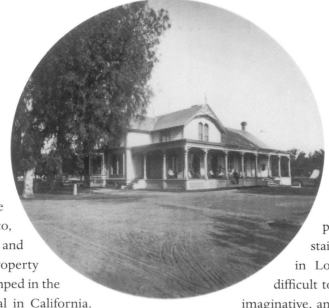

FIG. 2. The Sunny Slope Ranch, looking southwest from the Rose home, in 1886. Photograph by Carleton Watkins, courtesy of the Huntington Library.

SUNNY SLOPE

After traveling from El Monte north to Sacramento, San Francisco, and beyond, and south to San Pedro and San Diego, Rose finally bought property not far from where he originally camped in the San Gabriel Valley upon his arrival in California. Though accounts vary as to how much money he actually started out with,[9] L. J. was able to purchase piecemeal 2,200 acres that were formerly part of San Gabriel Mission lands.[10] He named his new home Sunny Slope and developed the acreage into some of the most productive land in all of Southern California (fig. 2).

The name of L. J.'s ranch derived in part from the fact that the road leading to the estate gradually ascended from its origin not far from the San Gabriel Mission. Approaching Sunny Slope, one first encountered a half-mile track, where colts were trained.[11] Beyond the course the road was fenced in with orange trees on both sides, followed by lemon, olive, and walnut groves. Past the house was a brook that carried water through the ranch year-round, a remnant of a dam built by Catholic missionaries nearly a hundred years before. Acres of vineyards stretched northward, followed by structures containing the wine presses and vats, and cellars full of casks. Adjoining these was a brandy distillery.[12] Unenclosed horse pastures full of alfilaria, burr clover, and wild oats lay at the periphery of Sunny Slope.

A visitor in 1875 described the Victorian-style house at the center of the estate:

> A handsome villa with wide verandas and projecting eaves, it is just the thing for the center piece of the picture. Beautiful without being ostentatious, the architecture is so well-adapted to the surroundings, so thoroughly in keeping that it does not attract, at first sight, the attention which is afterwards given. . . . So beautiful are the surroundings of the villa, so admirably arranged to please the eye, as though the landscape artist had exerted himself to the utmost to enhance the effect from the grouping of the different kinds of trees and shrubs.[13]

L. J. did, in fact, function as something of a landscape architect when designing Sunny Slope. Just north of the house stood a giant eucalyptus tree, ninety feet high, which Rose trimmed in order to make it "harmonize with a weeping willow a few yards away."[14] This nascent aesthetic sensitivity in the elder Rose appeared again when he collaborated with his painter son, Guy, on a series of stained-glass windows for a later home in Los Angeles (fig. 3). Indeed, it is difficult to imagine that the entrepreneurial, imaginative, and epicurean L. J. Rose did not support Guy's artistic inclinations from the very beginning.[15]

Guy Orlando Rose was born at Sunny Slope on 3 March 1867, the seventh of eleven children. In addition to his older sisters Nina Elizabeth and Annie Wilhelmina, who were brought across the westward trail with their parents, and Willie Ferdinand, who had died in Iowa in 1854, the older siblings were Harry Ezra (b. 1860 at Santa Fe), Leonard John, Jr. (b. 1862), and Hinda Alice (b. 1864). Four more children came after Guy: Cora Daisy (b. 1869), Maud Amanda (b. 1872), Mabel Rose (b. 1877), and Roy the Chief (b. 1880). All the Rose children enjoyed the advantages of living on the sumptuous Sunny Slope estate, which included ample space in which to play, fish, hunt, and ride horses.

Guy's older brother, L. J., Jr. (known to his family as "Leon"), recalled that while there were no favored children in the Rose family, Guy was always of a "different temperament": "Of a studious nature, very fond of books, knowing nothing of nor caring for horses, he [Guy] kept in close contact with my father in the evenings, who was also a great reader. Whereas with Harry and myself it was just the other way around. Guy

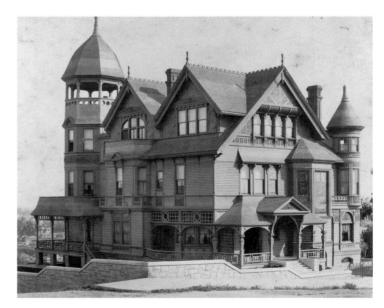

FIG. 3. View of the Rose family home at Fourth and Grand, Los Angeles. Photograph by Carleton Watkins, courtesy of the Huntington Library.

GUY ROSE (1867–1925): AN AMERICAN IMPRESSIONIST

was such a sweet, retiring little chap."[16] This difference of temperament emerged most fully after an accident that changed the course of young Guy's life.

Guy, not yet allowed to hunt, had made pets of the quail raised on the ranch, and at holiday time he bargained for their lives with the promise that his older brothers would bring home quail from the field for dinner. About nine at the time, Guy joined his brothers Harry and Leon on the hunting expedition. Harry's rifle discharged accidentally, and the blast struck Guy in the face, tearing away the flesh from his chin to his lower jaw. As Leon recalled: "Horror of horrors, as he fell I rushed to him and almost got my hand in his mouth, when I in my frenzy clasped it over the wound. It was more than a quarter of a mile to our house. How we got the little fellow there without his bleeding to death I cannot imagine."[17]

After dismissing an incompetent doctor, Guy's father treated the wound with crude petroleum, a gel that he used extensively and with great success in caring for his horses. The wound healed, though a scar "about the size of a silver dollar" remained. Again according to Leon, it was during the period of convalescence that Guy's artistic talents appeared: "While lying on his back, Guy developed artistic tendencies; he began to sketch and to use a small box of water colors. When up again and about and ready for school, the die for his future had been cast; his mind centered entirely on painting."[18]

Guy Rose received his first art instruction from Mrs. Cordelia Penniman Bradfield (1838–1902), either while still in elementary school, which is most likely, or when he attended Los Angeles High School.[19] The Vermont-born Bradfield had arrived in Los Angeles in 1874 and by 1880 was principal of drawing in all the Los Angeles public schools. This early student-teacher relationship was positive enough for Guy to be remembered later as Mrs. Bradfield's "pet."[20] Aside from Bradfield, Guy's exposure to paintings in general was very limited in the Los Angeles of the late 1870s and early 1880s. Unlike San Francisco to the north, Los Angeles had a comparatively undeveloped cultural life. A severe economic depression crippled the Southland in 1875, followed by a drought in 1877 that destroyed both crops and cattle. From a population high in 1876 of 17,600, the town shrank to just 11,000 inhabitants by 1880, the year the first asphalt pavement was laid on Main Street. General support for art and artists was not yet possible in what was still a very small, remote agricultural community.[21]

The first significant increase in population began in 1885,[22] the year Guy left for study in San Francisco. Prior to that, he may have seen chromolithographs and some paintings at the Los Angeles salesroom of V. Ponet at 66 Main Street, as well as the few paintings that hung at the Los Angeles Fair. Most Angelenos, however, purchased decorative items for their homes from itinerant vendors during the period before 1885—a larger market for art simply did not exist.

One is tempted to speculate that Guy's father, having both a substantial income and an interest in fine things, might have purchased some artwork for the villa at Sunny Slope while Guy was still living at home. Whether this was the case or not, Guy was nonetheless sufficiently informed about art at the time of his graduation from high school to know that there existed in San Francisco a serious art school, one staffed with recognized artists and capable of steering him toward a professional career. In 1885, at the age of eighteen, Guy enrolled in the San Francisco Art Association's California School of Design.

Though he would live successively in San Francisco, Paris, and New York, an important part of Guy Rose's personality had been molded by the expansive environment at Sunny Slope. He loved the out-of-doors. Throughout his life, Guy remained an avid hunter and fisherman, two favorite family activities on the ranch. He never felt as comfortable in cities as in the country, and always gravitated toward villages and hamlets in which to live and work for extended periods. Further, he learned determination and hard work from his father. Like his father, Guy had become a man who "rarely said anything that would have been better unsaid."

SAN FRANCISCO

San Francisco in the mid-1880s was a vital city, buoyed by the financial ventures of both Argonauts and railroad tycoons. It was connected to the American East by the iron horse, and to the Far East by its major port of entry for trade and immigration. A number of prominent artists, including Albert Bierstadt (1830–1902), William Keith (1838–1911), and Thomas Hill (1829–1908), established studios there, and other nationally known artists such as George Inness (1825–1894) visited. They were attracted by both the opportunity for local sales and the city's convenient proximity to the varied and spectacular landscape of the west.

The San Francisco Art Association's California School of Design was established by resident artists in 1874 to train the increasing number of students pursuing painting as a cultural refinement or social diversion, as well as those who had decided upon art as a career.[23] The first director and initially the sole teacher at the school was Virgil Macey Williams (1830–1886), a former Harvard drawing instructor who had studied in Rome (fig. 4). Recalled as a firm but fair man in his dealings with students, Williams was possessed of a sense of history and the need to understand the traditions within which one worked as an artist.[24] He was still teaching and running the school when Guy Rose arrived in 1885; he was the young artist's first professional instructor.

The curriculum of the California School of Design was patterned after the rigorous and disciplined methods of the European academies. Students first learned to draw by copying prints (a process known as "drawing from the flats"), then advanced to drawing from plaster casts, and, after demonstrating sufficient progress, were finally graduated to working from live models. Williams was an exacting instructor who taught the precise, linear, and academically time-honored use of charcoal for defining areas of light and shade along with achieving correct proportions. Guy's early success in this mode, and perhaps a certain youthful pride, can be clearly seen in a photograph of him seated with his drawing before a plaster cast of the Capitoline *Dionysus* (fig. 5).[25]

Although aware of the importance of the classics and tradition, Williams did not neglect the opportunity to exchange ideas with contemporary artists, such as his friend Albert Bierstadt. So current was he with training as it was practiced in Europe that Williams translated for his own students an anatomy lecture by Léon Bonnat (1833–1922), a pillar of the French academic establishment.[26] This lecture was doubtless

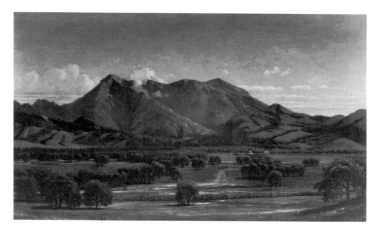

Fig. 4. Virgil Williams (1830–1886), *Mount St. Helena (from Knight's Valley)*, n.d. Oil on canvas, 26 x 41½ in. The Oakland Museum Kahn Collection, 65.63. Photograph by M. Lee Fatherree.

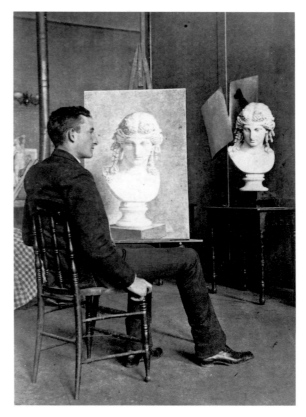

Fig. 5. Guy Rose in front of his drawing of the Capitoline *Dionysus*, taken while a student at the San Francisco Art Association's California School of Design, ca. 1887. Photograph courtesy of the Rose Family Collection.

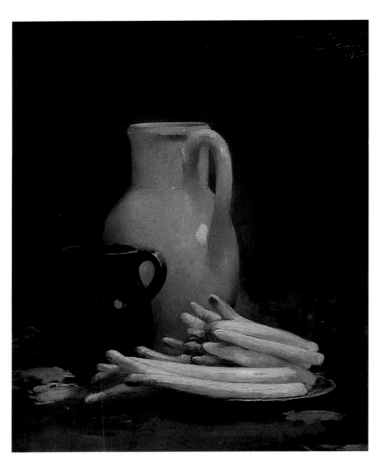

FIG. 6. Emil Carlsen (1853–1932), *White Asparagus,* 1891. Oil on panel, 24 x 18 in. California Collection of William and Zelma Bowser.

Offered the position of director after Williams's death, Carlsen arrived in San Francisco from New York in 1887. He brought a distinct sense of modernity to his still-life painting, the genre for which he remains best known. As opposed to the more tightly modeled and utterly clear forms observed in Williams's painting, Carlsen applied pigment broadly and in dramatic, baroque contrasts of light and dark. Carlsen was sensitive to lost edges in pictorial space, where, for example, the silvery scales of a fish give way softly to an enveloping dark, empty background. A gold highlight on a brass dish might be applied with an abrupt stroke, with no attempt at a smooth transition. In short, the tactile properties of paint itself were apparent in Carlsen's work. In certain discrete passages, the sense of illusion in a painting by Carlsen is balanced with the concrete, sensual presence of pigment. His confident application of thick, dark paint and brilliant highlights betrays a debt to Velázquez and certain of the Dutch masters. His fluid articulation of paint not only impressed Guy Rose but served as precedent for the considerably looser surfaces Guy would later come to understand and master.

Carlsen's influence on Guy Rose is evident in a comparison between Carlsen's *White Asparagus* (fig. 6) and Rose's *Spring Harvest (Still Life with Asparagus)* (fig. 7), a San Francisco–period painting dated 1887. In *White Asparagus,* Carlsen denotes both background and foreground in sweeping strokes. The still-life forms, by contrast, are clearly delineated. On each ceramic pitcher, a thick swatch of white paint defines the highlight. Rose's work is similar in many respects and no doubt derives from an earlier Carlsen variation on *White Asparagus.* The Rose shares the same compositional structure, dark, empty background, and dramatic highlighting.[29] Though seemingly unfinished, Rose's *Still Life: Jug with Fruit* (fig. 8) also reflects Carlsen's influence with its sonorous, tonal background, accentuated horizontality, and heavy impasto highlights.

Carlsen's intense devotion to his craft and his personal integrity also must have impressed Rose, as it did other students. Harwood recorded an incident in which a wealthy man approached Carlsen and offered him four hundred dollars for a painting of lemons. According to Harwood, "Carlsen told him no, he wouldn't sell it, and he guessed he would keep it. And in a few days he sold it for forty dollars. He wouldn't sell one [painting] to a man he didn't like at any price."[30] Since Harwood's time in San Francisco did not coincide with Carlsen's, this story was surely told to him in Paris by his roommate, Guy Rose, who saw in it a model for the behavior of the sincere

still in use in 1885. In addition, and not coincidentally, Guy later attended Bonnat's lectures in Paris. Williams would have shown Rose that past art and current experience could fruitfully coexist in the work of an artist, an idea that soon had special relevance for the young painter.

Virgil Williams died in 1886 and was succeeded temporarily as director of the school by Raymond Dabb Yelland (1848–1900), who taught outdoor sketching and painting classes from nature.[27] Rose had sketched out-of-doors since his arrival in San Francisco in 1885, the same year his classmate and later close friend James Taylor Harwood (1860–1940) came from Salt Lake City. Harwood later recalled how he, Rose, other students would camp along the shoreline with painting gear in tow, searching for the picturesque. At this early date, then, Guy was no stranger to working outside the studio. His strongest influence during his San Francisco years was, however, neither Williams, Yelland, nor the more famous artists residing in the city, but yet another School of Design teacher, Sören Emil Carlsen (1853–1932).[28]

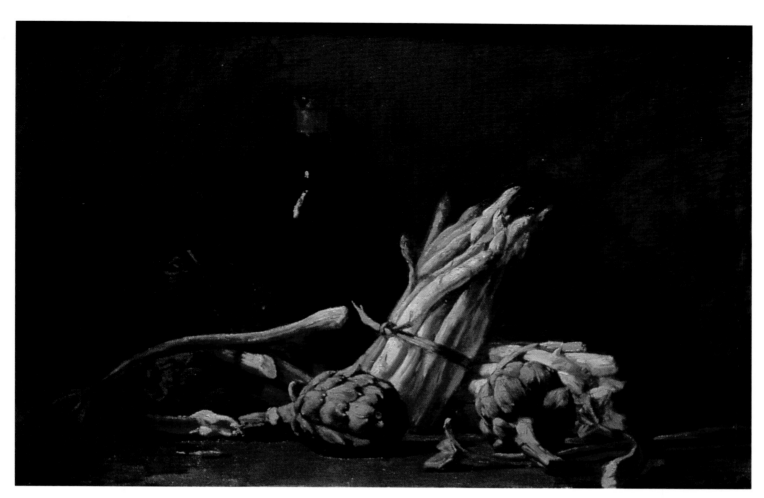

FIG. 7. Guy Rose, *Spring Harvest (Still Life with Asparagus),* 1887. Oil on canvas, 16 x 22 in. Harry Parashis Collection.

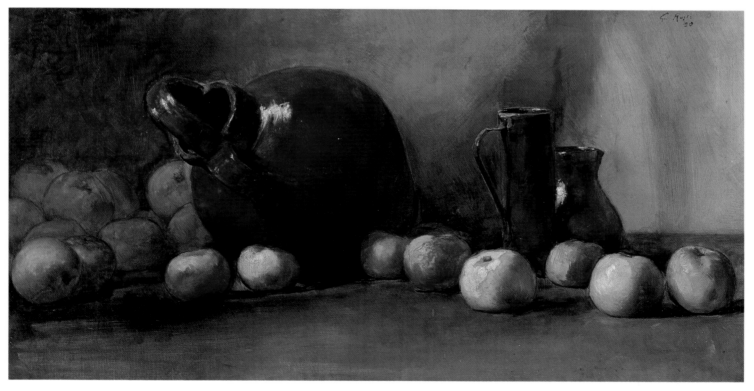

FIG. 8. Guy Rose, *Still Life: Jug with Fruit,* 1888. Oil on canvas, 28 x 34 in. The Oakland Museum, Gift of Dr. and Mrs. Jacob J. Foster, 82.62.

GUY ROSE (1867–1925): AN AMERICAN IMPRESSIONIST

FIG. 9. Guy Rose and L. J. Rose, stained-glass window for Rose house at Fourth and Grand, ca. 1886–88. Wood and paint on stained glass, 25 x 30 in. Richard and Janet Bruno Collection.

artist who paints for the sake of painting, not to create commodities.

Rose was aware of other artists in San Francisco, including William Keith and Edwin Deakin (1838–1923). Keith maintained a studio in downtown San Francisco at 417 Montgomery Street from 1885 to 1889, while Deakin's son was a friend to Harwood and Rose and introduced them to his father's work. Keith's dark, spiritual interpretations of landscape would have reinforced for Rose the romantic possibilities of painting.[31] Deakin was likewise a romantic, but in often more colorful and exotic scenes. His images of Chinatown, painted in the 1880s, were activated compared to the quiet and pastoral vision of Keith.

While still a student at the School of Design, Guy collaborated with his father on a series of stained-glass windows for a new house L. J. was planning to build in downtown Los Angeles (fig. 9; see also fig. 3).[32] These windows featured Guy's still-life paintings in the centers, paintings that demonstrate an awareness of Deakin's well-known and much-admired series of grape paintings (fig. 10).

The three years that Guy Rose spent at the California School of Design were fruitful in a number of ways. Academically, under Emil Carlsen's directorship, Guy won the Avery Gold Medal in painting, which recognized his excellence among his classmates. Socially, he formed deep attachments with his friends. In addition to the lifelong friendship he made with James ("Jim") Harwood, he befriended the slightly younger Frederick L. "Eric" Pape (1870–1938)[33] and Frederick Marvin (d. 1942), and the four students would continue their studies abroad together as roommates. Of great importance to his artistic development, his years in San Francisco exposed Rose to the work of highly competent artists working in different styles. When he left California for Paris, he took with him a respectable foundation in drawing and painting skills, three good friends, and a philosophical flexibility that would allow him to assimilate a variety of influences.

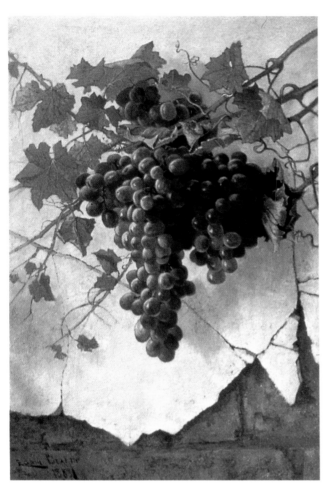

FIG. 10. Edwin Deakin (1838–1923), *Grapes against a Mission Wall,*
1883. Oil on canvas, 24 x 16 in. Courtesy of Garzoli Gallery,
San Rafael, California.

PARIS

It seems like nothing is spared to make things perfect here.

JAMES TAYLOR HARWOOD, 1888

While students at the School of Design, Guy Rose and
James Harwood discussed the possibilities of study in Europe.
Virgil Williams had provided initial encouragement with
ample stories of museums, castles, and antiquity. As proud of
their school as the San Francisco students were, they knew
there was a larger and more important center to the art
world—Paris.

From San Francisco, Rose maintained correspondence
with Harwood, who had returned to Salt Lake City in 1886.
Plans for their study abroad were finalized via letters, and the
pair rendezvoused in Ogden, Utah, on 20 August 1888.[34] Join-
ing them were Eric Pape and Frederick Marvin. From New
York, the four friends—"The Four Scars of the West"—sailed
for England on the steamer *Trave,* arriving in Southampton in
exactly seven days. From there, a ferry took them to Le Havre,
and then another train finally to Paris (fig. 11).

The time Guy Rose had lived in San Francisco had no
doubt prepared him somewhat for life in a city, as opposed to
the ranch life of Sunny Slope, but it could not have prepared
him fully for the cultural riches of Paris. With Harwood, Rose
visited the Louvre, the Luxembourg Museum, and Versailles.
For both, the city was a marvel. Harwood wrote home: "It
seems like nothing is spared to make things perfect here. The
buildings are more than I can describe and the streets are so
clean that at night they reflect like a mirror."[35] After a few days
spent in a hotel, they found an apartment at 50 rue d'Assas, and
the two enrolled at the Académie Julian on 12 September 1888.

For most American students who came to study art in
Paris in the late nineteenth century, the Académie Julian pro-
vided an attractive alternative to the government-sponsored
École des Beaux-Arts, which, though free, had stringent
entrance requirements. Founded by Rodolphe Julian in 1868,
the Julian employed prominent French artists as teachers and
critics and had no entrance requirements at all. Instruction at
the Julian was based on the academic mastery of drawing the
human figure. Students began drawing at eight o'clock in the
morning and continued until five in the afternoon, with an
hour off at noon. The model kept the same pose for most of
the week. Criticisms meted out by the masters could be severe.[36]

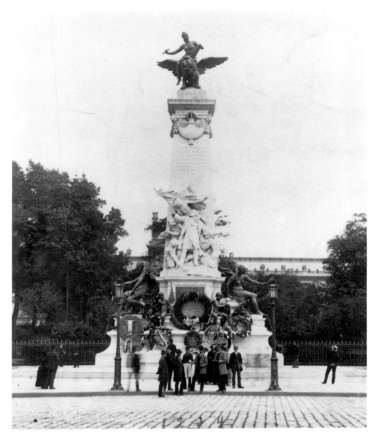

Fig. 11. "The Four Scars of the West" in front of the Gambetta Monument in Paris, 1888. *Standing, from left to right:* Frederick "Eric" Pape; James T. Harwood; Frederick Marvin; and Guy Rose. Photograph courtesy of the author.

Students were also given the weekly task of creating a composition from an assigned topic, usually, though not always, a biblical or mythological subject. Among the first compositions Rose was assigned was "workers in a field,"[37] a theme he later developed in several large-scale paintings. One or two of the best compositions from each section of the Julian were selected by the professors to compete for a grand prize at the end of each month. This system of *concours* created a spirit of fierce competition among the students.[38]

The Julian was also recalled by many of its students as a crowded and colorful mélange, where the atmosphere was often less than serious. Studying there at the same time as Rose was the future leader of New York's Ash Can school, Robert Henri (1865–1929), who later described the academy:

Julian's Academy, as I knew it, was a great cabaret with singing and huge practical jokes, and, as such, was a wonder. It was a factory, too, where thousands of drawings of human surfaces were turned out.

It is true, too, that among the great numbers of students there were those who searched and formed little groups which met independently of the school and with art as the central interest talked, and developed ideas about everything under the sun. But these small groups of true students were exceptional.[39]

Rose and Harwood formed the nucleus of just such a small, exceptional group, which eventually included the Utah-born sculptor Cyrus Edwin Dallin (1861–1944) as well as the Americans Albert Pike Lucas (1862–1945), Frederick Richardson (1862–1937), and former San Francisco School of Design student Ernest Clifford Peixotto (1869–1940).[40] Ever since the School of Design days, when Virgil Williams emphasized the role of history in art study, topics such as the nature of truth and beauty were not foreign to Rose. It was also common for these artist-friends to critique each other's work and to seek out the studios of artists not associated with the Julian. In addition, Rose attended anatomy lectures at the École des Beaux-Arts given by the portrait and historical painter Léon Bonnat and found time to attend open-air concerts in the parks.

Letters written by Harwood from Paris to his fiancée in Salt Lake City give some insight into Rose's character. Shortly after they had arrived in Paris, Jim and Guy were making dinner in their rooms as opposed to eating in the cafés, and Guy's frugality was impressive:

Today Rose and I bought a nice outfit that will make coffee, broil a steak or cook most anything we want. . . . Tonight we both took dinner in my room and it was right jolley [*sic*]—it makes one feel more to home. Rose and I together and the other two [Pape and Marvin]. If you could have seen how comfortable we were this evening all getting our supper ready you would have thought we were old hands. Can you imagine the son of a millionaire doing a thing like that to be economical? When he has a letter of credit with him all the time? His father gave it to him to use and use all he wanted. He could draw a thousand francs tomorrow. He just suits me, I like him very much.[41]

Harwood was not exaggerating when he reported in 1888 that Guy was the son of a millionaire. L. J. Rose had sold Sunny Slope in the spring of 1887 to an English firm for $1,035,000, a sum that did not include the horses and wine on hand at the time of sale.[42] L. J. had invested in yet another ranch, Rosemeade Farm (on land south of the old San Gabriel Mission which is now the city of Rosemead), and completed the building of his one-hundred-thousand-dollar mansion on Bunker Hill, at Fourth and Grand, in downtown Los Angeles. Guy seems to have remained unaffected by his familial wealth and avoided the pitfalls of extravagant behavior. Harwood made the following observation in October 1888:

He is a very fine young man and is very noble and good in thought and action. He seems to have become more serious lately. His aim in life is very grand. We have talked considerable together lately and we are both working for about the same end. He is here on money that he made himself and his aim is to work himself up without his father's help, though he is a millionaire, and to be able to make enough money for two. We will probably hang together all the time I am here. We are so much alike in disposition, that he seems like a brother.[43]

Guy's serious attitude manifested itself at the Julian. Working side by side with Harwood (fig. 12), Rose soon had drawings selected for the monthly compositions and won the *concours* twice. Though he is now best known for his Impressionist paintings, Rose was clearly influenced by his Julian instructors and the French academic tradition itself. His first two instructors were Jean-Joseph Benjamin-Constant (1845–1902) and Jules Lefebvre (1836–1912), followed by Jean-Paul Laurens (1838–1921).[44]

Benjamin-Constant established his reputation in the field of history painting, then later enjoyed success with orientalist subject matter, that is, with paintings of exotic North African settings. As with any of the academic masters, his drafting skills were refined and adequate to any representational task. Yet it was Benjamin-Constant's use of brilliant color and his control of complex lighting effects that would have appealed to Guy Rose, as they did to other students (fig. 13).

Like Benjamin-Constant, Lefebvre and Laurens were prominent painters and equally successful in terms of commissions, awards, and Salon recognition. It was of the utmost importance for all art students in Paris to receive favorable notice for their years of effort at the Salon, the officially sanctioned, premier art exhibition of Paris. Lefebvre and Laurens's exacting styles and their choice of subject matter, often mythological or pseudohistorical themes, provided an example of how to achieve this recognition. Rose painted biblical scenes during and after his Julian years and at least two quasi-mythological subjects (*The Moth,* 1894, and *Le Lutin [The Elf]*, 1890) that reveal his commitment to competing according to conventional standards.

In February 1889 Rose moved into a private studio, where he would have room to work on his Salon entries for the following year. He appointed his new place in the manner of a well-established French academic artist, with oriental decor around the doorway, fine pieces of drapery arranged on the walls, some old armor, a tiger skin on the floor, and a Turkish

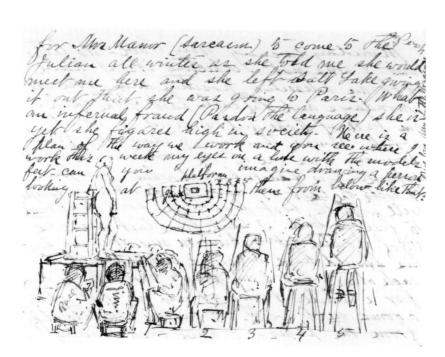

FIG. 12. James T. Harwood, diagram of the seating arrangements at the Académie Julian, including Guy Rose seated at the far left, sketched in a letter to Harriet Richards Harwood, 6 February 1889. Photograph courtesy of the author.

FIG. 13. Jean-Joseph Benjamin-Constant (1845–1902), *In the Sultan's Palace.* Oil on canvas, 25 x 19 in. Collection of the Utah Museum of Fine Arts, Gift of Dr. and Mrs. Elmer Sandberg in honor of Mr. and Mrs. Henry Robinson, Acc. 1973.81.1.

stool inlaid with ivory, among other items. A young friend of Guy's visited the studio, glanced around, and innocently said, "When you get the things cleared away and straightened up it will be very nice."[45]

Harwood likewise rented a studio to work on the obligatory and all-important Salon entry. Neither artist, however, felt compelled to paint solely in Paris. Both wished to continue working directly from nature as often as they could afford to, in addition to studio production. In late April and early May, Rose and their California friend, the painter Ernest Peixotto, went for a month to Crécy-en-Brie, a village about thirty miles northeast of Paris along the river Brie.[46] Upon their return, Rose and Harwood began to plan for an extended summer trip. These plans were altered with the arrival in Paris of Evelyn Marie McCormick (1862–1948), yet another California School of Design student and the romantic interest of Guy Rose.[47] During his first year in Paris, Guy, like Harwood, had been writing home to a loved one in America.[48] According to Harwood, Rose and McCormick met at the School of Design in 1885, where they became enamored of each other. Once in Paris, she was "with Rose most of the time."[49]

Rose returned to the countryside in the fall of 1889, most likely back to Crécy-en-Brie, though it is not known whether he was again joined by Peixotto or this time by McCormick, or whether he traveled solo.[50] Yet another possibility is that he was joined by Frank Vincent DuMond (1865–1951), a fellow student at the Julian who became a very close friend and who may have introduced Rose to Crécy. In addition to their shared interest in painting, DuMond was, like Rose, an avid fly-fisherman. Dumond and his brother, Frederick Melville DuMond (1867–1927), both sketched and painted at Crécy at this time, and Frank DuMond liked it so much that he established an outdoor painting class there in 1893.[51]

In any event, Guy returned to Paris in that same season, and Harwood reported that he did not see as much of Rose anymore, because of "his girl living in Paris." More important, he noted that Rose had done "some very fine things in the country. His three or four years . . . at the school in San Francisco gave him a fine start in painting."[52]

In late 1889 and early 1890, Rose also continued to labor over wholly studio-oriented paintings for the Salon. *La ménagère (The Housewife),* a variation on the by-then common, officially acceptable, and immensely popular theme of the rural peasant, and *Le lutin (The Elf)* were both accepted into the Salon de la Société des Artistes Français in April 1890. These

Salon efforts were created independently of the outdoor paint-ing, which was to become an increasing preoccupation, that he had undertaken at Crécy.

In the months following his Salon debut, Rose traveled to Italy and Switzerland.[53] Upon his return, he planned an extend-ed excursion into the French countryside that would have tremendous consequences for the rest of his career. It has been suggested that the American painter Theodore Robinson (1852–1896) encouraged Rose to visit Giverny, but it is far more likely that Rose either learned about this Norman village from Peixotto, who stayed there in September 1889, or passed through there himself on an earlier trip.[54] In any event, Rose registered at the Hôtel Baudy at Giverny in July 1890 and remained until January 1891. He was joined there by his mother and sisters, who had come to Europe from California,[55] and by his steady companion, Evelyn McCormick. Rose and McCormick returned again in May and stayed through July 1891. Indeed, he spent most of his remaining time at Giverny before returning to California in the fall, spending only the months of February through April 1891 in Paris.

Rose recalled his first impressions of Giverny in one of the few written records he left:

When I first saw the French country at Giverny, it seemed so queer and strange, and above all so wonderfully beautiful, that the first impression still lasts; so that whenever I think of France that is the way I always see it. . . .

Here the beautiful days come and go,—each changing season, each hour, more full of fascination than the last.[56]

Rose was enamored of Giverny as a charming locale, but most important he came into closer contact there with the type of painting—looser, brighter, and more vibrant—that he would slowly strive to develop in his own work. Once at Giverny, Rose was fully aware of the presence of Claude Monet. As Guy recalled later in the decade, "Monet himself was the chief object of interest in the place."[57] Monet's pres-ence gave rise to a legendary art colony of plein-air painting. Therefore it is not surprising that the only currently known paintings by Rose dating from 1890 to 1891 at Giverny are small outdoor landscapes.

Significantly, Rose did not return to the Académie Julian after his first stay in Giverny, nor did he attempt to enroll in the École des Beaux-Arts as did his former roommate, James Har-wood. Though he continued to paint academic pictures in the 1890s, his style underwent a very gradual but eventually com-plete transformation to Impressionism after this initial time at Giverny.

Rose gained Salon acceptance again in 1891 with *La fin de la journée (The End of the Day)* (fig. 14) and *Les ramasseuses de pommes de terre (The Potato Gatherers)* (fig. 15), neither of which was painted at Giverny. *The End of the Day* was begun at Crécy-en-Brie in 1889.[58] Comparing these two paintings of peasant subject matter, the same stone wall appears in each image in the same ratio to the background hills and haystacks.[59] The young girl in *The End of the Day* physically resembles the girl in the foreground of *The Potato Gatherers,* and each wears the same clothes and hairstyle, suggesting that the same model was used for both figures. It would seem that both these large-scale paintings were based on the same location at Crécy-en-Brie and finished in Rose's Paris studio while he was there from February through April 1891, when work was submitted to the Salon.[60] Each illustrates how well Guy had mastered the ability to render the human figure, a primary consideration for Salon recognition. Firmly within the academic tradition, these paint-ings nonetheless also indicate how Rose, like so many Ameri-cans of his generation, was receptive to and able to assimilate aspects of current painting styles not fully consistent with the dominant academic mode practiced by his Julian instructors.

By the time Rose painted *The End of the Day* and *The Pota-to Gatherers,* he had been repeatedly exposed to a number of painters in Paris whose work revealed solid draftsmanship and compositional sensitivity and who were also able to incorpo-rate fluid, feathery brushwork or brighter, more saturated color, or both. Indeed, he was a frequent visitor to the highly influential Exposition Universelle held in 1889. This interna-tional fair included the work of Jean-Baptiste Camille Corot (1796–1875), whose silvery, evanescent atmospheres influenced the Impressionists and generations of later artists. There was the painting *In Arcadia* (1885) by the popular American Alex-ander Harrison (1853–1930), which featured multiple figures in an outdoor setting, painted with an Impressionist-inspired, higher-keyed palette.[61] Other artists showing lighter palettes integrated with figure work included Pierre Puvis de Cha-vannes (1824–1898); those showing impressive bravura brush-work included the American John Singer Sargent (1856–1925).

Among the thousands of works on view in Paris, Rose saw certain paintings that were not considered at the time to be either fully academic in the traditional sense, nor were they judged stylistically radical in the same sense as Impressionist

Fig. 14. Guy Rose, *The End of the Day,* 1891. Oil on canvas, 39¾ x 98 in.
Formerly Walter Nelson-Rees and James Coran Collection. Destroyed by fire, October 1991.

FIG. 15. Guy Rose, *Les ramasseuses de pommes de terre (The Potato Gatherers)*, 1891. Oil on canvas, 51 x 64 in. Mrs. John Dowling Relfe Collection.

FIG. 16. Léon Lhermitte (1844–1925), *La moisson (The Harvest),* 1883. Oil on canvas, 92½ x 104 in. University Purchase, Parsons Fund, 1912. Collection, Washington University, St. Louis.

paintings. Indeed, a multiplicity of styles existed in Paris in the 1890s, offering young painters a wide variety of stylistic possibilities from which to choose. The idea that different approaches could influence each other and coalesce, an idea first suggested to him in San Francisco by the work and teaching of Emil Carlsen and Virgil Williams, was broadened and reinforced by the spectacle of the 1889 exposition. An artist represented there whose work had a definite impact on Rose and his peasant paintings was Léon Lhermitte (1844–1925). His *La moisson (The Harvest)* (fig. 16), originally shown at the Salon of 1883, was a popular favorite at the exposition of 1889. In it appear the high horizon line, distant haystacks, and the life-size close-up of figures and farm tools—all of which appear in Rose's *The End of the Day.* Indeed, when Rose first conceived the composition for *The End of the Day,* it was immediately following upon his visits to the Exposition Universelle. *La moisson* has been rightly interpreted as a "romantic reverie" despite its contemporary subject matter and meticulous detail.[62] The painting's poetic charm, as well as its technical prowess and exploitation of bright, outdoor light, appealed to Rose as it did to many young painters not yet ready, willing, or interested in painting in a looser style.

Of even more general significance to Americans of this period and to Guy Rose specifically was Jules Bastien-Lepage (1848–1884). His style held tremendous appeal for younger painters, as previous studies have identified.[63] The art of Bastien-Lepage likewise represented a compromise between the rigid, gray figure studies learned in the academies and the bright, naturalistic landscapes being attempted in open-air studies. Bastien-Lepage painted palpable, convincing figures in landscapes that were illuminated with a wide prismatic range afforded by direct observation of nature. He was represented by sixteen paintings at the exposition, including his famous *Jeanne d'Arc.* Rose's *End of the Day* is stylistically indebted to Bastien-Lepage, and thematically is closely related to the Frenchman's *Père Jacques* of 1881 (fig. 17).

Père Jacques was not in the exposition but was well known as a popular engraving. In *Père Jacques,* an old peasant man bends beneath the weight of the wood he has gathered, while a young girl blithely picks flowers. The figures embody the natural cycle of youth and old age: carefree and beautiful youth is represented by the girl; the burdens accumulated in life, by the old man. The approach of death, winter, is signaled by the autumn season. Rose likewise depicts two figures in *The End of the Day,* one of whom is an old man who carries a scythe, a symbol of death as well as a standard field implement. The figures occupy an attenuated horizontal landscape where the sun is setting, a symbolic equivalent to the onset of winter in *Père Jacques.* For the old man in the Rose painting, the end is near just as the day is done, and like the harvest itself, which returns every season, the old man will be replaced by the young girl as the cycle of nature continues.

An alternative interpretation of *The End of the Day* has been given by the art historian Ilene Susan Fort: "Rose's cou-

FIG. 17. Jules Bastien-Lepage (1848–1894), *Père Jacques (The Woodgatherer),* 1881.
Oil on canvas, 77½ x 71½ in. Layton Art Collection, Milwaukee Art Museum,
Gift of Mrs. E. P. Allis and daughters in memory of Edward Phelps Allis.
Photograph by Richard Beauchamp.

pling of the older man with a young girl, as well as the scythe and the dusty twilight enveloping the figure suggest that the scene symbolized the death of the traditional way of farming and the future of the next generation of French peasants who would not be totally dependent on the land."[64] This interpretation suggests that Rose had a sociopolitical intent, that is, that he was commenting on "increasing modernization and industrialization." However, Rose's other major allegorical work, *The Moth* (fig. 24), and his narrative works such as *St. Joseph Asking Shelter for Mary* (fig. 27), suggest that his interests were clearly more poetic and literary. This distinction is important to make, as the former interpretation implies that Rose was more socially conscious and thus more urbane and, by extension, more modern than he actually was. However much *The End of the Day* may be seen as a culmination of Rose's student tenure, it is nonetheless a youthful work and seems to embody an uncomplicated romantic notion in the vein of Lhermitte and Bastien-Lepage. Further evidence is that Rose never pursued explicit social commentary of any kind in his later work.

Fort has also suggested that the influence of Claude Monet, Giverny's most famous resident, should not be minimized as inspiration for *The End of the Day*, especially given the presence of grainstacks in the composition.[65] The French master had, in fact, been working on his series of grainstacks since the mid-1880s, and Rose very likely would have seen examples. If not, he certainly saw grainstack paintings in profusion by the other artists residing in Giverny, including those of Theodore

Robinson, who became a friend. However, since Rose began *The End of the Day* prior to his first visits to Giverny, one may assume that he included grainstacks in the image simply because they were a standard theme and because they dotted the picturesque local landscape as a matter of course. Though it is tempting to speculate that Rose modified *The End of the Day* in response to his experiences at Giverny, in this painting, as well as in *The Potato Gatherers,* Rose clearly drew his inspiration more from the spirit of the Barbizon school and the tradition of academic peasant painting (represented by artists such as Lhermitte and Bastien-Lepage) than the Impressionist mode of Monet.[66]

Guy Rose's contact with both Impressionism and Giverny itself in 1890–91, an early period in his career contemporaneous with his larger, more academic Salon painting, resulted in a gradual, rather than an instantaneous, conversion to the new painting. Like many of his fellow Americans, he was reluctant to modify radically the academic skills he had worked so hard to attain. Just past the turn of the century, however, this conversion was complete, and Rose became a permanent resident of Giverny for eight years as well as a close and perceptive disciple of Monet's style. It is tempting to speculate how much more rapid his transformation might have been, or how much more work he might have produced, had his fledgling career not been hampered so severely by an illness that struck him early in the 1890s, an illness that would plague him for the rest of his life.

FIG. 18. Guy Rose, *Giverny Hillside*, 1890–91. Oil on panel, 12⁷/₁₆ x 16⅛ in. Terra Foundation for the Arts, Daniel J. Terra Collection, 1992.2.

RETURN TO CALIFORNIA, PARIS AGAIN, AND TRAGEDY

Of all the young men and women who have left California to complete their education in Europe there are probably very few whose return has been looked forward to by the general public with as much interest as that of Mr. Guy Rose.

C. F. SLOANE, *Los Angeles Herald,* 4 October 1891

Guy Rose's return to California in the fall of 1891 was a triumphant one; he had enjoyed successful studies at the Julian and had exhibited at the Salon two years in a row. In October he presented his work in Los Angeles at an exhibition at Sanborn, Vail & Company, which included his Salon pieces as well as a number of Giverny landscapes. At the age of twenty-four, he was one of the most important artists claimed by Los Angeles, though he had yet to live there as an adult, nor would he for almost fifteen more years.

One local critic, discussing *The Potato Gatherers,* aptly recognized the affinity Rose had for the work of Bastien-Lepage: "Those who have seen Bastien-Lepage's famous picture, Joan of Arc, will be struck with the similarity of color and accessories, showing that both artists were faithful students of nature and painted with earnestness whatever they saw."[67] The critic who made this insightful comparison, C. F. Sloane, also

saw a clear relationship between Rose's smaller landscapes on display and the work of Monet: "Two medium sized works that deserve more than the passing notice that it is possible to accord them here are strongly impressionistic and thoroughly imbued with the spirit of the reigning deity in Paris at present—Monet, whom, as has been formerly stated in the HERALD, Mr. Rose met while painting out of doors one summer in Normandy."[68]

Sloane's recognition of the two different approaches in Guy Rose's painting underscores how consciously the artist was working in each of those distinct modes. Sloane described one of the medium-sized, Monet-influenced paintings: "One of these is a hillside lying in full sunlight, which intensifies the warm green of the early grass, and the other is a view of the church mentioned above. This is in a lower tone of color than the first, but is treated in the same broad manner and has the same clear feeling of atmosphere."[69] The "hillside lying in full sunlight" painting to which Sloane referred is *Giverny Hillside* (fig. 18). The "broad manner" Sloane described is not fully impressionistic; it is still linear with crisp edges and clear forms even in the distant house and trees. Yet *Giverny Hillside* does show the artist trying to capture effects of bright outdoor light and a more economical use of detail than can be seen in Rose's Salon work. While "imbued with the spirit" of Monet more than with Monet's technique, Guy's gravitation toward Impressionism was noticed at this early date.

Fig. 19. Guy Rose, *The Cabbage Patch,* 1890–91. Oil on canvas, 9 x 18 in. Rose Family Collection.

Fig. 20. Fannie Eliza Duvall (ca. 1861–1934), *Chrysanthemum Garden in Southern California,* 1891. Oil on canvas, 42½ x 68¼ in. Formerly Walter Nelson-Rees and James Coran Collection. Destroyed by fire, October 1991.

GUY ROSE (1867–1925): AN AMERICAN IMPRESSIONIST WILL SOUTH

Another plein-air work from Guy's first years at Giverny is *The Cabbage Patch* (fig. 19). Like *Giverny Hills, The Cabbage Patch* features economic brushstrokes to describe the effects of direct light. Compositionally, this small painting prefigures a good many of Rose's later skyless Giverny landscapes, with their intimate, foliage-shrouded backgrounds.

The Guy Rose exhibit at Sanborn, Vail & Company did not, as the California art historian Nancy Moure has written, result in the sudden appearance of impressionistic painting in Los Angeles.[70] She points out that the few major artists Los Angeles had were themselves in Paris at the time, and that even had they been home, most American artists required years of exposure to Impressionism before they could accept it. Still another reason why impressionistic paintings did not spontaneously appear is that perhaps the artists who did see Rose's work were far more impressed with *The End of the Day* and *The Potato Gatherers* and aspired to just this sort of academically rooted yet light-filled approach. Fannie Duvall's *Chrysanthemum Garden in Southern California* (fig. 20) may be just such a compromise work of art; where Rose painted the French peasant in landscapes with high horizons and distant grainstacks, Duvall substituted a Southern California gardener in a landscape with high horizons and distant trees.

Rose himself may have assessed the local scene and felt that support for art and resident artists in Los Angeles had not developed substantially since he left for San Francisco in 1885. His most important artistic undertakings while in Southern California were full-length portraits of his sisters.[71] In addition, photographs of the interior of the elegant and newly built Rose mansion in downtown Los Angeles show landscape paintings on the wall which may well have been Guy's unsold work from Normandy. Guy wished to support himself financially as a painter, but Los Angeles was still an impractical venue for such activity in the 1890s. Though art activity was discernibly on the rise, it was insufficient for an artist of Rose's proven caliber and ambition. He had already decided to establish himself in New York, where he had taken an apartment upon his return to America, and his trip home confirmed the wisdom of that decision. After a six-months' vacation in Los Angeles, a time recalled as "joyful" by his brother,[72] Guy returned to New York in 1892, where he earned his living, as so many painters did, by doing illustration work.

Before leaving California, Guy painted a somber and dignified portrait of his father, posed in a suit and seated by a desk (fig. 21). This handsomely crafted portrait conveys the image

FIG. 21. Guy Rose, *Portrait of L. J. Rose,* 1891. Oil on canvas, 39½ x 49½ in. Los Angeles Museum of Natural Science and History, on permanent loan to the Sunny Slope Water Company, San Gabriel, California.

of a man of refinement, perhaps conservative and certainly accomplished. It was both an homage to his father and a way for Guy to express his gratitude for the years of paternal support. Upon completion, the painting hung over L. J. Rose's desk. Guy also exhibited in San Francisco in 1892 at the Spring Exhibition of the San Francisco Art Association. One of the three paintings shown was entitled *November* (unlocated), which belonged to his longtime girlfriend, Evelyn McCormick. It is not known what caused the dissolution of their relationship, but McCormick did not follow Guy back to New York or to Paris when he returned there in 1894. She remained in San Francisco and, after the fire of 1906, relocated to Monterey, where she became a recognized and respected Impressionist painter. She died there in 1948.

In New York, Guy lived at 939 Eighth Avenue (fig. 22), as did Frank Vincent DuMond; it could well be they lived in adjoining apartments.[73] The two artists had studios across the street in the Van Dyke Studios at 938 Eighth Avenue. At this time, Guy was a regular illustrator for *Harper's Weekly.* Artists as varied as Winslow Homer and Childe Hassam had worked for the magazine, and some were made famous by their illustrations, most notably Frederic Remington. Most illustrators worked for more than one publication, and this was true of Guy Rose, who eventually also worked for *Scribner's, The Century,* and *Harper's Bazar,* as well as providing illustrations for various books.[74]

FIG. 22. Guy Rose in his New York studio, 1892. Photograph courtesy of the Rose Family Collection.

FIG. 23. Guy Rose, *The First Christmas Eve,* black-and-white illustration, *Harper's Weekly* 37, no. 1930 (16 December 1893): 1200.

Rose's first illustration for *Harper's Weekly* was a California scene, an exotic one of the variety that appealed so greatly to the magazine's eastern audience: *A Restoration of Yosemite Waterfalls.* The drawing appeared in July 1892 and may have been done either when Guy was still in California or in New York, from a photograph taken at Yosemite when he visited there during his six-months' sojourn home. In 1893 he was assigned to illustrate a series of articles entitled "Rulers of the Mediterranean" by Richard Harding.[75] Rose supplied images of merchants in Tangier and pyramids in Cairo that reflected the Western world's continued fascination with the exoticism of North Africa. His earliest illustrations were largely dependent on photographs and were so designated: "Guy Rose—after photographs." In this respect, he was like the vast majority of illustrators, whether or not those artists noted their use of a camera.

Late in 1893 Rose provided an illustration for *Harper's Weekly* entitled *The First Christmas Eve* (fig. 23). More so than any of his other early illustrations, this one shows Rose's ability to make good use of his Julian training. Obviously not taken from a photograph, the theme is much like those assigned weekly at the Julian when he competed in the *concours.* Rose utilizes the standard academic formula employed there, including the dramatic, almost theatrical poses and the gratuitous foreground still-life elements. In a fairly routine image, Rose nonetheless operated skillfully within the academic mode. There is no evidence that Rose was religious in any conventional sense, such as active membership in a specific church,[76] yet, like so many artists of his generation, he felt comfortable painting popular biblical themes, especially episodes from the lives of the Holy Family. He turned his attention to this subject matter at least three times in large oil paintings from 1894 to 1900, and entered all three in the Salon.

It was also in 1893 that Guy Rose participated in the largest exhibition of art, science, and industry yet organized in the United States, the Chicago World's Columbian Exposition, better known as the Chicago World's Fair. He exhibited *The Potato Gatherers, The End of the Day,* and *La ménagère* (under the title *Food for the Laborers*).[77] The first two of these proved popular favorites: "One of the youngest and, according to the judgement of fellow-artists, one of the most promising Americans whose work was shown at Chicago is unquestionably Guy Rose, whose pictures, 'Potato Gatherers' and 'The End of the Day,' attracted much attention."[78] In addition to showing, Rose served on the selection committee to choose representative

29

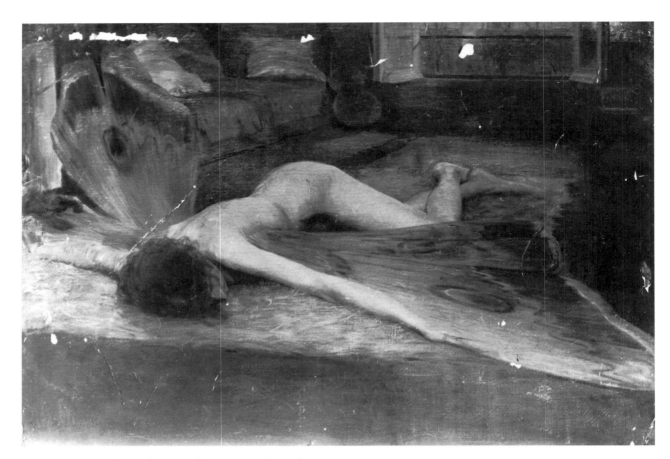

FIG. 24. Guy Rose, *The Moth,* 1894. Oil on canvas, unlocated.

California art (and would have thus been responsible, at least in part, for the inclusion of one of Evelyn McCormick's entries, *Morning at Giverny, France*).[79] Because of his close connection with the organization of the exposition, and because the fair was a major event in itself, it is very likely that Rose traveled to Chicago to see the art exhibits firsthand.

Both distinctions for an artist still in his mid-twenties confirmed that Rose was on a steady climb toward success within the art establishment. Perhaps he was aware of his own momentum and based upon it his decision to return to Paris in 1894. From there, he could continue to illustrate for the several different magazines published by the *Harper's* firm as well as bolster his American reputation with the creation of more large Salon paintings. Back in Paris, Rose had two works accepted to the Salon: *St. Joseph demandant asile pour La Vierge (St. Joseph Asking Shelter for Mary),* and *La teigne (The Moth).* Both were continuations of early interests in academic narrative and allegory.

The *St. Joseph* bears comparison with Rose's *First Christmas Eve* illustration of the year before. Unfortunately, we know the *St. Joseph* only from reproductions (see, for example, fig. 27). It is illustrated in the 1898 Pennsylvania Academy's Sixty-seventh Annual Exhibition catalogue.[80] The *St. Joseph* may have actually been started at the same time as *Christmas Eve,* though it was definitely conceived of much earlier than 1893: on the back of

Rose's 1890–91 *Giverny Hillside* is a preliminary sketch for the *St. Joseph.* Indeed, both the *St. Joseph* and the *Christmas Eve* images share a sense of staged composition that derives from Guy's early study at the Julian and the monthly assigned compositions, among them scenes from the life of the Holy Family.

Another inspiration for Rose's work with biblical subject matter must have been the work of his friend Frank Vincent DuMond, who won a gold medal at the Paris Salon of 1890 with his painting *The Holy Family.*[81] DuMond's early success provided a model for other young Americans desirous of Salon recognition and surely impressed Rose. Since the two were living at the same New York address in 1893, Rose would have known the three religious paintings DuMond exhibited at the World's Fair.[82]

Rose's *Moth* (fig. 24), also unlocated, represents by far the more interesting development, as it features a nude figure for the first time in a major painting and is an ambitious foray into more symbolic expression. Like *The End of the Day, The Moth* is an allegory, though perhaps even less thinly veiled, and likewise deals with a literary construct: a moth, irresistibly drawn to a flame, is destroyed by it, symbolic of the soul's self-sacrificial love of the divine light (alternatively understood as God, Beauty, Truth, etc.). Rose, described along with his father as being a "great reader," could have found the comparison of an artistic muse with a moth in Percy Bysshe Shelley's poem *Epipsychidion:*

How beyond refuge I am thine. Ah me!
I am not thine: I am a part of *thee*.
Sweet Lamp! my moth-like Muse has burnt its wings. . . .[83]

Though it is not clear from the black-and-white photographs available of Rose's painting, one contemporary account describes the moth's wings as "scorched."[84] One wing bends upward and suggests an unfortunate landing after flying through an open window into what may be the artist's studio. An open fire lights her body, the fire that attracted her. Though the obvious interpretation is that the moth is here a muse, a more sophisticated and tempting interpretation, though wholly speculative, is that the painting functions, as does Shelley's poem, as an elegy for a loved one. *The Moth* was painted not long after, perhaps even immediately following, Rose's separation from Evelyn McCormick. It could well have been painted as a romantic coda to their relationship.

Nowhere else in Rose's oeuvre is there a painting quite like *The Moth*. Despite the tentative interpretations given here, *The Moth* is arguably a Symbolist painting that defies simple and definitive interpretation. Symbolist artists of the late nineteenth century searched for alternative modes of representing reality, with an emphasis on internal rather than external phenomena, in a reaction against materialism and naturalism. In their quest to find new forms to evoke or suggest states of mind, the Symbolists, an international array of artists including Paul Gauguin, Odilon Redon, Ferdinand Hodler, and Gustav Klimt, were among the vanguard. Rose's participation in this broad movement is an indication of his own modern temperament, however slight and short-lived that temperament was.

The Moth relates to a similar work by America's leading visionary painter of the nineteenth century, Elihu Vedder (1836–1923), *A Soul in Bondage*. Vedder's painting was exhibited at the Chicago World's Fair, where Rose could have seen it in the year just before he painted *The Moth*.[85] Like Rose, Vedder depicts a nude female with wings; Vedder's is perhaps an angel, though not necessarily—the title designates her as a "soul." Also like Rose's, Vedder's figure has met with a catastrophic fate; here, the woman is bound and abandoned in a void. Finally, she holds in her hand what appears to be either a butterfly or a moth. Each painting, as multivalent symbol, summons general ideas of loss (of freedom and of life) and of painful constraints and limitations.[86]

While abroad, Rose traveled extensively doing illustration work for *Harper's Weekly*. He was working in Venice when he met the aspiring art student and illustrator Ethel Boardman. A native of Providence, Rhode Island, Boardman was touring Italy with her mother and sister.[87] Guy and Ethel began a romance that was destined to last the rest of his life.

In the spring of 1894 Guy returned to Paris. A meaningful and no doubt sentimental assignment done at this time was the illustration of scenes of student life in Paris.[88] These sketches included the procession of the *nouveaux* (new entrants into the École des Beaux-Arts), as well as a scene of young artists struggling to work by candlelight—something Guy himself had done only a few years earlier. And, as he had done during his student years, Rose again visited Giverny. He registered at the Hôtel Baudy for three months, from March through May 1894, joining his friend and colleague Ernest Peixotto and, more important, being joined by Ethel Boardman, who arrived at the Baudy in late March.[89] While Rose's time in Giverny was no doubt of significance to his deepening relationship with Boardman, it also signaled his continued interest in and commitment to outdoor painting.

Rose went to Greece on assignment for *Harper's* in the summer of 1894, and it was there that he first felt the adverse effects of what would later be diagnosed as lead poisoning. Lead is a common component of oil paints and is absorbed into the system through the skin. In Rose's case, the absorption of lead from oil paints may have been his second, not first, unfortunate ingestion of the toxin: his gunshot wound as a child may have left him with high background levels of lead that never decreased in light of the fact he took up oil painting at the very time he was recuperating from the accident.[90]

The initial symptoms associated with lead poisoning described in the late nineteenth century included abdominal colic (that is, acute abdominal pain) and the inability to extend the wrist or fingers, called "potter's palsy" or "wrist drop."[91] The victim could suffer restlessness and disorientation, weakness, digestive problems, tremor, and paralysis. Indeed, the most common symptoms of lead poisoning were understood as a wide variety of effects on different parts of the body, and it is not surprising that Rose's problem was not identified specifically until later, when the levels of lead in his blood were measured. Before this diagnosis, his earlier bouts with sickness could have been interpreted as a host of different problems.

Lead poisoning was not, however, an obscure medical problem in Rose's day. To the contrary, the dangers of lead as a toxin were known even in ancient times, and certain classic

Fig. 25. Guy Rose in front of the Rose family home at Fourth and Grand, Los Angeles, in 1895. Photograph courtesy of the Rose Family Collection.

symptoms were described by the Roman historian Pliny. That lead could be absorbed into the body through the skin was known in the 1890s. By 1902 the French government prohibited the use of lead white except when already mixed with oil and passed a law in 1909 prohibiting its use in paint altogether (a regulation apparently not enforced). Other countries passed similar regulations designed to control lead in industrial and commercial use.[92] By the time Rose's condition was determined to be lead poisoning and not some other illness, the chance of a false diagnosis does not seem probable.

It was most likely from Greece that Guy Rose wrote about his poor health to Frank Vincent DuMond, who in turn wrote about it to his future wife, Helen Xavier: "I had a letter from Guy Rose today and poor fellow; he is very ill. He said that he had just risen from a sick bed for the seventh time."[93] When Rose returned to France, he was still not completely well. Again according to DuMond: "I expected Rose to come yesterday but he didn't. However he must be along before very long. Poor boy! I'm almost afraid to see him in fear that he is hopelessly ill."[94] Indeed, though Guy's condition was not hopeless, it would prove to be chronic, abating for periods and then returning with severity. He was eventually able to visit DuMond at Crécy, where the latter had been conducting his outdoor painting class for Americans.[95] Rose's illness was not his only misfortune that summer. In August 1894 paintings he had stored in DuMond's New York studio were lost when destroyed by fire.[96]

In the fall of 1894 Guy Rose, Ethel Boardman, and Frank Vincent DuMond were all in Paris, and it was only then that the ever-private Rose informed DuMond of his intentions to marry Boardman, plans which DuMond relayed to his own future wife:

They are engaged as he afterwards told me. I naturally felt badly about it at first, unreasonably of course. I realized that all my dreams of having time with me as a sympathetic genuine friend were over and that the pleasure of our old days together could never come back again. But that was all foolish and selfish and I am really overjoyed, for Rose will be happy with this simple hearted natural girl. She has seen much of the hard side of life and knows. She appreciates dear good Rose and is a girl willing to face anything which life can offer. They are both artists and live exactly on the same line the world over. I congratulated them with a sincerity and feeling of happiness which seldom goes with this which is so much a matter of form.[97]

Guy Rose and Ethel Boardman were married in Paris on 3 January 1895 and returned to America soon thereafter. Before leaving Paris, Guy extended an invitation to DuMond to visit Los Angeles, a trip that artist would make twenty years later.

Rose took his new bride to California to meet his family, and the trip afforded Guy a chance to convalesce (fig. 25), though he continued to illustrate regularly for *Harper's*. He also painted a portrait of Ethel at this time and exhibited it at the gallery space of the Art Association, located in the Chamber of Commerce building. The unlocated *Portrait of Mrs. Guy Rose* of 1895 (see fig. 60) was described as displaying a "modern influence in treatment" by one critic,[98] while another claimed that it lacked the color and texture of the earlier work Guy had done "while under the influence of Monet."[99] Local critics, however broadly they understood academic versus impressionistic painting, continued to be alert to the fact that Rose's style vacillated.

Guy and Ethel Rose remained in Los Angeles for six months, after which they moved to New York, where they established a home at 62 Washington Square. It is difficult to assess just how much Guy Rose suffered from lead poisoning during the latter 1890s. His brother Leon recalled that Guy was "ill at intervals" while living in New York and that "he did very little painting."[100] Indeed, Guy's general artistic production dropped dramatically in the later 1890s. According to his brother, Guy's hands were at times "so inflamed that they had to be strapped flat to a board," and his eyes were sufficiently affected that they required surgery.[101] He exhibited a number of the same paintings repeatedly, suggesting he was not able to produce new major works and that, as Leon reported, he painted very little.

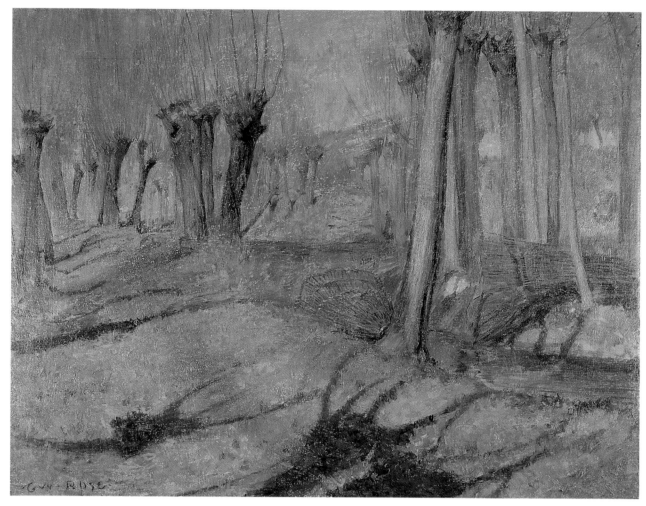

FIG. 26. Guy Rose, *Giverny Willows,* 1890–91. Oil on canvas, 15 x 18 in. Private collection.

In March 1896 Guy exhibited two paintings, *Giverny Willows* (a picture akin to fig. 26) and *Late Spring Afternoon,* at the Providence Art Club, in Ethel's home state of Rhode Island. The following month, he showed four paintings at the Eighteenth Annual Exhibition of the Society of American Artists: *The Moth, The Annunciation, Moonlight Study,* and *The Garden.* Of these four, all unlocated, *The Annunciation* was perhaps the largest and most ambitious. It was part of a series on the life of the Holy Family of which *St. Joseph Asking Shelter for Mary* and *The First Christmas Eve* were other examples, and could have been started, if not completed, in 1893. *Moonlight Study* and *The Garden* may have been new works.

However much Guy was struggling with the effects of his illness at this time, he was able to complement his illustration work and exhibition schedule with a new role—that of instructor. In the spring of 1896 he began teaching portraiture and drawing at the Pratt Institute in Brooklyn twice a week. There, he associated with the teacher and painter Arthur Wesley Dow (1857–1922),[102] whose interest in Asian art and motifs may have partially inspired Rose's own future depiction of oriental fans

and kimonos. Another instructor at Pratt was Henry Prellwitz (1865–1940), who, like Rose, had spent time painting at Giverny.

In the summer Rose conducted a five-week outdoor sketching class at Fallsburgh, New York. That September, he exhibited at the National Academy of Design a painting entitled *Early Spring Morning,* which may also have been a new work. After teaching his outdoor sketch class, Guy did not return to the city but instead traveled to Maine and its woods, where, it was reported in the *Pratt Institute Monthly,* "such annoyances as mail and telegrams could not pursue him."[103] There he could hunt and fish as well as continue to sketch. And he may have needed isolation to convalesce. That his poor health was in evidence is suggested by this optimistic observation in the same report: "It is safe to say that he will return refreshed and rested."

In 1896 Guy's Salon success of 1894 for which he won an honorable mention, *St. Joseph Asking Shelter for Mary,* was used as the frontispiece for the December issue of *Harper's Monthly Magazine* under the title *Flight into Egypt* (fig. 27).[104] Capitalizing upon its notoriety, or possibly because he was not feeling well

33

FIG. 27. Frank French, *Flight into Egypt,* engraved for *Harper's Monthly Magazine* 94, no. 559 (December 1896), after Rose's painting *St. Joseph Asking for Shelter for Mary on the Journey into Egypt.*

enough to create a new major work, or both, Rose showed the painting again in May at the Society of American Artists.[105] He left the city for the country in the summer.

In 1897, while in Sullivan County, New York, Guy painted one of the very few paintings he ever dated, *July Afternoon* (fig. 28).[106] The central focus of the image is sunlight falling on an open meadow, which is framed by trees on either side. The skyless distance is filled with trees and a simple strip of a low-lying hill, while the foreground is a mixture of shimmering green blades of grass and spots of yellow flowers. *July Afternoon* clearly demonstrates that his interest in Impressionism was as strong as it had ever been up to that point.

It was while teaching at Pratt that the true nature of Guy's illness was determined, linking his physical problems tragically to his love of painting.[107] *July Afternoon* may have been one of the last paintings he did before he was ordered to avoid oil paints completely. According to his wife, Guy did nothing but illustration work from 1897 to 1907, a full ten-year period.[108] Though there are no dated paintings to contest her very specific recollection, evidence suggests that Guy did attempt to paint occasionally. There is no doubt, however, that his production in oils dropped off dramatically, and that Ethel's remembrance is largely correct. For a young artist, just thirty years old, the situation was surely one of great frustration and disappointment.

It was also in 1897 that Guy wrote his sentimental reminiscence of life in Giverny, that "wonderfully beautiful" place, where he had once painted with ambition and enthusiasm, where he could still hunt and fish in the picturesque landscape even if he could no longer capture it on canvas, and where he could be beyond the "annoyances" of big-city life. It was no doubt at this time that Guy, in concert with Ethel, planned a return to the countryside of France. He taught through June 1898 at Pratt, and by March 1899 he and his wife were again registered at the Hôtel Baudy.

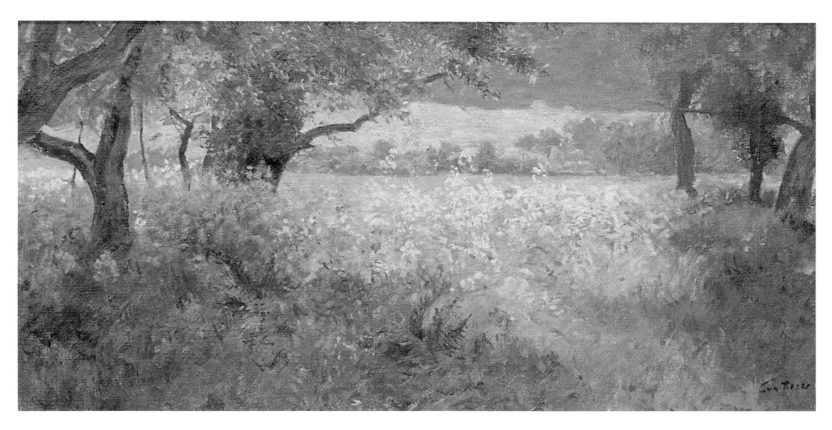

Fɪɢ. 28. Guy Rose, *July Afternoon,* 1897. Oil on canvas, 15¾ x 29¾ in. Rose Family Collection.

GIVERNY

*The village is on the road from Paris to Rouen, in the lovely
Seine valley. . . . A long winding road is bordered with plastered
houses, whose lichen-covered, red-tiled roofs gleam opalescent
red and green in sunlight, or look like faded mauve velvet in the
shadow. High walls surround picturesque gardens; and long
hillsides, checkered with patches of different vegetable growths,
slope down to low flat meadows through which runs the river
Epte, bordered with stunted willows . . . poppies and violets are
everywhere. Peasants . . . call a greeting as they sit or lie on the
grass beside their grazing cattle, or drive their great Norman
horses, made picturesque by high blue fur-trimmed collars.*

GUY ROSE, "At Giverny," 1897

With these words Guy Rose remembered the Giverny of
the early 1890s, and the small village had not changed much by
the time he returned in 1899, except that there were more
artists living there than ever before. They were drawn by the
ongoing lure of the countryside, Norman peasant and lumi-
nous grainstack, and the towering figure of Claude Monet,
whose name had become synonymous with both the village of
Giverny and Impressionism.

FIG. 30. Guy Rose, *Portrait of an Algerian,* ca. 1900. Oil on board,
13¾ x 10¾ in. Private collection.

FIG. 29. Guy Rose, second from left, and entourage during the winter of 1900 in Algeria.
Photograph courtesy of the Rose Family Collection.

For Guy Rose, a return to Giverny may also have been self-prescribed for health reasons. Associates of the artist were later to attribute his return to painting to the beneficial effects of life at Giverny, and the artist may well have believed the countryside to be therapeutic. When Guy was young and suffered a gunshot wound to the face, his father dismissed the doctor's treatment in favor of applying a home remedy. It is therefore not unlikely that the adult Guy Rose did not have complete confidence in the diagnosis offered by his New York doctor. It was still a common belief in the 1890s that rest and relaxation in the countryside could cure a good many ills.

The Roses' initial return to Normandy was cut short, however, by tragic news that must have reached them soon after they registered at the Hôtel Baudy on 24 May. On 17 May Guy's father had died at his home in Los Angeles. L. J. Rose, once a millionaire and a California state senator, had seen his business ventures fail in the years after the sale of Sunny Slope. Deeply distraught over what he had considered an insurmountable debt, he took his own life. Guy and Ethel returned to Paris, where communication with the United States was somewhat faster. They apparently did not return to California following L. J.'s death; the most satisfactory explanation is that Guy himself was not well enough to make the trip.

Guy and Ethel spent the winter of 1900 in Algeria. In addition to her pursuits as an illustrator, Ethel had a keen interest in writing and eventually published a number of feature articles. She wrote two unpublished accounts of adventures in Algeria, which describe camping in the desert, hunting, horseback riding, and the search for water under the relentless desert sun (fig. 29).[109] Guy participated in all of these activities, and earned the respect of his Arab guides for his ability as a marksman and his skill in finding water.

Guy's active schedule while in Algeria may have prompted him to try to paint, despite the prohibition placed on him by his doctor. Three paintings in particular suggest he worked in Algeria: *The Algerian Market* (Rose Family Collection), *An Algerian Divorcee*,[110] and *Portrait of an Algerian* (fig. 30). All three paintings are small and could easily have been done on location. The last of the three is a vibrant study of a youthful Algerian wearing a turban and a blouse with knitted blue arabesque patterns, all set against a turquoise background. Rose responded, as did so many Americans of the period, to the brilliant color and exoticism of North Africa. The painting also recalls the work of one of Rose's Julian professors, Benjamin-Constant (see fig. 13), who specialized in orientalist subjects.

Back in France, the Roses spent time in Paris but seem to have traveled as well, as they had no permanent address.[111] In the Salon of 1900 Guy showed *The Annunciation,* a painting dating sometime between 1893 and 1896. His entry for the Buffalo Pan-American Exposition of 1901 was *The Moth,* of 1894. He entered *July Afternoon* of 1897 in the Forty-fifth Annual Exhibition of the San Francisco Art Association of 1902. That each one of these paintings had already been exhibited often and were years old reconfirm that Guy had, at the very least, suspended creating any new major work.

For their livelihood, he and Ethel continued to illustrate (fig. 31). Ethel became the Paris fashion representative for *Harper's Bazar* about 1899, an opportunity that facilitated their return to Europe; she held that position for the next thirteen years.[112] As a result, both husband and wife did numerous fashion illustrations for *Harper's Bazar* on a monthly basis. Their respective styles are nearly interchangeable. A page from a 1906 issue shows a drawing by Ethel side by side with one by Guy (fig. 32). Each is marked by a straightforward if not formulaic presentation of a fashionably dressed woman, and each meets the standard requirement of accurately describing the featured clothing. Though their considerable output for *Harper's* provided a steady income, the work in no way substituted for Guy's desire to paint.

The Roses remained financially dependent on illustration, even after Guy had resumed painting, and for him it was drudgery. As Ethel recalled: "It was a great grief to him that his ill health and the necessity for doing illustrating would not allow him time nor strength to paint as much as he wished, nor work as hard."[113] The tedium of the work was no doubt countered for Rose when he and Ethel acquired an old stone cottage at Giverny in 1904.

The purchase signaled the couple's intent to establish long-term residence in France, and it seems inconceivable they would have selected any place other than Giverny. They bought the cottage on part of the property known as the sente des Grosses Eaux, located at the far west end of the village, a little over half a mile from the home of Monet and within walking distance of virtually every other artist who lived there.

At Giverny the Roses could live cheaply, and Guy could indulge his two favorite hobbies, hunting and fishing.[114] He could also associate with the other painters, though this last activity no doubt increased his frustration at not being able to paint himself without risk.[115] Among the artists he befriended were Frederick Frieseke (1874–1939), Lawton Parker (1868–

Fɪɢ. 31. Guy Rose, "Smart Evening Gown," 1907. Reproduction of ink-and-watercolor-wash drawing, *Harper's Bazar* 10, no. 41 (October 1907): 9.

Fɪɢ. 32. Illustrations by Guy Rose and Ethel Rose from *Harper's Bazar* 41, no. 11 (November 1907): 1064.

1954), Edmund W. Greacen (1876–1949), Louis Ritman (1889–1963), Alson Clark (1876–1949), Richard Miller (1875–1943), Lilla Cabot Perry (1848–1933), and Theodore Earl Butler (1861–1936).

A painting by Butler, who was Monet's son-in-law, documents some of the social activity enjoyed by the artists at Giverny. In *Late Afternoon at the Butler House, Giverny* (fig. 33), a casual interlude of entertainment and comaraderie is depicted. Included in the painting, from left to right, are Guy Rose, James Butler, an unidentified man, Lili Butler, Ethel Rose (playing solitaire), Edmund Greacen (playing the banjo), Marthe Butler (Monet's stepdaughter), and Mrs. Greacen. The banjo depicted here is more than a decorative prop; it often accompanied the singing of old spirituals and popular songs alike, as music was a favorite diversion among the villagers.

At the Hôtel Baudy, where many Givernois continued to take dinner whether or not they owned a cottage, there was a billiards table, and tournaments were held. The Baudy also served as a locale for Saturday evening dances. Outside the hotel, a tennis court was built that was reportedly in constant use. A photograph by the painter Alson Clark captures Frederick Frieseke and Guy Rose on a break from a tennis match

(fig. 34). Particularly close to Frieseke, Rose eventually painted Sarah, Frederick's wife, no fewer than three times (fig. 35).[116] The Roses themselves hosted parties and dinners, one of which is pleasantly described in a 1909 letter by Thomas Sergeant Perry, Lilla Cabot Perry's husband:

Last night we dined most agreeably at the Roses. You haven't seen their very pretty house and you haven't seen the pretty things they have in it. Their dining room has Chinese furniture, teak inlaid with shell, work is very fine, they have picked up the most beautiful glass in the world, decanters and tumblers. They work hard at their fashions and it is better to go and see Mrs. Rose to find out what women are going to wear next March than to see a clairvoyant. . . . At this season Rose himself does more painting and recently sold one of his pictures. As I have told you, he is painting very well now, and has quite blossomed out.[117]

After two to three years living in this quiet, pastoral village, Guy had, indeed, finally returned to painting, a decision that was prompted by a combination of factors: he had built up an irrepressible desire to paint again; his illness was most likely in remission or perceived as stable; and he may have

FIG. 33. Theodore Earl Butler (1861–1936), *Late Afternoon at the Butler House, Giverny,* ca. 1907. Oil on canvas, 46⅞ x 46⅞ in. Claire and Jean-Marie Toulgouat Collection, Giverny.

FIG. 34. From left, Frederick Frieseke, Guy Rose, and two unidentified men, on a break from playing tennis. Photograph by Alson Clark, courtesy of the Rose Family Collection.

GUY ROSE (1867–1925): AN AMERICAN IMPRESSIONIST

FIG. 35. Guy Rose, *Five o'Clock,* ca. 1910. Oil on canvas, 15 x 18⅛ in. Santa Barbara Museum of Art, Gift of Mrs. Edward R. Valentine, 1978.16.

thought that using oils again would be safe if he just avoided contact with lead. By simply wearing gloves, the transfer of lead through the skin could be prevented and his condition not worsened. Indeed, a photo from the Rose family album shows Guy painting in Giverny about 1906–7 wearing gloves (fig. 36). (It might be argued that he is also wearing a coat, and the gloves are a response to the weather. However, few plein-air painters wear gloves in even the coldest weather, as one cannot feel the brush directly and therefore cannot control it adequately.)

In addition to wearing gloves, Guy's own research into available paints may have led him to experiment with nonlead paints such as zinc white.[118] According to Ethel, her husband investigated color from a scientific point of view: "He read in French and English technical books of all sorts—chemistry of colors, treatises on paints, etc." He was, she wrote, "studying and learning constantly."[119]

Once back at the easel, Guy Rose produced scores of paintings before leaving Giverny in 1912. His technique no longer vacillated, as he worked with a full commitment to Impressionism. He painted landscapes and figures, and combinations thereof, with a mature sensitivity to the interpretation of transient color and fugitive light. Though Rose associated

with and knew intimately the work of his American friends at Giverny, the primary and most important source for his style, and theirs, was that of Claude Monet. Volumes have been written on Monet and the Impressionist movement, and the general tenets of that literature are well known. But certain of these bear repetition in relation to Rose. Monet's work represented the idea of modernity to the younger Americans, as it was identified with a departure from the academic tradition which Rose and the other Americans knew well. As opposed to the rigorous reconstruction of form, exemplified in academic painting, Monet dematerialized it. Impressionism provided a method by which a painter could gain access to the rhythms and sensations of nature. It was, and remains, a challenging and stimulating manner of realist painting, and yet one that allows the individual artist great freedom in the process of finding equivalents in paint for what is seen. In an impressionistic landscape, the tactile qualities of nature are interpreted via direct experience in a way that those of a studio-bound painting cannot be. A brilliant reflection, a misty fog, or a row of iridescent poplars were valid subjects for painting. Thematically emptied of academic conventions or readily identifiable narrative, an impressionistic painting records a series of perceptions and experiences culled from a heightened awareness

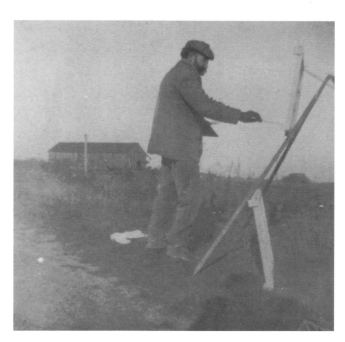

Fig. 36. Guy Rose painting in Giverny, ca. 1906–7. Photograph courtesy of the Rose Family Collection.

of the visible. These unfold as ordinary and familiar, replete with the richness and mystery of ordinary and familiar things.

Contemporary art history rightly pursues other meanings in Impressionism not to be summarily discounted, political, social, and psychological meanings among them, since any painter brings to bear on every painting the sum total of his or her cultural and historical background. But understanding the act of seeing as a way of actively participating in the sensual world likewise cannot be dismissed in the search for meaning; seeing in this way was consciously a priority for painters such as Guy Rose.

As to his actual relationship with Monet, there can be no doubt that Rose knew him and his paintings. Rose may have met Monet through his son-in-law, Theodore Butler, with whom the Roses were friendly, or through one of the other American artists, perhaps Theodore Robinson or the Roses' neighbor, Lilla Cabot Perry. In any case, when asked about Monet shortly after his return to America in 1912, Rose rendered a rare personal opinion derived from direct acquaintance: "Monet is a wonderful man, both as a man and an artist. . . . Have you seen any of his 'pond lily' set, as it is called? . . . They are simply marvelous, showing the aspects of water lilies and their shapely pads, floating upon still pools of surfaces like mirrors, reflecting colors of ethereal beauty."[120]

Despite news reports of the time, Monet did not give lessons to Americans living at Giverny; to the contrary, he maintained a distance from most residents of the village.[121] However, though Rose was not a formal student, according to Ethel he was one of the few residents of Giverny who actually socialized with Monet:

> There is one mistake that every critic who knows we lived in Giverny always makes—why I do not know—and that is that Guy worked with Monet. Of course he was very much influenced by Monet and admires him and his work tremendously, but I do not believe that anyone ever worked with Monet or even had him criticize their work. I do not know of any American painter in Giverny, except [Frederick William] MacMonnies and ourselves, who ever knew Monet socially, and certainly he never spoke to Guy about Guy's work, though he showed us his own and we talked of that. He is very much of a recluse so far as anyone outside his circle of friends is concerned.[122]

GUY ROSE (1867–1925): AN AMERICAN IMPRESSIONIST

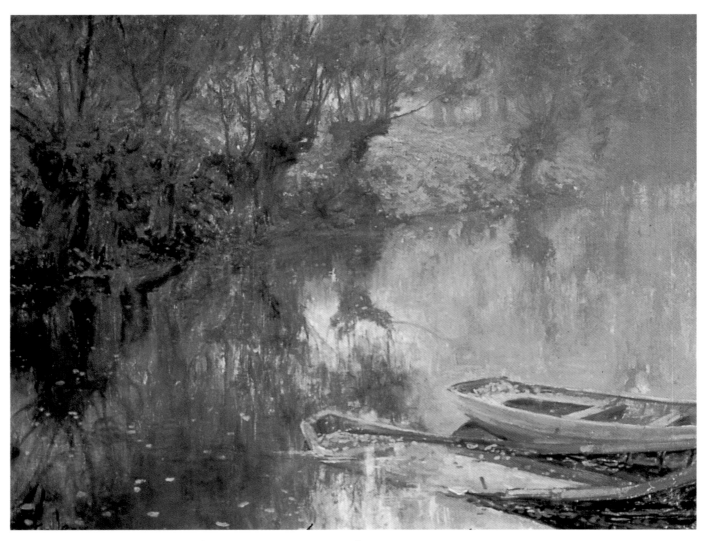

FIG. 37. Guy Rose, *November,* ca. 1910. Oil on canvas, 24 x 29 in. Private collection.

What Guy learned from these personal conversations with Monet about Monet's painting would have been formidable and invaluable instruction in and of itself. While Rose was living at Giverny, Monet was at work on a series of paintings of his water-lily pond. This series, so admired by Rose, demonstrated the abstract possibilities in painting reflected color. Capturing the shimmering distortions of colored light on water, Monet broadly suggested known objects, but more often he directly exploited expansive areas of agitated, brilliant hue. The fragmented reflections of trees, flowers, and air meshed in his water-lily series, becoming less and less descriptive of those things per se than a record of refined perceptions. As did so many other painters, Rose saw in Monet's technique a method with which to interpret the sensations of being in nature in addition to merely describing nature.

In Rose's *November* (fig. 37), nearly two-thirds of the painting's surface is composed of colored reflections on the water of what is most likely the river Epte, which flows through Giverny. Mirrored on the water, the shapes of streamside wil-

lows become shifting masses of blue-gray, green, and sparkling white, all punctuated with flickering strokes that stand for fallen leaves. As the eye follows the river's course, the dense growth along the bank fuses into shrouds of muted, vaporous color. The flat and formless quality of the foreground is contrasted with the inclusion of boats, a picturesque convention of many Giverny paintings.

Rose successfully converts the cold, gray atmosphere of late autumn in Normandy into pictorial terms; the sensation of a dense atmosphere amid the deep smell of wet trees and shrubs is palpable and convincing. The stillness of the water and the absence of people contribute to a mood of calm and quiet. *November* exemplifies the type of composition and execution Rose used most successfully, in part because solitude in nature was for this artist a desired physical and mental state. As Ethel Rose wrote, her husband "loved the country and was always happy when alone and occupied."[123]

Untitled (River Epte, Giverny) (fig. 38) is an interesting variation on *November:* the willows and bank of the Epte are moved

42

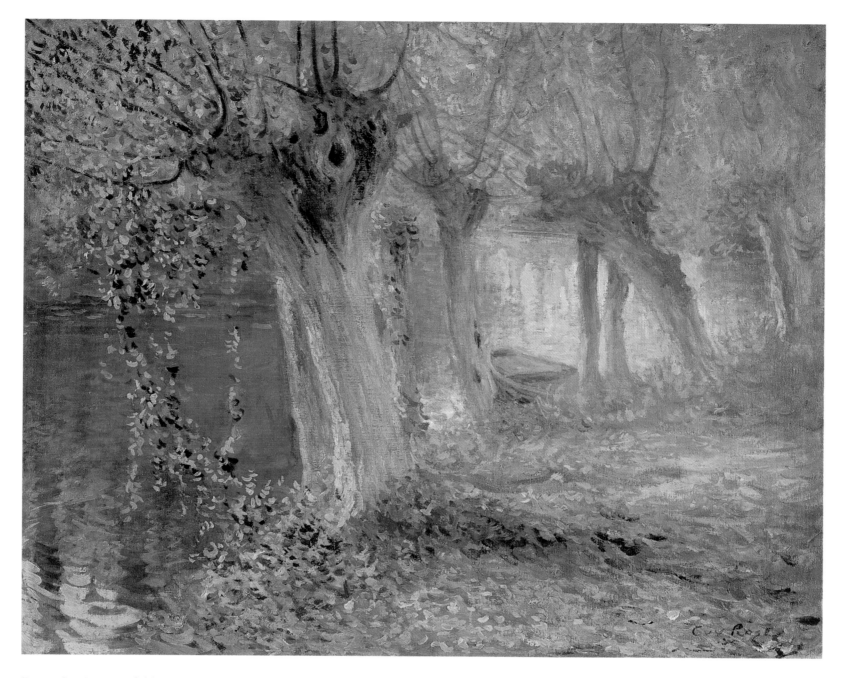

FIG. 38. Guy Rose, *Untitled (River Epte, Giverny)*, ca. 1910. Oil on canvas, 24 x 29 in. James and Linda Ries Collection.

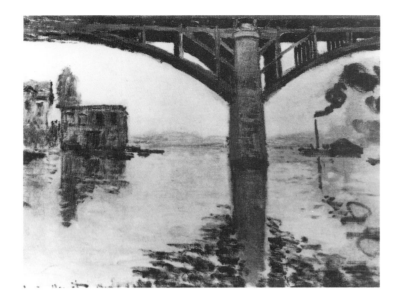

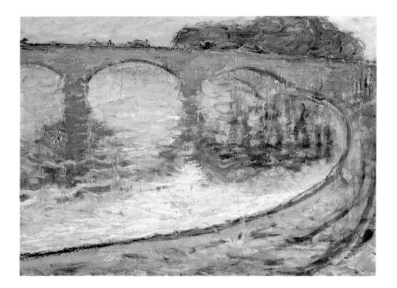

to the foreground, while the river, with a small boat positioned at the painting's center, moves diagonally toward the background from right to left, effectively inverting *November's* composition. Lively oranges and yellows are emphasized, as opposed to the pervasive blue-green palette of *November.*

Rose's interest in reflections on water culminated in a tour de force, *The Old Bridge, France* (fig. 39). Fully three-quarters of the vertical composition are subsumed by vibrating patterns of light on the river Epte.[124] The structure of the bridge functions like a frame within a frame, pulling the eye deeper into the still space and quickening reflections. The actual placement of the bridge near the upper edge of the canvas may have been inspired by Monet's *Road Bridge, Argenteuil* (fig. 40), a painting Rose could have seen at Monet's Giverny studio.[125] Theodore Butler also employed a similar composition in his painting *Bridge at Vernon* (fig. 41).

The very same bridge that appears in Rose's painting was also depicted by Guy's close friend and fishing companion, the painter and illustrator Arthur Burdett Frost (1851–1928), who resided in Giverny from 1908 to 1910 (fig. 42).[126] It could well be that Rose and Frost painted on location together, just as they pursued outdoor sports together. Frost's painting survives as additional evidence of the close camaraderie as well as the aesthetic shared among the Givernois.

FIG. 40. Claude Monet (1840–1926), *The Road Bridge, Argenteuil* (W. 315), 1874. Oil on canvas, 21 x 28½ in. Unlocated. From Wildenstein, *Claude Monet,* vol. 1, p. 250.

FIG. 41. Theodore Earl Butler (1861–1936), *Bridge at Vernon,* 1905. Oil on canvas, 21½ x 28½ in. Courtesy Museum of Art, Brigham Young University, Gift of Dr. Darrell F. Smith. Photograph by David Hawkinson.

FIG. 42. Arthur Burdett Frost (1851–1928), *The Old Bridge, Giverny,* ca. 1910. Oil on artist's board, 13 x 16 in. Albert Stickney Collection, courtesy D. Wigmore Fine Art, Inc., New York. Photograph by Joshua Nefsky, New York.

FIG. 39. Guy Rose, *The Old Bridge, France,* ca. 1910. Oil on canvas, 39½ x 32 in. Rose Family Collection.

GUY ROSE (1867–1925): AN AMERICAN IMPRESSIONIST

FIG. 43. Guy Rose, *Poppy Field*, ca. 1910. Oil on canvas, 23⅝ x 28¾ in. Rose Family Collection.

FIG. 44. Claude Monet (1840–1926), *Le champ d'avoine aux coquelicots (Oat Field with Poppies)* (W. 1258), 1890. Oil on canvas, 25⅔ x 36¼ in. Musée d'Art Moderne de Strasbourg.

The "love of the country" noted by Ethel Rose and a preference for solitude are often combined in Guy's Giverny work, as well as in his later California scenes, sensitively filtered through the optical wizardry of Monet's technique. The focus of Rose's *Poppy Field* (fig. 43) is a foreground array of intensely red poppies set against a cool green background. How well Rose had assimilated the general compositional strategies used by Monet can be seen here in comparison with Monet's *Le champ d'avoine aux coquelicots (Oat Field with Poppies)* (fig. 44). Indeed, Rose seems to have painted the very same field located in the northern part of the valley of Giverny from a spot looking east. Rose's relationship with and admiration for Monet is further suggested by his painting *La maison bleue (The Blue House)* (fig. 45), a Giverny house that belonged to Monet, where that artist kept an extensive vegetable garden.

WILL SOUTH

Fig. 45. Guy Rose, *La maison bleue (The Blue House),* ca. 1910. Oil on canvas, 24 x 29 in. Mr. and Mrs. Thomas B. Stiles II.

Fig. 46. Guy Rose, *La grosse pierre (The Large Rock),* ca. 1910. Oil on canvas, 32 x 39¼ in. The Schoen Collection, New Orleans, Louisiana.

FIG. 47. Guy Rose, *The Valley of the Seine,* ca. 1910. Oil on canvas, 24 x 29 in. Mr. and Mrs. Leslie A. Waite.

GUY ROSE (1867–1925): AN AMERICAN IMPRESSIONIST

Rose's view of nature in all these paintings is philosophically benign at the same time as it is sensually rich. His is the nature of Thoreau and Walden; nature as brilliant, effulgent, and spiritually plentiful. It is nature as described by John Ruskin, that is, as the artist's first mentor and teacher, the source of the artist's sustenance and the object of the artist's refined talents. The physical world, with all its mysteries and complexities, provides the artist with metaphors for diversity within unity: "The passions of men," William Wordsworth wrote, "are incorporated with the beautiful and permanent forms of nature."

Working in early-twentieth-century France, Rose was nonetheless spiritually closer to nineteenth-century American artists such as William Keith and George Inness for whom the painting functioned as a mediating device between nature and a near-pantheistic perception of nature. These artists hoped to wrest from earth and sky an eloquent grandeur in sufficient quantity to invest their own canvases with life-enriching experience, as opposed to Monet, who coolly dissected the empirical world without a conscious regard for notions of transcendence. This attitude toward nature—poetic, humble, and subservient—lay beneath the carefully crafted visions of Guy Rose.

One of the paintings that best embodies Rose's quiet and reclusive personality is *La grosse pierre (The Large Rock)* (fig. 46), a view of the limestone cliffs overlooking Giverny. The railroad bridge over the river that served travelers from Vernon to Gisors is faintly visible in the distance. The river, the village, and the landscape beyond are submerged in an allover, uniform blue-gray tone, while the foreground limestone cliffs are in sharper focus. Details in the distance are suppressed, forms are obscured and edges lost, and the dense, wet atmosphere is maximized. This is not the intense, brilliant outdoor light that one often equates with Impressionism; the stimulation of a multicolored canvas is exchanged for the reductive calm of a single tone. This is the depiction of an atmosphere that conceals. Color in this painting has a symbolic function as much as a descriptive one, as it evokes an insular, distant melancholy.

Rose's affinity for literary and poetic allusion in his painting was present early in his career, most clearly in *The End of the Day* and *The Moth*. With *La grosse pierre,* these early inclinations had matured into a thoughtful, self-searching aestheticism. In this image, solitude and silence coalesce within a composition that is built primarily on empty space. *La grosse pierre* invites speculation regarding Rose's admiration for James

McNeill Whistler (1834–1903), innovator and major practitioner of that painting referred to as Tonalism.[127] In paintings such as *Nocturne in Blue and Gold* of 1866 (which Rose could have seen on exhibit in Paris in 1890), Whistler assigned the role of abstract emotional and intellectual equivalents to soft washes of grayed color. He was the painter most fully identified with Aestheticism, the art-for-art's-sake movement so cleverly articulated by Oscar Wilde and Théophile Gautier and so unfortunately derided by John Ruskin. Rose's fishing and tennis companion and fellow Giverny resident, Frederick Frieseke, had actually studied with Whistler, albeit for perhaps only a week. Rose and Frieseke no doubt discussed the merits of the Whistlerian mode, especially as it addressed itself to the intimate, enigmatic scene. Whistler influenced generations of American painters in the tonal aesthetic, which, while not a movement with a clear agenda, emphasized soft-focus, muted, meditative scenes composed within a restricted tonal range.

When Guy Rose saw signs of the modern world encroaching on the countryside, he described them in terms as harmonious as those found in his pure landscapes. In *The Valley of the Seine* (fig. 47), a train, smoke billowing from its engine, is depicted on a steel track that bisects the painting. The track itself forms a complementary rhythm to a road that sweeps down in an S-curve from a hill to the left. Another dramatic S-curve moves in counterpoint from the right foreground to the background hills. Here, nature and technology are not in conflict. Rose had seen his father, L. J. Rose, develop and enrich thousands of acres in the San Gabriel Valley; it is not unlikely that Guy felt that industrial development of various kinds might find a useful and beneficial balance with nature.

The American Impressionists would occasionally paint a factory or urban view but collectively avoided describing the abject conditions of workers in coal mines and factories that made technological advances possible. Such painful realities were in direct conflict with the ideology of art as a mode of poetic transcendence. There is no American Impressionist body of work equivalent to Jack London's 1907 novel, *Iron Heel,* a book detailing and condemning the exploitations of the worker under rampant capitalism, or Upton Sinclair's *The Jungle,* of 1906, which chronicles the barbarous conditions of Chicago slaughterhouses.

Guy Rose and Frederick Frieseke shared, as did every member of the colony at Giverny, an interest in the same non-volatile themes: landscape, garden and boating scenes, and figures posed in outdoor light, all themes explored by the

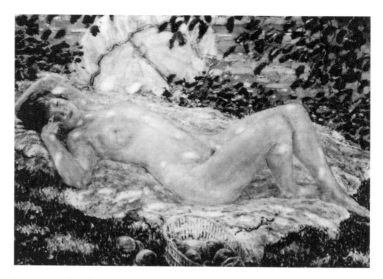

FIG. 48. Frederick Frieseke (1874–1939), *Autumn,* 1914. Oil on canvas, 38 x 51½ in. Museo d'Art Moderna di Ca' Pesaro-Venezia, Venice.

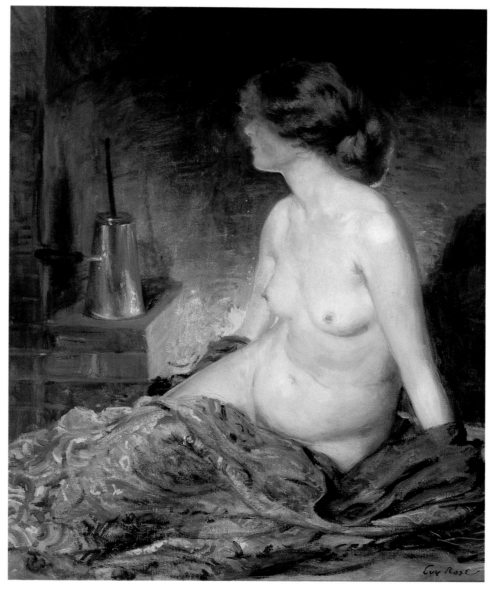

FIG. 52. Guy Rose, *By the Fireside,* ca. 1910. Oil on canvas, 24 x 20 in. Rose Family Collection.

GUY ROSE (1867–1925): AN AMERICAN IMPRESSIONIST

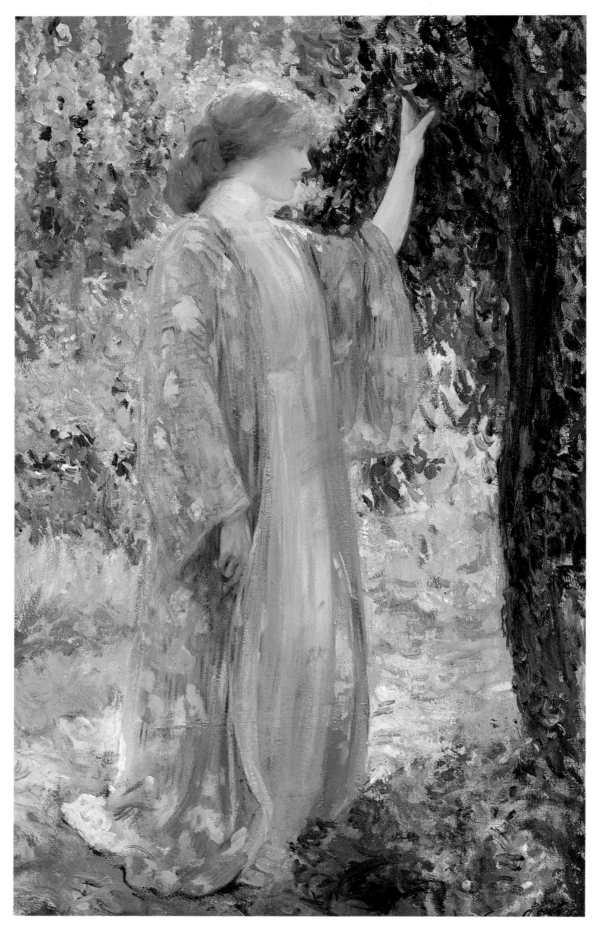

FIG. 50. Guy Rose, *The Blue Kimono,* ca. 1910. Oil on canvas, 34 x 19 in. Terry and Paula Trotter Collection.

French Impressionists as well as by earlier American artists in France. Indeed, figure painting was as popular a genre among the later painters at Giverny as landscape. Frieseke painted the female figure draped and undraped, indoors and outdoors, over and over. One of the best known of these is his *Autumn* (fig. 48) of 1914, a sensitively controlled study of flesh set amid a frenetically decorative background. Richard Miller (1875–1943) was another friend of Guy Rose who concentrated on the figure, composing often texturally complex interiors such as *Reflections* (fig. 49), which afforded the opportunity for the artist to display his skill and sense of color harmony.[128] Guy Rose painted fewer female figures than his Giverny colleagues, though those he did paint, such as the outdoor *Blue Kimono* (fig. 50) and the indoor *The Difficult Reply* (fig. 51), display the same decorative intensity observed in Miller and Frieseke.

In *The Blue Kimono* the young model becomes a foil for the execution of painterly effects; the diaphanous quality of the floral gown, the deft highlights on auburn hair set off by bright pink hollyhocks and roses, and the busy background garden greenery are all skillfully transcribed. The scene is rich and effusive, an updated rendition of the mythic garden of earthly delights.

Rose converts the model herself into a romantic abstraction—she is, like Whistler's *Woman in White*, Rossetti's *Beatrice Beatrix*, or any of Bouguereau's Madonnas, an ideal and a poetic device. Just as the American Impressionists collectively abstained from describing the harsher realities of industrialization, they jointly sustained the inherited cultural view of woman as pure and passive, the object and not the agent of social and aesthetic discourse.[129] Rose's *By the Fireside* (fig. 52) is example of the romanticized female figure and is one of the few nudes Rose painted during this period.[130]

Despite his interest in the sensuous possibilities of the figure, shared with the Giverny painters, no paintings by Rose of the nude posed in the out-of-doors have been located. One must conclude that this particular genre held little attraction for him. It is not unlikely that such paintings conflicted with Rose's own sense of propriety or, even more likely, his own aversion to the sensational and deliberately provocative. Outdoor nudes with no pretense to classical or poetic reference were still considered shocking in America at the time; Frieseke himself said that he had come to France to be able to paint them: "I am more free and there are not the Puritanical restrictions which prevail in America. Not only can I paint the nude out of doors, but I can have a greater choice of subjects."[131]

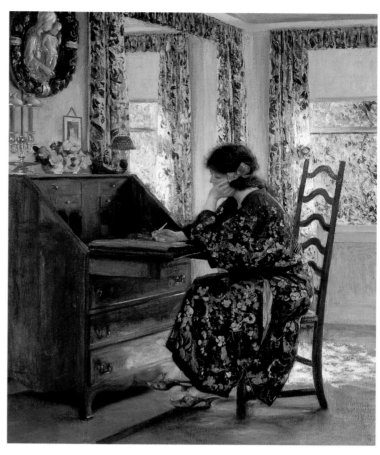

FIG. 51. Guy Rose, *La réponse difficile (The Difficult Reply)*, ca. 1910. Oil on canvas, 29 x 24 in. The Buck Collection.

FIG. 49. Richard Miller (1875–1943), *Reflections*, ca. 1910. Oil on wood panel, 36 x 36 in. Courtesy Museum of Art, Brigham Young University, Steed Memorial Collection. Photograph by David Hawkinson.

GUY ROSE (1867–1925): AN AMERICAN IMPRESSIONIST

FIG. 53. Guy Rose, *Warm Afternoon,* ca. 1910. Oil on canvas, 29 x 24 in. The Oakland Museum, Museum Donors Acquisition Fund, 67.43.

WILL SOUTH

Fɪɢ. 54. Guy Rose, *On the River*, ca. 1910. Oil on canvas, 24 x 19½ in. Rose Family Collection.

FIG. 55. Guy Rose, *Falaise à Pourville (Bluff at Pourville)*, ca. 1910. Oil on board, 12¾ x 15½ in. Private collection.

The calmly introspective qualities to be found in many of Rose's landscapes are also found in certain of his figurative paintings, such as *Warm Afternoon* (fig. 53). Though somewhat self-consciously posed, the central figure in this painting is, as opposed to the women in *The Blue Kimono* and *On the River* (fig. 54), small in scale relative to the picture plane. The shape of her seated body mimics that of the evenly spaced tree trunks behind her, while two of those trees form a frame around her profile. The use of diffused backlighting gives her form, and the trees, an even, subdued tonality at the same time as it illuminates the mass of leaves and shoreline behind her. *Warm Afternoon* evinces the artist's own preference and affinity for intimate and subtle images.

Rose's earliest surviving seascapes date from his years at Giverny. Though his later California seascapes remain much better known, his French seascapes share with his landscapes the artist's penchant for calm, subdued imagery (they also serve as a record of how frequently Rose traveled throughout France). *Falaise à Pourville (Bluff at Pourville)* (fig. 55) depicts a simple juxtaposition of sea and shore and dense atmosphere with an overall muted tone. *Foggy Morning, Veules* is a variation

on this same composition and tonal treatment.[132]

A number of Rose's later compositional preoccupations regarding the seascape, such as the integration of complex shapes created by trees with the basic flatness of the ocean, were first attempted in France. In *Fig Trees, Antibes* (fig. 56) a row of writhing fig trees is aligned with the Mediterranean which bisects the canvas. The inclusion of architectural forms, while uncharacteristic of Rose, is nonetheless effective here in the visual contrasts created. Also, as he did with certain of his French landscapes and would do later in California, Rose painted near-identical scenes on the French coast under varying atmospheric conditions.

Another theme less popular at Giverny owing to the general commitment to outdoor painting but still practiced occasionally by Rose was the conventional indoor still life. Unlike his early, tonal still lifes done under the influence of Emil Carlsen, *From the Dining Room Window* (fig. 57) incorporates strong backlighting and a high-keyed palette. (The same diamond patterns of light created by the decorative windowpane appear in *Sunshine and Firelight*, a nude painted in the living room adjacent to the kitchen in the small Rose cottage [fig. 58].)

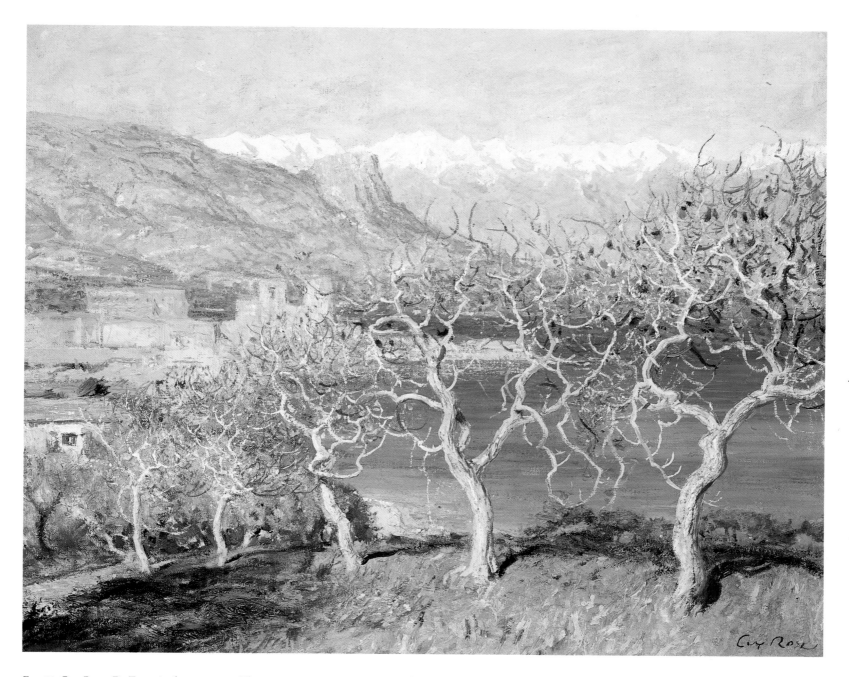

FIG. 56. Guy Rose, *Fig Trees, Antibes,* ca. 1910. Oil on canvas, 24 x 29 in. Courtesy of The Redfern Gallery, Laguna Beach, California.

GUY ROSE (1867–1925): AN AMERICAN IMPRESSIONIST

FIG. 57. Guy Rose, *From the Dining Room Window,* ca. 1910. Oil on canvas, 35 x 23 in. Mr. and Mrs. Thomas B. Stiles II.

FIG. 58. Guy Rose, *Sunshine and Firelight,* ca. 1910. Unlocated. Photograph courtesy of the Rose Family Collection.

Concurrent with the resurgence of his painting, Guy Rose resumed an active exhibition schedule during his later Giverny years, sending many of his French pictures back to the Macbeth Gallery in New York. His reclaimed productivity, as well as his camaraderie with the other Giverny artists, resulted in a group show in 1910 at the Madison Gallery, also in New York. The New York *Sun* called the exhibition of "The Giverny Group," composed of Richard Miller, Lawton Parker, Frederick Frieseke, and Guy Rose, "one of the most brilliant given in that interesting gallery."[133]

Rose's generally good health and active involvement with hunting and fishing at Giverny are documented in two articles by Ethel: "Shooting in France," which was published in 1911; and "Trout Fishing in Normandy," of 1913, both in *Scribner's*. Guy and Arthur Burdett Frost provided the illustrations. The fisherman who appears in most of these illustrations is Rose himself (fig. 59). Ethel, writing in a colorful prose style, discussed the real importance of fly-fishing and, in the process, also described the subject matter that so compelled her husband:

> To most true lovers of the sport [fly-fishing] much of the charm of it lies in the being out of doors in all weathers and amid varied scenes; and if you have not before seen and enjoyed the French country, there are unknown delights of that kind to be found there.
>
> There will be sunny summer days when the fields of grain, the village, the meadows, and the hills seem to float in a delicate gold haze; the greens, so vivid close at hand, becoming more delicate, bluer, more ethereal, in the distance, when the cattle stand in close groups under the trees and the faint sweet smells of hay or blossoms or the not far distant ocean come to you now and then.
>
> There are raw, damp days in spring when the ground is like a sponge, the trees are nearly bare, and the keen west wind makes you glad you have on two sweaters, a rain-coat, and water-tight boots.
>
> And there are warm, gray, rainy days, more mist than rain, when you are coated all over with infinitely small silvery drops that look like hoar-frost, and you feel as if you were in the living heart of a great blue-green opal with shifting, changing lights, and no limits and no horizon—nothing but moving layers of pale mist through which you see soft greens of trees against soft blue of hillsides, wet gleams from red-tiled roofs far away, faint, irregular shapes slowly moving through this dream-world, and near at hand, to give some substance of reality, the little dull-gray stream gliding dizzily at your feet.[134]

Fig. 59. Arthur Burdett Frost (1851–1928), illustration of Guy Rose fishing for Ethel Rose's article "Trout Fishing in Normandy," *Scribner's Magazine* 54 (October 1913).

Guy Rose believed the interpretation of all these natural sensations to be the proper function of the artist—a belief that was crystallized and refined during his Giverny years. The body of work he produced from around 1907, when he returned to painting, to the end of 1912, when he returned to the United States for the last time, form the strongest testament to how fully he committed himself to that interpretation.

Guy and Ethel Rose might have remained in this tiny French village indefinitely; painting, fishing, socializing and writing, and living the life they both preferred. However, the source of their regular income from illustrating was terminated. As Helen Xavier DuMond concisely explained the situation years later: "They [Guy and Ethel Rose] have left Paris you know because *Harper's Bazar* gave up their Fashion Page."[135] Though it is possible they may have simultaneously tired of the rural French lifestyle and its isolation, a move back to America would place Rose in closer proximity to the art market and dealers, eliminate transatlantic shipping and communication, and facilitate a return to teaching and a regular income.

Thus, after eight years in Giverny and nearly a full thirteen years abroad, Guy and Ethel Rose returned to America. They lived alternately in New York, where Guy continued to exhibit at the Macbeth Gallery, and in Rhode Island, where he taught an outdoor sketch class at Narragansett Pier. This arrangement lasted less than two years; by the fall of 1914, the Roses had relocated to Southern California, where Guy would live the rest of his life.

CALIFORNIA

Guy Rose had not been a permanent resident of Southern California since 1885, when he left for San Francisco and the California School of Design. At that time, there were few professional artists in the Los Angeles area. Upon his return in 1914, there was an active contingent of regional painters, including William Wendt (1865–1946), the husband and wife duo of Elmer Wachtel (1864–1929) and Marion Kavanaugh Wachtel (1876–1954), and Hanson Duvall Puthuff (1875–1972). As the *Los Angeles Times* art critic Antony Anderson wrote at the time he met Rose: "we have artists galore, and more are coming all the time, driven here by eastern winters and lured here by our perpetual summers. . . . Guy Rose, notwithstanding his adventures around the globe, is 'one of us,' his birthplace being the historic village of San Gabriel."[136] Within six months of his arrival, Rose mounted an exhibition at the Steckel Gallery in Los Angeles, and established himself as a leader among that contingent.

At this show, held in February 1915, Rose showed a large group of his Giverny works, many of which had different titles then than they are known by now. These paintings are sufficiently described by Anderson in his review "Guy Rose Again" (*Los Angeles Times,* 21 February 1915) to establish their identity. Included were *By the Fireside,* then titled *Model Resting; The Difficult Reply,* then titled *Petit bleu;* and *On the River,* then titled *In a Boat.*[137] The next month, the bulk of this show was moved to the Elizabeth Battey Gallery in Pasadena, not far from where Rose had established residence in Alhambra. A number of paintings previously unexhibited were added. Among these were *The Sheik's Daughter* (unlocated, perhaps dating from Rose's trip to Algeria), *Warm Afternoon,* then titled *Hot Afternoon,* and *Portrait of Mrs. Guy Rose* (fig. 60).[138] Reviewing the latter exhibit, Antony Anderson made the following astute and prophetic observation: "The return of Guy Rose . . . was an event of importance to Los Angeles, and of even greater interest and importance is the fact that his stay will probably be permanent."[139]

Guy Rose's presence in Southern California, prestige, and influence contributed to the consolidation of American Impressionism as the dominant regional style and affirmed its status as the style best suited to the interpretation of California's scenic diversity and Mediterranean climate. Over the next six years, until he suffered a debilitating stroke in 1921, Rose continued to paint, exhibited widely (including three solo exhibitions at the Los Angeles Museum of Science, History and Art

in Exposition Park), and sold numerous canvases. He enjoyed a widespread popularity and appeal that cannot be fully understood and appreciated outside the cultural context of Los Angeles in the 1910s, a context characterized by a narrow range of appreciation and a conformist set of values.

In 1913, just one year prior to Rose's return, the former *Los Angeles Times* literary critic and author Willard Huntington Wright took aim at what he saw as the cultural lethargy of his hometown in an article entitled "Los Angeles: Land of the Chemically Pure." In this satirical piece written in the mode of H. L. Mencken, Wright claimed Los Angeles had the cultural temperament of a church bazaar: "they have a righteous horror of shapely legs . . . at concerts they applaud the high notes, and they vote their pastor's choice of candidate." Those who controlled this stultifying, prohibition-minded city, according to Wright, were "the pietist, the killjoy, the lawn sprinkler."[140] Wright's article, excessively acerbic and ultimately self-serving, nonetheless identified the pervasive conservatism of Los Angeles society in the teens. Not unlike most Americans of the period, Angelenos who looked at paintings admired and purchased those that confirmed their own notions of the beautiful, that is, paintings that were attractive, comprehensible, and in accord with their essentially Victorian attitudes about the goodness of nature.

In 1915 Willard Huntington Wright published a book entitled *Modern Painting* extolling the virtues of total abstraction in art.[141] In an otherwise well-intentioned review of the book, Edwin Arthur Hunt wrote that "Mr. Wright's Modern Painting is of no avail if we cannot apply his principles to the work of Southern California painters." Hunt proceeded to do just that, and through a limited understanding of Wright's principles concluded that among the most modern of painters was none other than Guy Rose:

Guy Rose in [a painting entitled] the *Old Bridge* [see fig. 39] is modern in every respect. He shows joy, not only by the multitude of vertical lines, but by the scintillating light. The color of his bridge is not black, but of a purple tinge, the result of the intense light. Rhythm is shown by the lines of the banks of the stream converging in the top of the picture and influencing each other in direction. . . . It is probably most typical of Southern California and modern art in that it has brilliant light, rhythm, balance, and expresses an emotion.[142]

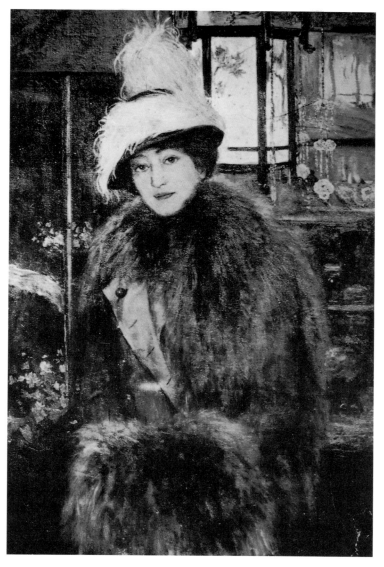

FIG. 60. Guy Rose, *Portrait of Mrs. Guy Rose.* Unlocated. Photograph taken from Beatric de Lack-Krombach, "Art," *Los Angeles Graphic* (16 February 1915): 54.

The art of Guy Rose did, in fact, represent modernity to Hunt and to the Southern California public. Compared to the predominantly brown, dark canvases of the Barbizon school of landscape painting or to the few examples of Renaissance and baroque painting known to the local community, Impressionism was a significant and highly energized reinterpretation of light at the same time as it remained intelligible. Cubism and Futurism, on the other hand, were simply bizarre terms known only to a few readers of art journals. As paintings, they were oddities that shocked Los Angeles's assorted world-travelers when in Paris. Rose himself summarized the local attitude toward these new movements shortly before he moved back to Los Angeles:

> What do I think of the "Futurists" and the "Cubists" and that ilk. I think they are simply crazy. I don't see how it is possible to paint anything any worse. I was glad to get away [from Paris], for the place is simply overrun with them. I don't think it will have any lasting effect, however, and then we shall come back to sane work.[143]

Rose's art was not only modern to Southern Californians, it was sane. It combined the traditional and recognizable values of accurate drawing and careful observation with what was for them the still wholly vanguard Impressionist aesthetic of light. Rose's painting offered clarity and order, two primary virtues subscribed to by his audience, at the same time as it described the sun-drenched and colorful California landscape in terms of a heightened sensuality. His synthesis of technical prowess in paint with obvious lyric sensibilities represented to his viewers a just and reasonable balance between nature and poetry. In short, for Southern Californians Guy Rose was the right artist in the right place at the right time; he materialized their shared attitudes and values about the land and how to live in it. When understood metaphorically, his paintings of towering eucalypti and ocean shorelines confirmed California as a paradise of limitless resources in a country mythologized as the Land of Opportunity.

In 1915 Rose was as active in the arts as at any point in his career and apparently in good health. In addition to his show at

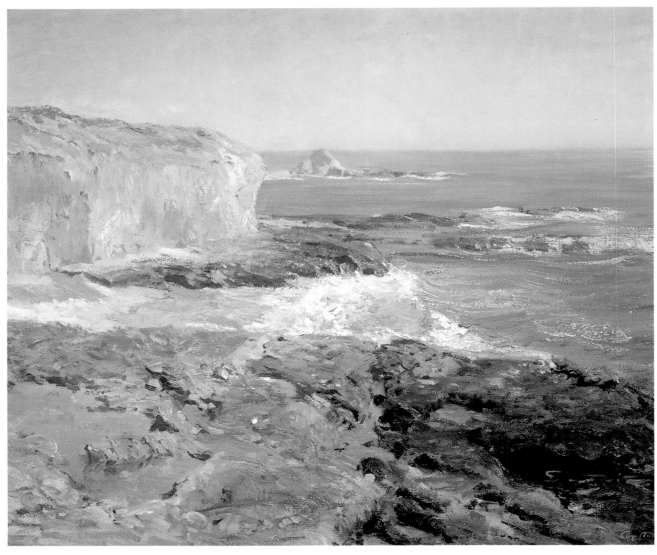

FIG. 61. Guy Rose, *Laguna Rocks, Low Tide*, ca. 1915–16. Oil on canvas, 21 x 24 in. Joan Irvine Smith.

the Steckel and Battey galleries, he became a member of the board of governors of the Los Angeles Museum of History, Science and Art, founded in 1913. He also joined the largest and most powerful local art organization, the California Art Club. He exhibited two oils in California's most important exhibition up to that date, the Panama-Pacific International Exposition, held in San Francisco, an international fair organized to celebrate the opening of the Panama Canal in 1915.[144] He continued to paint out-of-doors and also completed the largest full-figure portrait of his career, *The Leading Lady,* Miss Lucretia del Valle as Señora Josefa Yorba (see p. 7).[145] After a trip to the P.P.I.E., Guy's old and dear friend, Frank Vincent DuMond, visited Rose and called the del Valle portrait "a unique and original conception."[146] This flamboyant painting of the actress as a character in John McGroarty's pageant *The Mission Play,* performed at San Gabriel, was awarded the gold medal at San Diego's Panama-California Exposition of 1916.

In February 1916 Rose had his first one-person exhibition at the Los Angeles museum. The majority of the twenty-one works shown were new paintings of the California coastline.

Antony Anderson recognized the affinity Rose displayed for seascapes: "Rose had never painted the sea till a year ago, and when he gazed upon the Pacific it must have been with a new and 'wild surmise' for he immediately sat himself down to paint it—and discovered he had come into his own. Luckily for him, and thrice luckily for us."[147]

The artist had, in fact, painted the sea early in his career in San Francisco and had done coastal scenes while in France, but he turned his attention to the ocean beginning in late 1914 with a focus unknown in his earlier work. In painting the Pacific, Rose could indulge two of his major pictorial interests explored at Giverny; reflections on water and multifarious atmosphere. It also satisfied his personal penchant for creating images of solitude and quiet. In 1915 and 1916 he visited the Southern California beach communities of Laguna and La Jolla and painted the coastline with a complete command of the impressionistic strategies he had mastered at Giverny.

Laguna Rocks, Low Tide (fig. 61) and *Indian Tobacco Trees, La Jolla* (fig. 62) both date from 1915–16 and both maximize the effect of deep space. In *Laguna Rocks* the agitated strokes that

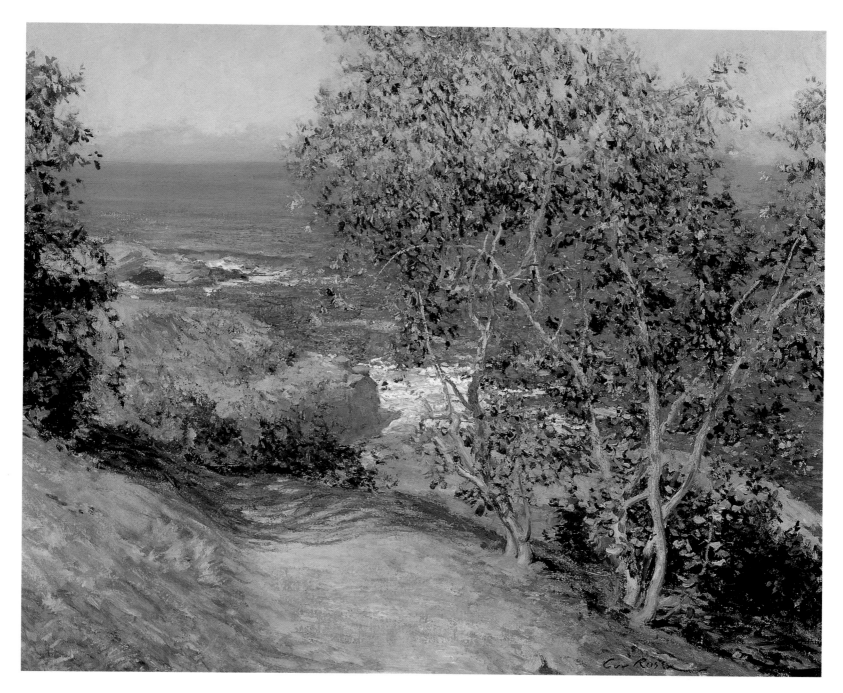

FIG. 62. Guy Rose, *Indian Tobacco Trees, La Jolla,* ca. 1915–16. Oil on canvas, 29 x 24 in. The Fieldstone Collection.

GUY ROSE (1867–1925): AN AMERICAN IMPRESSIONIST

describe the rocky shore contrast with an absolutely empty, vaporous sky. Between the rocks and sky, the ocean recedes in increments of increasingly diffuse brushwork. The fully and evenly lit cliff at the left suggests that the time is midday. Rose's keen attentiveness to actual atmospheric conditions, derived most fully from Monet, intensifies the experience of openness and recession.

In *Indian Tobacco Trees* the foreground is again contrasted with a serene, empty sky, and, again, foreground and background are separated by an opalescent ocean. Rose knew, as does every competent painter, that warm colors advance toward the viewer and cool colors recede from the eye. He enhanced the distinction between near and far in *Indian Tobacco Trees* by emphasizing the warm oranges and yellows of the foreground hill and by reducing the horizon to a cool, pale violet haze.

At the same time that his 1916 show was on view, Rose was in the process of organizing an exhibition of contemporary American art for the Los Angeles Museum. The museum's director, Frank Daggett, in conjunction with the board of governors, which included Rose, had decided to host an annual show of the best in current American painting and to build a collection for Los Angeles based on purchases from these shows. It occurred to those involved that collecting the work of living artists other than that by local painters would be an undertaking that required some finesse. Ethel Rose countered this anticipated grievance in an article for the *Graphic*, writing: "What, for instance, would the Boston Art Museum amount to if it had confined itself to the work of Massachusetts artists, or what the Corcoran if it collected only pictures painted in Washington?"[148]

The First Annual Exhibition of Contemporary American Painters opened in March 1916 and included works by Rose's former teacher Emil Carlsen and his Giverny colleague Frederick Frieseke. Of a total of fifty-three artists represented in the show, only thirteen were from Southern California; many painters from the East were invited and not subject to a jurying process, while local painters were required both to apply and to be juried. Antony Anderson expressed in a *Los Angeles Times* article the predicted discontent of some local artists: "Here we come up against the appalling big fetich of the superiority of the New York men, a fetich which is three parts illusion. . . . Complaints are abroad that the jury who met last week turned down pictures by Los Angeles painters that are at least as good as some by the eastern men."[149]

Rose, one of the jurors and also an exhibitor, made a rare and uncharacteristic outing in print to respond to these accusations. In a letter to the *Times,* Rose made it clear that worthy art was being created outside the Southland:

Of the strictly local men, none were invited out of deference to the silly idea that seems to prevail here that every painter in Southern California is the best in the world. . . .

What you say about the recognized big men's work not being better than the work done here makes me feel that you have not seen the pictures at Exposition Park, you know as well as I do that it is the artist and not the subject that makes good work.

As to the taxes the [local] artists have had to pay to get this work out here, they ought all, as I and others do, to consider it money well spent to enable them to see and study pictures of such a high standard and compare them with their own work. If taken in a big broad-minded spirit it is an opportunity of exceptional educational value, which we hope will be gradually made permanent by the acquisitions of the museum.[150]

Before the year was out, Rose took a seven-week painting trip into the Sierra Nevada. He rounded out the year with a small exhibition in Chicago,[151] and a show of nearly thirty paintings at the Friday Morning Club in Los Angeles in November. It was also in 1916 that Rose's old friend and Giverny colleague, the artist Richard Miller, came to live in Pasadena. His presence no doubt provided both camaraderie and perhaps even a spirit of competition. Though Miller's stay in Southern California lasted only two years, Mabel Urmy Seares noted in 1917 that "his presence has been a great inspiration to a group of local painters who for several years have been in revolt against the use of the old palette in depicting this preeminently sunny climate."[152] Miller offered criticisms at the Stickney Memorial School of Art in Pasadena, where Rose had begun teaching in 1915.

Rose opened 1917 with yet another exhibition at the Battey Gallery in Pasadena and showed a number of paintings he had done of the Sierra. In March 1918 he held another one-person show at the Los Angeles Museum. The busy schedule of painting and exhibiting Rose had maintained since his return to Los Angeles in late 1914 would suggest that his health problems had completely disappeared. Such was not the case. As Ethel reported, and as has already been noted, Guy was ill some portion of every year. Since his time in Giverny, and the relative stabilization of his symptoms while living there, Guy

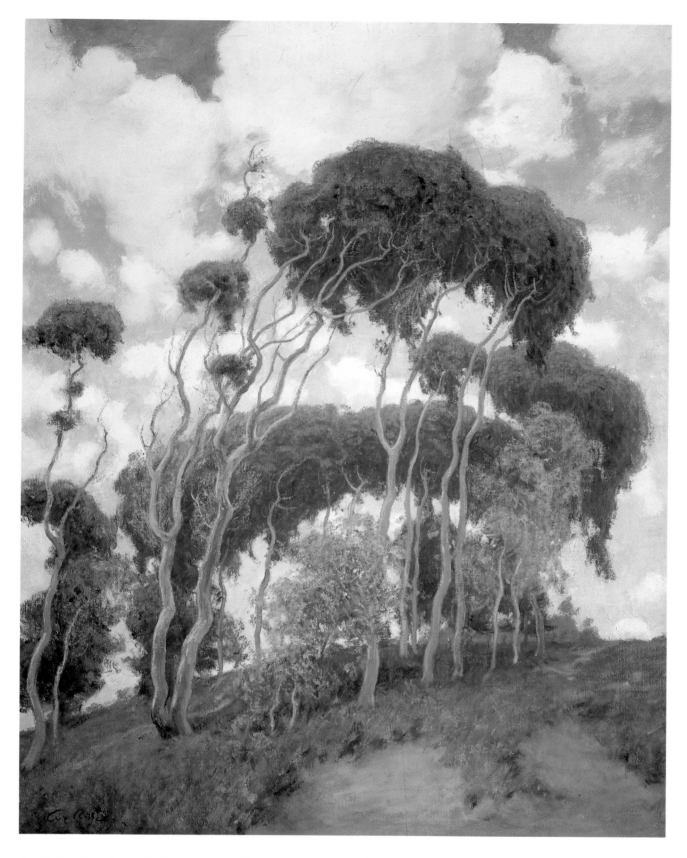

FIG. 63. Guy Rose, *Laguna Eucalyptus,* ca. 1917. Oil on canvas, 40 x 30 in. The Irvine Museum, Irvine, California.

evidently had come to believe his condition was manageable. He continued to work in California as he had in France, with an awareness of the dangers of lead-based paint, and continued to endure periodic bouts of illness. He was also selling paintings as never before—he wrote to his New York dealer, William Macbeth, that he had sold more paintings than any other local artist.[153] Near the end of 1917 he sent to Macbeth one of his seminal images of Southern California, *Laguna Eucalyptus* (fig. 63).[154]

Macbeth had once warned Rose not to send him "any of that damned brown California stuff" to sell in New York. Rose responded that there would be no problem since "California does not look that way to me."[155] Rose clarified for Macbeth just how California appeared to his eyes with this monumental image of an expansive, cloud-filled sky streaked with towering eucalypti. The emerald clusters of leaves on the trees echo the shape of the clouds, which themselves restate the curve and sweep of the foreground hill. The trees surge upward in the composition and the clouds outward, pushing empty space to the fringes.

With *Laguna Eucalyptus* Rose not only restated pictorial themes refined in France but materialized on canvas a number of long- and widely held assumptions regarding California as the newest and greatest Eden, where nature is everywhere resplendent, pleasing, and plentiful. These shared assumptions, compelling to earlier California pioneers (including Rose's father) and eventually exploited by the greediest of boosters, underlie the complex myth known as the California Dream. This myth is an extension of a larger American one that first understood the land as a mirror of divine plan, and then as a divine right in the scheme of manifest destiny. Artists such as Thomas Cole (1801–1848) and Frederic Edwin Church (1826–1900) painted nature as Creation early in the nineteenth century; Albert Bierstadt and Thomas Moran (1837–1926) later reflected the political credo of that understood Creation as privilege and prerogative. Rose's *Laguna Eucalyptus* participates in the long stream of American landscapes that both described the perceived divinity and majesty of America and served collectively to reinforce and confirm those same perceptions. In short, Rose painted beauty as he saw it and felt it, at the same time as he ineluctably conveyed the ethos of his culture.

CARMEL-BY-THE-SEA

Here where the surf has come incredible ways out of the splendid west, over the deeps
Light nor life sounds forever; here where enormous sundowns flower and burn through color to quietness

ROBINSON JEFFERS, "Meditations on Saviors"

While living in New York City, Guy Rose sought the solitude of the Maine woods; while in Paris he frequented Giverny; and when in Los Angeles he took extended trips to Laguna and into the High Sierra. After his first visit to Carmel, this seaside hamlet became his newest and final retreat from more populated areas.

The shoreline both north and south of Carmel affords some of the most spectacular scenery in all of California. Word of the scenic possibilities there had already attracted not only many Californian painters and writers but also America's most famous impressionist painter, Childe Hassam (1859–1935) in 1914 (fig. 64). The Californian artist Mary DeNeal Morgan had settled in Carmel in 1910, and it was at her request that William Merritt Chase (1849–1916) came to teach a summer painting class, also in 1914.[156] Rose may have been encouraged to visit Carmel by the artist Channel Pickering Townsley (1867–1921), who served as director of Chase's summer school, and who then became director of the Stickney Memorial Art School after deciding to remain in California. Townsley used Carmel as the site for the summer classes of the Stickney in 1915–16, a time when Rose was teaching at the Pasadena school. Marion Kavanaugh Wachtel, related to Rose by marriage, painted in the Carmel area in 1915, and yet another source of inspiration to visit Carmel may have come from Rose's old colleague and former love, Evelyn McCormick. After the devastating earthquake and fire in San Francisco in 1906, many artists moved to new locations. Evelyn McCormick moved to Monterey, just north of Carmel, and exhibited at the Del Monte Hotel, the elegant resort that had opened an art gallery in 1907.

Rose's schedule in Southern California since his return in late 1914 had been a full one, and, despite hearing Carmel's praises, he does not seem to have visited there until the summer of 1918, as his paintings of the area were not exhibited in Los Angeles until October 1918 in the Ninth Annual Exhibition of the California Art Club. Once discovered, however, Carmel-

WILL SOUTH

FIG. 64. Childe Hassam (1859–1935), *Point Lobos, Carmel*, 1914. Oil on canvas, 28 5/16 x 36 1/16 in.
Los Angeles County Museum of Art, Mr. and Mrs. William Preston Harrison Collection, 29.18.2.

by-the-Sea became the primary focus of what were to be his last years of painting. Guy and Ethel Rose spent the summers of 1918, 1919, and 1920 at Carmel. That Guy himself was anxious to produce and perhaps experiment stylistically is suggested by comments he made to Antony Anderson prior to his first Carmel visit. Anderson reported: "Mr. Rose is to paint at Carmel this summer, and hopes to bring back a number of pictures in an entirely different vein from those already exhibited in Los Angeles and Pasadena."[157] Indeed, Rose painted a substantial number of his best-known works in what was less than a year's time at Carmel, and, focusing on coastal views, he attempted to extend the expressive significance of the painted atmosphere.

The extremes of sunlit clarity and form-obscuring mist were often explored by Rose using the same vantage point. A favorite painting spot was Point Lobos, the picturesque peninsula (and later preserve) replete with natural beauty, featuring stunning, rocky shores, that juts out into the Pacific Ocean at the south end of Carmel Bay. In *Point Lobos, Carmel* (fig. 65) Rose makes the distant horizon line a crisp blue edge and gives equal clarity to the cliff, rocks, and background shoreline. All forms are saturated in light, rendering the foreground water a deep ultramarine blue.

By contrast, in *Mist over Point Lobos* (fig. 66), featuring the same cliff and rock formation painted from approximately the same spot, the horizon and northernmost shoreline are completely obscured by a heavy, wet mist. The warm rocks of *Point Lobos, Carmel* are here coated in a cold, white frosting, and the opalescent sea is veiled in a dense atmosphere. It was clearly

not Rose's intent to paint the same scene over and over, but rather to paint the varied experiences of expansiveness versus enclosure, of translucence versus opacity, or warmth versus cold.

Naturally, Rose's versions of the same scene under different conditions beg comparison with Monet's practice. The French artist had painted a number of objects in series, including Rouen cathedral, grainstacks, and his own water-lily pond (with which Rose was familiar and had commented on). More germane to Rose's interpretations of Point Lobos is the series Monet painted of the rock formations at Étretat, Port-Coton, and Belle-Île.[158] Rose understood that Monet's subject matter was not the objects per se but the effects of light, which created an unlimited series of formal abstractions for which the artist must find pictorial equivalents.

Another example of Rose's treating the same subject under different conditions is the two versions of the Carmel coast painted in the morning mist (fig. 67) and again in the afternoon sunlight (fig. 68). The ceaseless interplay between the appearance and dissolution of form, and the challenge of transfixing a moment's perception, continued to fascinate Rose as it had his precursors in Impressionism.

In addition to his coastal studies, Rose revisited a number of favorite themes while at Carmel. The intimate, shrouded, and skyless landscape with light filtering through trees, so successfully interpreted at Giverny in paintings such as *November* (fig. 37) and in Southern California in *San Gabriel Road* (fig. 69), was reconstituted by Rose in *Oak Grove, Carmel* (fig. 70), just as the solitary female figure in a forest depicted in Giverny's

Fig. 65. Guy Rose, *Point Lobos, Carmel*, ca. 1919. Oil on canvas, 24 x 29 in. Joan Irvine Smith Fine Arts, Inc.

FIG. 66. Guy Rose, *Mist over Point Lobos,* ca. 1919. Oil on canvas, 28½ x 24 in. The Fleischer Museum, Scottsdale, Arizona.

GUY ROSE (1867–1925): AN AMERICAN IMPRESSIONIST

FIG. 67. Guy Rose, *Carmel Shore,* ca. 1919. Oil on canvas, 23½ x 28½ in. Rose Family Collection.

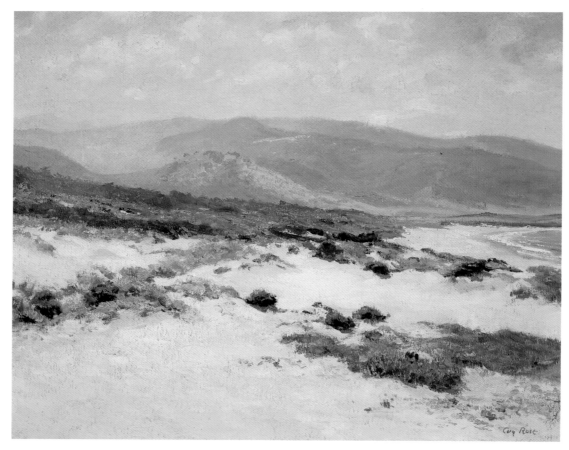

FIG. 68. Guy Rose, *Carmel Shore,* ca. 1919. Oil on canvas, 23½ x 28½ in. Joan Irvine Smith Fine Arts, Inc.

WILL SOUTH

PAGE 71

FIG. 69. Guy Rose, *San Gabriel Road*. Oil on canvas, 24 x 29 in. Joan Irvine Smith Fine Arts, Inc.

GUY ROSE (1867–1925): AN AMERICAN IMPRESSIONIST

FIG. 70. Guy Rose, *Oak Grove, Carmel,* ca. 1919. Oil on canvas, 21 x 24 in. The Fieldstone Collection.

FIG. 71. Guy Rose, *In the Oak Grove,* ca. 1919. Oil on canvas, 24 x 21 in. Courtesy of The Redfern Gallery, Laguna Beach, California.

GUY ROSE (1867–1925): AN AMERICAN IMPRESSIONIST

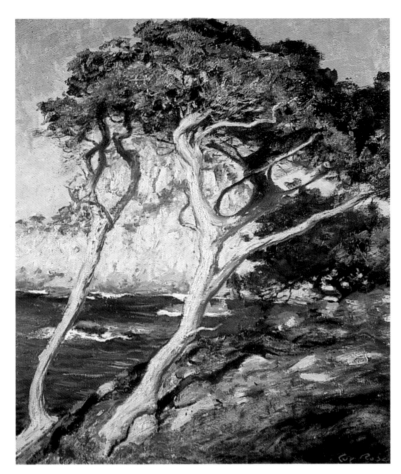

FIG. 72. Guy Rose, *Point Lobos Trees,* ca. 1919. Oil on canvas, 18 x 15 in. Marcel Vinh, Daniel Hansman Collection.

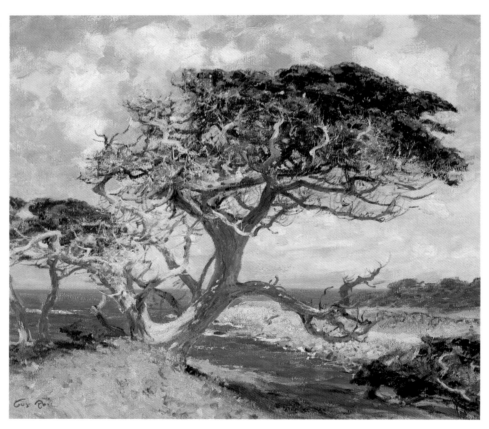

FIG. 73. Guy Rose, *Monterey Cypress.* Oil on canvas, 23½ x 20 in. Wendy Webster Collection.

FIG. 74. Guy Rose, *Monterey Forest,* ca. 1919. Oil on canvas, 23½ x 29½ in. Private collection.

Warm Afternoon (fig. 53) was reformulated for *In the Oak Grove* (fig. 71). Likewise, Guy's interest in the rhythms of a single tree or group of trees against the sky, which he painted at both Giverny and in Southern California, manifests itself in a series of views of twisting cypress (figs. 72 and 73), and paintings such as *Monterey Forest* (fig. 74), which features coast live oak, Monterey cypress, and Monterey pine all in the same composition.

After Guy's first trip to Carmel in 1918, he and Ethel vacationed briefly in the East. Guy painted outdoors near New London, Connecticut, and the Roses visited with Frank Vincent DuMond and his wife who were then staying in Lyme.[159] Two currently unlocated works, *At Duck Cove, Rhode Island* and *Girl in a Wickford Garden, New England*[160] perhaps date from this trip.

Rose returned to Pasadena and assumed the directorship of the Stickney Memorial School of Art, where he had taught since 1915. He also continued to serve on the board of governors for the Los Angeles Museum and to pursue an active exhibition schedule. In April 1919 he was awarded the first prize at the California Art Club's Spring Exhibition for *A Sierra Trout Stream* (unlocated).[161] At the same time, and unabashedly following upon the example of the Ten American Painters,[162] a group of American Impressionists who united for exhibition and promotional purposes, Rose and nine of his local colleagues organized as the Ten Painters Club of California and exhibited at the Kanst Gallery throughout 1919.[163]

Immediately following his show with "the Ten," Rose again had a one-person exhibition at the Los Angeles Museum

75

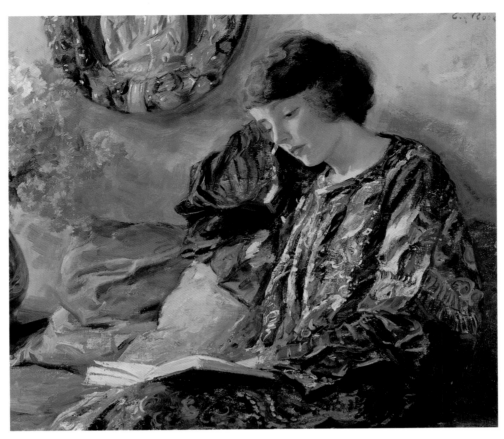

FIG. 75. Guy Rose, *Marguerite,* ca. 1918. Oil on canvas, 18 x 15 in. Bowers Museum of Cultural Art, Santa Ana, California.

in May 1919, a show that included many of his Carmel- and Monterey-area scenes. It also included *Marguerite* (fig. 75), an indication that despite his obsession with coastal views, Rose had not lost interest in figurative work. He supplemented his one-person and small group shows with regular participation in annual exhibitions, including the one sponsored by the National Academy of Design in New York. He showed *Point Lobos, Carmel* (fig. 65) there in 1920, a painting known then as *Rock and Sea, Point Lobos.*[164]

It was also in 1920 that Guy Rose rendezvoused in Carmel with his old friend and former roommate James Harwood, who had moved to Oakland that very summer. Rose had written to Harwood: "It will be so fine to see you!"[165] The pair had much catching-up to do, as well as much reminiscing over the thirty-five years they had known each other.

At the turn of 1921, at the age of fifty-three and in full command of his creative powers, Guy Rose was enjoying his status as an accomplished and recognized American Impressionist. Then, on 2 February, the artist suffered a stroke that effectively ended his career. The damage suffered by his central nervous system from years of lead poisoning may have contributed to his sudden incapacitation. Though his previous

work continued to be exhibited widely through the efforts of his wife and his Los Angeles dealer, Earl Stendahl, Rose could no longer paint.

Just a few months after his stroke, Rose was awarded the William Preston Harrison Prize for the most meritorious work of art at the Second Annual Exhibition of Painters and Sculptors of Southern California for *In Arcadia* (unlocated).[166] In 1922 the Los Angeles Museum purchased *Carmel Coast* (fig. 76) for the permanent collection,[167] and in October of that year, the Stendahl Gallery held a retrospective exhibition for Rose that featured sixty-five paintings, spanning most of his career. In 1925 he was the subject of a feature article in the magazine *International Studio.*[168] While these and other honors were bestowed upon him, the artist was confined to his bed.

On 17 November 1925 Guy Rose died at his home in Pasadena. The local paper reported: "During the past five years, Mr. Rose was an invalid, in bed nearly all of the time in his La Loma road home. . . . there will be no services here and request that no flowers be sent. This last is an express wish."[169]

One may assume that the artist who had experienced nature so deeply for so long wished for the flowers to remain in bloom in their gardens, along the shore, and in the hills.

WILL SOUTH

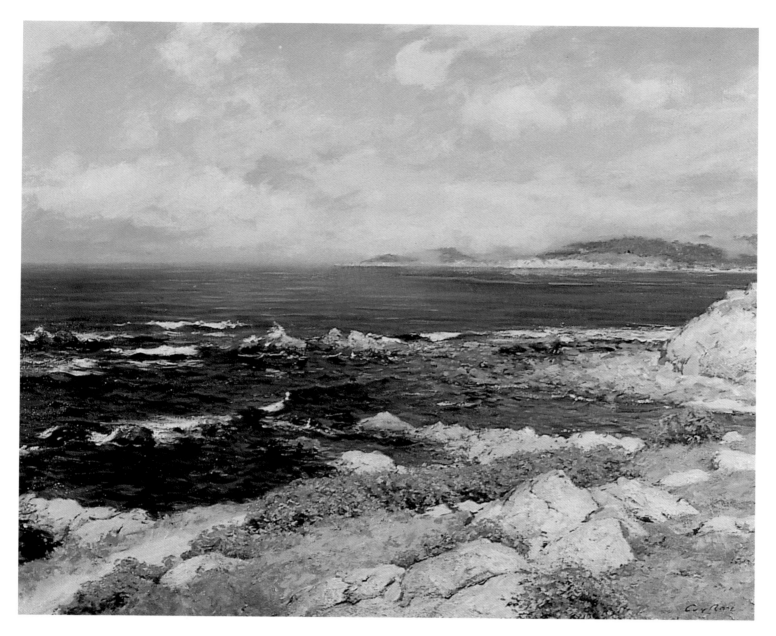

FIG. 76. Guy Rose, *Carmel Coast,* ca. 1919. Oil on canvas, 30 x 40 in. Collection of Jason Schoen, New Orleans, Louisiana.

NOTES

1. For a nostalgic yet detailed account of the life of L. J. Rose, see L. J. Rose, Jr., *L. J. Rose of Sunny Slope: California Pioneer, Fruit Grower, Wine Maker, Horse Breeder* (San Marino, Calif.: The Huntington Library, 1959; reprint, San Marino, Calif.: The Huntington Library, 1994).

2. L. J. Rose, "Cross-Country Reminiscences," *The Californian Illustrated Magazine* 3, no. 1 (December 1892): 114.

3. Ibid.

4. J. W. Cheney, "The Story of an Emigrant Train," unpublished text in Rose Family Archives, courtesy of the Rose Family Collection. The so-called Mormon War began in the summer of 1857, when President James Buchanan sent troops into Utah and appointed a territorial governor who directly challenged the authority of the Mormon leader, Brigham Young. Though an actual war never materialized between Mormons and federal troops, significant tension in the area resulted in a massacre that the Rose party no doubt knew about; on 11 September 1857 a group of Mormons, reacting to fear and insecurity, joined with Indians in southern Utah to attack a California-bound immigrant party and murdered 120 persons. This lamentable event, remembered today as the Mountain Meadows Massacre, is explored in detail in Juanita Brooks, *Mountain Meadows Massacre* (Stanford, Calif.: Stanford University Press, 1950).

5. In his own account of his westward trek, Rose describes his party's confrontation with the Mojave Indians in very different terms than does Cheney (cited above). Yet a third account is given in J. J. Warner et al., "Hon. L. J. Rose," in *An Illustrated History of Los Angeles* County (Chicago: Lewis Publishing Company, 1889). A fourth, and by far the most involved and colorful, version is found in Rose, *Sunny Slope*, 18–33. The essentials of the four accounts are the same and are those related here. All versions of the immigrant ordeal seem compromised by a less than accurate recording, as evidenced by their differences.

6. Cheney, "The Story of an Emigrant Train."

7. Warner et al., "Hon. L. J. Rose," 622.

8. Rose, "Cross-Country Reminiscences," 122.

9. One account states that Rose came to California with only eight thousand dollars, not fourteen. See "Los Angeles As It Appears to a Stranger," *Los Angeles Star*, 10 April 1873.

10. For a detailed account of the history of the Sunny Slope Ranch, see William A. Myers, *Ranches to Residences: The Story of Sunny Slope Water Company, 1895–1995* (Pasadena, Calif.: Sunny Slope Water Company, 1994). According to information supplied by Roy Rose, L. J. Rose's mother-in-law, Elizabeth Jones, provided some of the funds for the purchase of Sunny Slope.

11. According to L. J. Rose, Jr., his father's ranch was "the first instance of an exclusive blooded-horse stock farm." Rose bought his first breeding stock in 1869, and the following year he imported ten choice horses from Kentucky, an event "heralded all over the State. . . . With Father's importations from Kentucky and the advent of Mr. Titus, horse racing gained quite an impetus in Los Angeles County. There was a track in the outskirts of Los Angeles, where races were occasionally held, but there had been no regular organization or racing. In March 1871 a meeting was held in Los Angeles for the purpose of organizing an agricultural society, with horse racing as an adjunct, for the counties of Los Angeles, Santa Barbara, San Diego, San Bernadino, and Kern" (*Sunny Slope*, 68, 69, 70).

12. "[B]y the 1870s, over a thousand acres were planted in vines which produced more than 100,000 gallons of wine annually. From this stock, four distillation units at Sunny Slope's 'Great Winery' annually made 1,000 gallons of brandy, which was marketed in drug stores nation-wide by the firm of Stern & Rose under the 'Sunny Slope' label. The farm's oranges were almost as well known despite the difficulty of transporting them long distances in the days before refrigerated railroad cars: over 10,000 boxes of Sunny Slope citrus were shipped in the season of 1879 alone. The farm also produced an abundance of grains, feeds, vegetables, fruits and nuts. Race horses and breeding stock were the other well-known products of Sunny Slope farm; Rose made a major name for himself in California horse racing circles for his championship trotters" (Myers, *Ranches to Residences*, 19–20).

13. "Sunny Slope: Estate of L. J. Rose," *Los Angeles Herald*, 1 January 1876. Also see Myers, *Ranches to Residences*, 23: "Built in 1862, the home originally stood just south-west of the La Presa dam on land today occupied by Clairbourn School. Around 1902 the ranch house was moved about a hundred yards east to the corner of Sunny Slope Drive and La Presa Drive, where it remains to this day."

14. "Sunny Slope: Estate of L. J. Rose," *Los Angeles Herald*.

15. L. J.'s artistic inclinations were recognized by his son and biographer: "Father, though practical and reserved —he was one person who rarely said anything that would have been better unsaid—was visionary and a great dreamer, but with his great determination was one who made his dreams come true. He was of artistic temperament, had high ideals, knew good things when he saw them, strove for them and usually attained them" (Rose, *Sunny Slope*, 58).

16. Ibid., 121.

17. Ibid., 120–21.

18. Ibid., 122.

19. See Sarah Bixby Smith, *Adobe Days: Being the Truthful Narrative of the Events in the Life of a California Girl on a Sheep Ranch and in El Pueblo de Nuestra Señora de Los Angeles While It Was Yet a Small and Humble Town; Together with an Account of How Three Young Men from Maine in 1853 Drove Sheep & Cattle across the Plains, Mountains, & Deserts from Illinois to the Pacific Coast and the Strange Prophecy of Admiral Thatcher about San Pedro Harbor* (Los Angeles: Jake Zeitlin, 1931), 123.

20. "So individual was his work that he became the pet of Mrs. Blashfield [sic], the drawing teacher of our public schools" (Beatric de Lack-Krombach, "Art," *The Graphic* [16 February 1915]).

21. The California art historian Nancy Moure has likewise noted that an art community in Los Angeles "was only possible after Los Angeles's resident population became large enough to support it" (*Loners, Mavericks, and Dreamers: Art in Los Angeles before 1900* [Laguna Beach, Calif.: Laguna Art Museum, 1993], 39).

22. "Late in 1885 the Atchison, Topeka & Santa Fe Railroad completed its own line [in addition to the Southern Pacific line, completed in 1882] from Kansas City to Los Angeles and San Diego. The two railroads promptly entered into a rate war on passenger fares in 1886 and 1887. . . . The combination of inducement and opportunity was irresistible. More than three hundred thousand people who had been hearing about Southern California for more than ten years decided to pack up and see for themselves. The boom—the *big* boom—was on" (T. H. Watkins, *California: An Illustrated History* [New York: American Legacy Press, 1983], 249–50).

23. On the school, see Raymond L. Wilson, "The First Art School in the West: The San Francisco Art Association's California School of Design," *The American Art Journal* (Winter 1982): 42–55.

24. See Williams quoted in Theophilus Hope d'Estrella, "Virgil Williams' Art Notes to a Deaf-Mute Pupil," *Overland Monthly* 9, no. 19 (March 1887): 288: "I want him [the student] to learn something of the technique, to handle his materials, and learn certain canons of beauty and proportion. This is best done from the antique; then when he can do something and has the power to represent what he sees, it is time for him to look around."

25. The Capitoline *Dionysus*, once part of a late-classic full figure of the god which does not survive, is in the Museo Capitolino, Rome, where it is exhibited as no. 71 in the main gallery. The author wishes to thank Dr. Douglas Lewis of the National Gallery of Art, Washington, D.C., for his assistance in the identification of this bust.

26. Léon Bonnat, *Anatomical Lecture Delivered before the Students of the Atelier of M. Bonnat, École des Beaux-Arts*, trans. Virgil Williams (San Francisco: Mr. H. C. de Boyer, 1880).

27. A photo of Yelland's landscape class painting outdoors is in the collection of the California Historical Society, in San Francisco, and reproduced in Wilson, "The First Art School," 54.

28. On Carlsen, see Christina Orr-Cahall, ed., *The Art of California: Selected Works from the Collection of The Oakland Museum* (Oakland, Calif.: The Oakland Museum Art Department and Chronicle Books, 1984), 70; see also Janice T. Driesbach, *Bountiful Harvest: Nineteenth-Century California Still-Life Painting* (Sacramento, Calif.: Crocker Art Museum, 1991).

29. For a discussion of Carlsen and Rose within the context of California still-life painting, see Driesbach, *Bountiful Harvest*. Despite Carlsen's strong influence on Rose, it is interesting to note that Rose seems never to have attempted etching, although Carlsen was a competent etcher of still-life prints.

30. James Taylor Harwood [hereafter JTH] to Harriet Richards Harwood [hereafter HRH], 1 May 1889. Author's file.

31. For Keith, see Alfred C. Harrison, Jr., *William Keith: The Saint Mary's College Collection* (Moraga, Calif.: St. Mary's College, 1988).

32. Reproduced and discussed in Moure, *Loners, Mavericks, and Dreamers*, 89. That these stained-glass windows were a collaboration is recorded in "Los Angeles Homes: Some of the Richly Adorned Residences in This City," *Los Angeles Evening Express*, 4 October 1890: "On the hill at the corner of Grand avenue and Fourth street there stands another beautiful example of the American Renaissance in the spacious residence of Hon. L. J. Rose. . . . [A]ll of the stained glass used in the house was designed by Mr. Rose and his son Guy, who is studying art at the Julian Atelier in Paris and who has had two large pictures in the Salon this year."

33. For Pape, see Regina Armstrong, "An American Painter: Eric Pape," *International Studio* 17, no. 66 (August 1902): 83–89. Frederick Marvin is the only one of the four artist-roommates who never achieved distinction; nothing is currently known of his career.

34. To raise funds for his European study, Harwood sold his accumulated output of painting at auction, the first event of its kind in Utah. There were over two hundred paintings and sketches offered, among them a painting contributed by Guy Rose, entitled *Retired Nook* (unlocated). These are listed in the *Catalogue of J. T. Harwood's Oil Paintings, Drawings, and Sketches*, auction brochure, Thursday, 21 June 1888. Author's file.

35. JTH to HRH, 11 September 1888.

36. During his first week at the Julian, Harwood was told by Gustave Boulanger that he should be "ashamed to make such a thing with the model before him" (JTH to HRH, 17 December 1888).

37. JTH to HRH, 16 November 1888.

38. For additional discussion of the Julian, see H. Barbara Weinberg, "The Académie Julian," in Weinberg, *The Lure of Paris: Nineteenth-Century American Painters and Their French Teachers* (New York: Abbeville Press, 1991).

39. Robert Henri, *The Art Spirit* (1923; reprint, New York: J. B. Lippincott Company, 1960), 104–5.

40. "Six of us dine together every evening at a little restaurant. Their names are Russ, Lucas, Richardson, Rose, Harwood and Peixotto" (JTH to HRH, 6 February 1889).

41. JTH to HRH, 28 November 1888.

42. Rose, *Sunny Slope*, 162.

43. JTH to HRH, 24 October 1888.

44. Gustave Boulanger (1824–1888) was teaching at the Académie Julian for the first week that Rose was in attendance, but died suddenly and was replaced by Benjamin-Constant.

45. JTH to HRH, 4 April 1889. Both a description of Rose's studio and a recounting of the friend's visit are contained in this letter.

46. JTH to HRH, 18 April 1889: "I am quite alone now for awhile. Rose and Peixotto have gone out in the country for a month. Well, I don't care, though I would like to be with them."

47. For McCormick, see Helen Spangenberg, *Yesterday's Artists on the Monterey Peninsula* (Monterey, Calif.: Monterey Peninsula Museum of Art, 1976), 33: "A popular member of the early painting group in the area, Miss McCormick was described by Charles Rollo Peters as 'the grandest person who ever lived.' Her generosity was well known among less fortunate artists and she numbered such greats as Sarah Bernhardt among her close friends."

48. JTH to HRH, 11 September 1888: "Last night I was looking for something that was right before me, and Rose made the remark that 'I must be in love.' I told him that I would plead guilty. He said he could sympathize with me, so he is in the same bar. I expected as much as he writes whenever he gets a chance."

49. JTH to HRH, 5 June 1889.

50. JTH to HRH, 9 October 1889.

51. That Rose was associated with the DuMond brothers already in 1889 is a certainty: "I think the west would be the place [to relocate in America]. They say if you can paint a portrait that you can live royally there, especially in California. Rose says that and he knows the state pretty well" (Frederick DuMond to his parents, 27 December 1889, Frank Vincent DuMond Papers, Archives of American Art, Smithsonian Institution [hereafter AAA], roll N70-75, frames 751–52). On Frank Vincent DuMond, see Jeffrey W. Andersen, *The Harmony of Nature: The Art and Life of Frank Vincent DuMond, 1861–1951* (Old Lyme, Conn.: Florence Griswold Museum, 1990), and Barbara Mellin, "Universal Truths and the Laws of Nature: The Life, Art, and Teaching of Frank Vincent DuMond" (Master's thesis, Harvard University, 1994). Frank Vincent DuMond's Salon debut was in 1889 with a painting entitled *Crécy-en-Brie*. See Lois Marie Fink, *American Art at the Nineteenth-Century Paris Salons* (Washington, D.C.: National Museum of American Art; Cambridge: Cambridge University Press, 1990), 339.

52. JTH to HRH, 1 January 1890.

53. "The last monies arrived just in time to miss the cheapest and by far the best excursion ever made to Italy and back by way of Switzerland but now we are just that much more monies ahead. Rose is on it now" (Frederick Melville DuMond to his parents, 4 April 1890, AAA, roll N70-75, frame 258).

54. Peixotto's presence at Giverny is recorded as 10–29 September 1889 in the guest register of the Hôtel Baudy, transcribed by Carol Lowrey and reprinted in William H. Gerdts, *Monet's Giverny: An American Colony* (New York: Abbeville Press, 1993), 222–27. Rose was also preceded at Giverny by his friends Harry Russ, there 16–25 March 1889; Frederick Richardson, there along with Russ; and by Frederick Pape, there 7–10 May 1889.

55. Kate Kinsella to Philip Hale, 14 July 1890, in Philip Hale Papers, AAA, roll D98.

56. Guy Rose, "At Giverny," *Pratt Institute Monthly* 6 (December 1897): 81.

57. Rose, "At Giverny," 81.

58. Hitchcock reports that Rose painted *The End of the Day* in Crécy in 1890 (see Ripley Hitchcock, *The Art of the World: World's Columbian Exposition 1893*, 5 vols. [New York: D. Appleton and Company, 1894], 4:142). In the same year that Rose exhibited *The End of the Day* at the Salon, Peixotto exhibited a painting entitled *À l'église; Crécy-en-Brie*. Peixotto and Rose had traveled to the countryside together in May 1889 (see n. 46), and Rose very well may have returned to Crécy-en-Brie in September–October 1889, when he was reported as being out again in the country painting (JTH to HRH, 9 October 1889). After 1889, Rose is documented as living either in Giverny or in Paris and nowhere else, evidence that supports the conclusion that he only worked in Crécy at this early date with Peixotto and most likely with Frank Vincent DuMond.

59. This stone wall was a well-known feature of Crécy: "Around the town is an old stone wall which once had ninety-nine round towers" (Marry S. Potter, "Summer Sketches in Quaint Old Crecy," *The Detroit Free Press*, 11 August 1895).

60. The similarities between these two paintings were first noted in Walter Nelson-Rees and James Coran, *If Pictures Could Talk: Stories about Paintings in Our Collection* (Oakland, Calif.: WIM, 1989), 82.

61. Harrison's gravitation toward a lighter, open-air palette, his progressive attitude, and a connection to Bastien-Lepage were recognized early in American art history. See Samuel Isham, *The History of American Painting* (New York: The Macmillan Company, 1936), 440: "Like Bridgman, Alexander Harrison was also a pupil of Gérôme; but unlike him there is no trace even in his earlier pictures of his master's classical tastes. From the first he felt the fascination of the open air. His student days came at a time of enthusiasm, when for a group of the younger men, Bastien-Lepage was a name to conjure with, and when they were striving, like him, to look at nature out-of-doors with eyes unblinded by old traditions." *In Arcadia*, 1885, was featured at the Exposition Universelle and was purchased by the French government and is today in the Musée d'Orsay, Paris.

62. See Mary Hamel-Schwulst's entry on Léon Lhermitte's *La moisson* in *A Gallery of Modern Art at Washington University in St. Louis* (St. Louis: The Washington University Gallery of Art, 1994), 30, no. 7.

63. The most lucid explanation of the influence of Bastien-Lepage on American artists in Paris is to be found in William H. Gerdts, *American Impressionism* (New York: Abbeville Press, 1984), 26: "This [dilemma in training] led to what now seems an almost schizophrenic aesthetic for some Americans: solidly structured, monochromatic figure painting and brilliantly prismatic landscapes painted with amazing dash and vigor, the former created in the artists' Paris studios, the latter on summer holidays in the countryside. This dual aesthetic also accounts for the great popularity of Jules Bastien-Lepage. Among the French masters of the 1870s and early '80s, just as Impressionism first arose, Bastien-Lepage and his art represented a proper balance of academic tradition and modern concepts. Beyond his personal magnetism and his sympathetic reception to Ameri-

cans, such as J. Alden Weir, was the greater appeal of his art. Fashioned around advanced ideas of unidealized naturalism, it was devoted to monumental images of the downtrodden peasant. Bastien-Lepage's figures were solidly constructed but in no way formulaic, and, while his space was carefully defined, he utilized the modern devices of a high horizon and plunging perspective. He was modern, too, in posing his subjects naturally, outdoors, in one overall illumination. As with space, so with technique: he represented a compromise between academic finish and blatant painterliness." Following on Gerdts, the Bastien-Lepage–Guy Rose connection appears in Ilene Susan Fort, "The Cosmopolitan Guy Rose," in William H. Gerdts and Patricia Trenton et al., *California Light, 1900–1930* (Laguna Beach, Calif.: Laguna Art Museum, 1990).

64. Ilene Susan Fort, "The Figure Paintings of Guy Rose," *Art of California* 4, no. 1 (January 1991): 48.

65. See Fort, "Cosmopolitan Guy Rose," 95–96.

66. Gerdts, *Monet's Giverny*, 73.

67. C. F. Sloane, "Mr. Rose's Paintings," *Los Angeles Herald*, 13 October 1891.

68. Sloane, "Mr. Rose's Paintings." The nature of Rose's relationship with Monet has been a question mark to American art scholars. Fort clarified this essential point: "Rose need not have been an intimate of Monet to have felt his influence" ("Cosmopolitan Guy Rose," 97). Indeed, one might well argue that there are students of Monet working today though the artist is dead—artists learn as much or more from looking as they do from being criticized. Ethel Rose, Guy's wife, stated that Guy did not study with Monet (*Laguna Life*, 27 October 1922), and she meant study in some kind of formal way. None of the Giverny artists studied with Monet formally. However, she also makes it very clear that her husband did know Monet personally: "I do not know of any American painter in Giverny, except [Frederick William] MacMonnies and ourselves, who ever knew Monet socially."

69. Sloane, "Mr. Rose's Paintings."

70. Moure, *Loners, Mavericks, and Dreamers*, 63.

71. None of these portraits are located. One seen years ago by Roy Rose was subsequently destroyed. Interview with Roy Rose, September 1994.

72. Rose, *Sunny Slope*, 196.

73. DuMond's 1893 address is recorded in a letter to Helen Xavier, DuMond Papers, AAA, roll 53, frames 859–61. Also see DuMond to Xavier, frame 991: "My right hand neighbor came in and helped to eat one of the pies while we read a little from Browning." As noted in this essay, Rose later titled one of his paintings *By the Fireside*, after a Browning poem.

74. Notable among the books to which Rose contributed illustrations is the fifteen-volume *Writings of Bret Harte* (Boston and New York: Houghton, Mifflin and Company, 1899). The publishers noted that they had invited the aid of "artists familiar with the type of character illustrated by Mr. Harte" (1:vi). Early in his career, Harte set his adventure stories in California and by 1871 was one of the most popular writers in America.

75. Harding's "Rulers of the Mediterranean" appeared in *Harper's Weekly* 37 (July–August 1893).

76. Guy's family, however, was from a Roman Catholic background, common mainly in Bavaria and Southern Germany. Interview with Roy Rose, September 1994.

77. For Rose entries in the 1893 World's Fair and for an overview of American art at the Fair, see Carolyn Kinder Carr and Robert W. Rydell et al., *Revisiting the White City: American Art at the 1893 World's Fair* (Washington, D.C.: National Museum of American Art and National Portrait Gallery, The Smithsonian Institution, 1993).

78. Hitchcock, *The Art of the World*, 4:145.

79. "Art for the Fair," *San Francisco Chronicle*, 18 February 1893: "The report of the jury appointed to select pictures to be sent to the World's Fair has been completed, and was sent in by Arthur Mathews yesterday. The committee consisted of William Keith, chairman, A. F. Mathews, A. Joullin, F. Happersberger, Mary Curtis Richardson, all of this city, W. F. Jackson of Sacramento and Guy Rose of Los Angeles." McCormick also exhibited *Old San Luis Rey Mission*, no. 703 in the *World's Columbian Exposition Official Catalogue of Fine Arts* (Chicago: W. B. Gonkey Company, 1893).

80. *Joseph Asking Shelter for Mary*, listed as no. 388 in *Catalogue of the Sixty-seventh Annual Exhibition, Jan. 10, 1898, to Feb. 22, 1898* (Philadelphia: The Pennsylvania Academy of the Fine Arts, 1898), illustrated 47.

81. See Andersen, *DuMond*, 29.

82. *Christ and the Fishermen, Monastic Life*, and *The Holy Family*. See Carr and Rydell, *Revisiting the White City*, 237. Like Rose, DuMond was apparently not religious in the conventional sense: "DuMond was not an overtly religious man, at least in the sense of organized religion (which he referred to as 'superstition'), but he was fascinated by the life of Christ and traveled extensively in the Holy Land" (Andersen, *DuMond*, 6).

83. *The Complete Works of Percy Bysshe Shelley*, ed. Roger Ingpen and Walter E. Peck (New York: Gordian Press, 1965), 358.

84. "The 'moth' lies prone on the floor, her wings scorched, before an open fire that lights one side of the figure" (Antony Anderson, "A Biography of Guy Rose," in *Catalogue of the Guy Rose Memorial at the Stendahl Art Galleries* [Los Angeles: Stendahl Art Galleries, 1926], 9).

85. See Carr and Rydell, *Revisiting the White City*, 337. Of related interest to Rose and *The Moth* is Albert Pike Lucas's *Music*, 1891, also exhibited in the Chicago World's Fair. See *Revisting the White City*, 281. As noted above, Lucas was a regular dinner companion of Rose's in Paris. His unlocated painting *Music* depicts a full-length nude woman in front of a harp. A rather shallow allegory, Lucas's painting was undoubtedly known to Rose and was one more contemporary example of a female nude figure used allegorically.

86. For a discussion of *The Moth* based narrowly on current gender studies, see Bram Dijkstra, "The High Cost of Parasols," in Gerdts and Trenton, *California Light*, 43: "This woman [*The Moth*], we are clearly meant to understand, is paying the price for her ambition. Like a moth, she flitted too close to the fire of masculine power and was burned. Rose depicted her as she lay, scorched by her sins, helplessly waiting for the inevitable end." Also of related interest to both Vedder's painting and Rose's is Stephen Vincent Benét's short story *The Devil and Daniel Webster* (Weston, Vt.: The Countryman Press, 1937), in which a soul collected by the devil is described as "something that looked like a moth."

87. "Mr. and Mrs. Guy Rose Return," *Los Angeles Herald*, 5 February 1895.

88. Rose's illustrations accompanied John M. Howells, "An Architect at the Gates of the Beaux-Arts," *Harper's Weekly* 38, no. 1893 (22 December 1894): 1222.

89. The registration of Ethel Boardman's name is illegible, but her age at the time, twenty-two, and her home of Providence are both recorded. She left the Baudy on 1 June 1894, the same day as Rose.

90. Although linking Rose's later problems with lead posioning to his childhood accident must remain speculative, sufficient literature exists to make such a connection plausible. See Joshua M. Farber, Mahvash Fafii, and David Schwartz, "Lead Arthropathy and Elevated Serum Levels of Lead after a Gunshot Wound of the Shoulder," *American Journal of Roentgenology* 162 (February 1994): 385–86; Dr. William J. Meggs et al., "The Treatment of Lead Poisoning from Gunshot Wounds with Succimer (DMSA)," *Clinical Toxicology* 32, no. 4 (1994): 377–85; Vincent Fiorica and J. E. Brinker, "Increased Lead Absorption and Lead Poisoning from a Retained Bullet," *Oklahoma State Medical Association* 82 (February 1989): 63–67; and especially Mahmoud H. Aly et al., "Hemolytic Anemia Associated with Lead Poisoning from Shotgun Pellets and the Response to Succimer Treatment," *American Journal of Hematology* 44 (1993): 280–83. The introduction to this last article states: "Lead poisoning due to retained pellets from a shotgun wound is even rarer [than exposure to lead in industrial settings], but it can lead to a life-threatening toxicity. A common misconception is that retained shotgun pellets in soft tissues are harmless." My thanks to Denise E. Beaudoin, M.D., M.S.P.H., Coordinator of the Epidemiologic Studies Program for the State of Utah, for her generous assistance and insights into the complexities of toxicology. As for Rose painting in oils during his recovery, his childhood work in this medium survive in the Rose Family Collection.

91. For a recent and authoritative general discussion of lead poisoning, see Deborah A. Cory-Slechta, "Lead Poisoning," in *Handbook of Hazardous Materials*, ed. Morton Corn (San Diego: Academic Press, 1993), 411–29. For a thorough study written in Rose's lifetime, see Thomas M. Legge and Kenneth W. Goadby, *Lead Poisoning and Lead Absorption with Symptoms, Pathology, and Prevention, with Special Reference to Their Industrial Origin and an Account of the Principal Processes Involving Risk* (London: Edward and Arnold, 1912).

92. Legge and Goadby, *Lead Poisoning*, 292–93.

93. Frank Vincent DuMond to Helen Xavier, ca. summer of 1894, AAA, roll 53, frame 899.

94. DuMond to Xavier, ca. summer of 1894, AAA, roll 53, frame 733.

95. "Had a letter this morning from a friend in Paris who is coming out today with three friends—Rose is one of them—to spend the day. I wish it were Rose alone then there would be some chance of [having] a good time" (DuMond to Xavier, ca. summer of 1894, AAA, roll 53, frames 654–56). Further evidence of DuMond and Rose's friendship is that DuMond owned a painting entitled *November Morning* by Rose, which he loaned to an 1894 exhibition. See *November Morning*, no. 45, loaned by Frank Vincent DuMond, Esq., in *Loan Collection of Paintings by American Artists Exhibited at the Annual Meeting of the Union League Club, January 11, 1894*, exhibition catalogue in AAA, roll N459, frame 879.

96. "Just think of the accident which has happened to me. . . . [E]verything I had in the world was in that studio and I am afraid to sit down and think over the different things which are probably utterly ruined. . . . There too is the chest of drawers, my big easel, thousands of photographs, some of Rose's pictures and paintings and some of my brother's, too" (DuMond to Xavier, AAA, roll 53, frames 775–77). Also see "Studios Wrecked by Fire," *New York Times*, 6 August 1894.

97. DuMond to Xavier, ca. fall of 1894, AAA, roll 53, frames 801–3.

98. "Loan Exhibit," *Los Angeles Express*, 20 April 1895.

99. "Art in Los Angeles: The Exhibit Now in the Chamber of Commerce," *Los Angeles Express*, 15 June 1895.

100. Rose, *Sunny Slope*, 216.

101. For a contemporaneous account of the effects of lead poisoning on the eyes, see Legge and Goadby, *Lead Poisoning*, 158–61.

102. For Dow, see Frederick C. Moffat, *Arthur Wesley Dow (1857–1922)* (Washington, D.C.: Smithsonian Institution Press, 1977).

103. *Pratt Institute Monthly* 5 (October 1896): 22.

104. *Joseph Asking Shelter for Mary* was engraved under the title *Flight into Egypt* by Frank French as a frontispiece for *Harper's Monthly Magazine* 94, no. 559 (December 1896). The complete title of *Joseph Asking Shelter*, given in the *Pratt Institute Monthly* 5 (May 1897): 284, is *Joseph Asking for Shelter for Mary on the Journey into Egypt*. The painting illustrates the episode from Matthew 2:13: "When they had departed, behold, the angel of the Lord appeared to Joseph in a dream and said, 'Rise, take the child and his mother, flee to Egypt, and stay there until I tell you. Herod is going to search for the child to destroy him.'" There has been some confusion as to *Joseph Asking Shelter*. It was not in the Paris Salon of 1896 under the name of *Flight into Egypt*, as has been reported in other sources, and it is not a different painting than *Joseph demandant asile pour la Vierge* in the Paris Salon of 1894.

105. *Joseph Asking Shelter for Mary*, Society of American Artists catalogue, in AAA, roll N456. Rose also exhibited *Sheep Pasture* and *Wash Women*, both unlocated.

106. Fort makes the astute observation that the composition of this painting may have been influenced by the work of Arthur Wesley Dow; see Fort, "Cosmopolitan Guy Rose," 96.

107. Rose, *Sunny Slope*, 216.

108. "He was forbidden to have oil paints in the house and from 1897 to 1907 did nothing but illustrating" (Ethel Rose, biographical statement on Guy Rose, 1940, Ferdinand Perret Papers, AAA).

109. Ethel Rose, "An Afternoon in Algeria" and "Camping in Algeria," unpublished. Both articles courtesy of Roy Rose.

110. Unlocated, listed in the 1926 Stendahl Gallery *Guy Rose Memorial* exhibition catalogue as number 49.

111. Under "Names and Addresses of Artists" in the *Catalogue of the Exhibition of Fine Arts* for the 1901 Buffalo Pan-American Exposition, for example, Rose's address is listed simply as "Europe."

112. See "Mrs. Guy Rose" in Owne H. O'Neill, ed., *History of Santa Barbara County: Its People and Resources* (Santa Barbara, Calif.: The Union Printing Company, 1939), 69–70. Rose V. S. Berry reported that Ethel Rose at the time was "the highest paid woman-artist, of her kind, in the world" ("A Painter of California," *International Studio* 80 [1 January 1925]: 333).

113. Ethel Rose to Peyton Boswell, 23 January 1926, Stendahl Gallery Papers, AAA, roll 2723.

114. Though Guy was an avid hunter, in 1904 Ethel opposed the establishment of a shooting range in the quarries between Giverny and the Bois-Gérôme that would have disrupted the natural landscape. Guy may well have opposed it, too. See Claire Joyes, "Giverny's Meeting House, the Hôtel Baudy," in *Americans in Brittany and Normandy*, 102: "A petition [to prevent the establishment of a shooting range] circulated in the village signed by Monet, Alice Monet, Germaine and Albert Salerou, Mrs. MacMonnies and, at the Hôtel Baudy, by Beaudoin, Hopkins, Van Buren, West, Whitman and Ethel Rose."

115. Guy's chronic vision problems, symptomatic of lead poisoning, were exacerbated by an accident not described but noted peripherally by Monet's son-in-law, the painter Theodore Butler, in a 1904 letter to the artist Philip Hale: "The Roses were in to see us last evening and are quite well. Rose saw the oculist with whom he was much pleased on Monday and was assured that there was no glass in his eyes. He had passed a sleepless night and had had a high fever. All is well that ends well" (Theodore Butler to Philip Hale, 15 September 1904, Philip Leslie Hale Papers, AAA, roll D98).

116. Sarah Frieseke is the model in *On the River, Five o'Clock*, and *The Green Parasol*.

117. Thomas Sergeant Perry to Marion Lund Meteyard, Lilla Cabot Perry Papers, AAA, roll 4570. Yet another indication of the interwined social lives of the Giverny artists is recorded by Medora Clark, wife of Alson Clark, in a diary entry of 1 November 1910: "We were so reduced for amusement during the day that in the morning we went to Fred's [Frederick Frieseke] taking a pot-au-feu to cook over the fire, while we all played parcheesi. In the late afternoon after tea at Lawton's [the painter Lawton Parker], we all had more parcheesi and then a great fire. It grew steadly colder and in the evening we all went to the Rose's to have coffee. It was nice to have so pleasant a place to go in such rough weather. Fred and Sadie [Frieseke] were there and the Officers and we had a game of hearts, and then some good punch before going out" (Alson and Medora Clark Diaries, AAA, unfilmed).

118. In the nineteenth century, zinc oxide competed with lead white as the dominant white used in easel painting. See Rutherford J. Gettens, Hermann Kuhn, and W. T. Chase, "Lead White," in *Artist's Pigments: A Handbook of Their History and Characteristics*, ed. Ashok Roy (New York: Oxford University Press, 1993), 2:67–82. Future spectroscopic examinations of Guy Rose paintings may answer some of the questions surrounding his use of lead white after 1897.

119. Ethel Rose to Peyton Boswell, 23 January 1926, Stendahl Papers, AAA.

120. "The World of Art," *Providence Journal* (1914). Clipping from the Rose Family album, copy courtesy of Roy Rose.

121. "His [Monet's] own friends come from Paris and the outer world to see him for he has never mingled with the village crowd and has known few of them even to speak to, though every one who goes there finds out who he is at once" (Ethel Rose, "Honor to a Great Artist of France," article ca. 1920 from the Rose Family album, courtesy of Roy Rose).

122. Ethel Rose, letter to "Life and Art," *Laguna Life* 9, no. 459 (27 October 1922): 1.

123. Ethel Rose to Earl Stendahl, 23 January 1926, Stendahl Papers, AAA.

124. Another, smaller version (28 ¾ x 23 ¾ in.) of this same painting is reproduced in the 1922 Stendahl Guy Rose catalogue as number 21.

125. Guy could well have seen either in Paris or in Monet's studio yet another painting of this same bridge with the same composition, which was exhibited at the Exposition d'Art Moderne in Paris, 1912. See *Le pont routier d'Argenteuil* in Daniel Wildenstein, *Claude Monet: Biographie et catalogue raisonné* (Lausanne: La Bibliothèque des Arts, 1974), 1:250, no. 314. Likewise, Monet's composition may have been inspired by confrontation with James Whistler's *Nocturne: Blue and Gold—Old Battersea Bridge*, 1872–75, 26 x 19½ in., Tate Gallery, London.

126. On Frost in the context of Giverny, see Gerdts, *Giverny*. Also see Henry M. Reed, *The A. B. Frost Book* (Rutland, Vt.: Charles Tuttle and Co., 1967).

127. See William H. Gerdts, Diana Dimodica Sweet, and Robert R. Preato, *Tonalism: An American Experience* (New York: The Grand Central Art Galleries Art Education Association, 1982).

128. Richard Miller said to one of his Giverny students: "Art's mission is not literary, the telling of a story, but decorative, the conveying of a pleasant optical sensation" (quoted in Gerdts, *Giverny*, 184).

129. Fort has suggested that this Victorian view of women shared by the American Impressionists was threatened by industrialization and the suffrage movement, making Rose's figurative paintings a "reactionary response to the threat to traditional middle-class values" (Fort, "Cosmopolitan Guy Rose," 98).

130. A second and near-identical version of this painting is in the Bowers Museum of Cultural Art, Santa Ana, California. The model, who also appears in *The Blue Kimono*, was reported to be the very same one used by Paul Chabas (1869–1937) in his well-known painting *September Morn*, 1912?, oil on canvas, 64½ x 84¼ in., The Metropolitan Museum of Art, New York. In the Salon of 1912, this painting won a medal of honor. When exhibited later in New York, the head of the New York Society for the Suppression of Vice ordered it removed, a scandal that served to increase its fame. The original title of the Rose painting was simply *Model Resting*. The later title change may have been derived from a poem of the same title by Robert Browning (1812–1899). Browning's poem deals in part with the themes of age versus youth and the passage of time—subjects Rose had dealt with in his earlier painting *The End of the Day*. Although *By the Fireside* does not specifically illustrate any part of the Browning poem, it nonetheless represents a romantic image, as does the poem: "And to watch you sink by the fireside now / Back again, as you mutely sit / Musing by fire-light, that great brow / And the spirit-small hand propping it / Younder, my heart knows how!" (see Browning, "By the Fireside," in *Browning's Complete Poetical Works*, ed. Horace E. Scudder [New York: Houghton, Mifflin Company, 1895], 185–87).

131. Clara T. MacChesney, "Frieseke Tells Some Secrets of His Art," *New York Times*, 7 June 1914 (quoted in Gerdts, *Giverny*, 177–78).

132. *Foggy Morning, Veules*, unlocated, is reproduced as number 22 in the 1926 Stendahl *Guy Rose Memorial* catalogue.

133. "Seen in the World of Art," (New York) *Sun*, 8 January 1911. For additional reviews of this same exhibit, see *New York Globe and Commercial Advertiser*, 23 December 1910; *New York Times*, 25 December 1910; *New York Telegraph*, 21 December 1910; and *New York American*, 26 December 1910.

134. Ethel Rose, "Trout-Fishing in Normandy," *Scribner's* 54 (October 1913): 468–69.

135. Helen DuMond to Frank Vincent DuMond's parents, 26 August 1918, AAA, roll N70-75.

136. Antony Anderson, "Two Newcomers," *Los Angeles Times*, 27 December 1914.

137. Many of these titles were apparently changed by Ethel Rose and Earl Stendahl to enhance their saleability at Rose's 1922 and 1926 retrospective exhibitions, according to an interview with Roy Rose, September 1994. However, at least one, *La réponse difficile (The Difficult Reply)*, was retitled by Rose, as it appeared under that title in a show at the Los Angeles Museum in March 1918. See "Guy Rose's Impressions," *Los Angeles Times*, 31 March 1918. *Model Resting* was a title later given to a picture of a model resting on a green divan. See Antony Anderson, "Of Art and Artists," *Los Angeles Times*, 10 August 1919.

138. See Antony Anderson, "Guy Rose in Pasadena," *Los Angeles Times*, 21 March 1915, for descriptions of these paintings.

139. Ibid.

140. Willard Huntington Wright, "Los Angeles: Land of the Chemically Pure," *Smart Set* (March 1913): 107–14.

141. Willard Huntington Wright, *Modern Painting: Its Tendency and Meaning* (New York: John Lane, 1915).

142. Edwin Arthur Hunt, "The Wright Criterion," *Out West Magazine* 43, no. 4 (April 1916): 161.

143. Rose, "The World of Art."

144. The two paintings were *The Backwater* and *November Twilight* listed in *Catalogue of the Department of Fine Arts, Panama-Pacific International Exposition* (San Francisco: The Wahlgreen Company, 1915).

145. See Antony Anderson, "Portrait of Miss Del Valle," *Los Angeles Times*, 13 June 1915: "Guy Rose has just finished at his studio in Alhambra a remarkable portrait of Miss Lucretia del Valle in the character of Signora Josefa Yorba, the part which she is giving in 'The Mission Play' at San Gabriel, and which she has been rendering for several seasons."

146. Frank Vincent DuMond, quoted in "Exhibition of Guy Rose's Pictures at the Ambassador," *Laguna Life* (30 September 1921): 3.

147. Antony Anderson, "Paintings by Guy Rose," *Los Angeles Times*, 20 February 1916. For another review of this same show, see *The Museum Graphic* (19 February 1916), clipping in the Natural History Museum of Los Angeles Scrapbook for 1915–17.

148. Ethel Rose, [title obscured], *The Graphic* (26 February 1916), clipping in the Natural History Museum of Los Angeles Scrapbook for 1915–17.

149. Antony Anderson, "Juries and Other Fetiches," *Los Angeles Times*, 5 March 1916.

150. Rose to Antony Anderson and the *Los Angeles Times*, 12 March 1916. Anderson's "Fetich" article prompted many local artists to respond to the jury system, some in accord with Anderson, others not. Helena Dunlap wrote: "I am sure the jury did the best they knew how, and they were all broad, big men with no petty jealousies." By contrast, Jean Mannheim wrote: "I have read your article in this morning's Times, and wish to congratulate you. It is splendidly written, and it is just" (both letters *Los Angeles Times*, 12 March 1916).

151. "Summer Exhibitions," *Bulletin of the Art Institute of Chicago* (October 1916): 204.

152. Mabel Urmy Seares, "Modern Art and Southern California," *American Magazine of Art* 9, no. 2 (December 1917): 63.

153. Rose to William Macbeth, 5 April [1917?], Macbeth Gallery Papers, AAA, roll 2628.

154. *Laguna Eucalyptus* almost certainly dates from 1917. It first appeared in an exhibition at Macbeth's in February 1918 and was sold by Macbeth for three hundred dollars the next month.

155. Rose to Macbeth, 5 April 1917, Macbeth Gallery Papers, AAA, roll 2628.

156. See *Six Early Women Artists: A Diversity of Style* (Carmel, Calif.: Carmel Art Association, 1991), 77.

157. Antony Anderson, "In the Realm of Art," *Los Angeles Times*, 30 June 1918.

158. See especially Monet's *Pyramides de Port-Coton, mer sauvage*, 1886, 25¼ x 31½ in., in the Pushkin Museum, Moscow (W. 1084), and related works in this series, for an interesting comparison with Rose's Point Lobos paintings. Both focus on unusual, but well-known, rock formations in the sea as viewed from above. Furthermore, the *pyramides* at Port-Coton physically resemble the rocks jutting out from the Pacific at Point Lobos.

159. "We had one afternoon of Guy Rose & his wife. They are spending the summer not far from here on the other side of New London & we have asked them to come over & visit us in September" (Helen DuMond to Frank Vincent DuMond's parents, 26 August 1918, AAA, roll N70-75).

160. For reproductions of both paintings, see Antony Anderson and Peyton Boswell, *Catalogue of the Guy Rose Memorial*, exh. cat. (Los Angeles: Stendahl Galleries, 1926).

161. Described in Antony Anderson, "Landscapes by Guy Rose": "There is a stretch of light spring verdure in 'A Sierra Mountain Trout Stream,' and beyond it the gray-pink of mountains that hold snow in their ridges while the foreground shows a surging mass of purple flowers and willows over a greenish stream."

162. On the Ten, see *Ten American Painters* (New York: Spanierman Gallery, 1990).

163. On the Ten Painters Club of California, see Antony Anderson, "Of Art and Artists," *Los Angeles* Times, 10 August 1919. The ten painters were Maurice Braun, Benjamin Chambers Brown, R. Clarkson Colman, Edgar Payne, Hanson Puthuff, Guy Rose, Jack Wilkinson Smith, Elmer Wachtel, Marion Kavanaugh Wachtel, and William Wendt.

164. Illustrated in Berry, "A Painter of California," 332.

165. Rose to James T. Harwood, ca. 1920 (courtesy of Mrs. Ione Harwood, Honolulu).

166. Listed in the 1926 Stendahl *Guy Rose Memorial* catalogue as number 83, with this caption: "Bequeathed to the National Arts Club of New York, of which Mr. Rose was a life member. Awarded the Harrison prize for best picture in the exhibition at Exposition Park, Los Angeles, 1921."

167. This painting and other works by Guy Rose were deaccessioned from the Los Angeles County Museum of Art in a 1977 Sotheby Parke-Bernet sale to benefit new acquisitions. See Sotheby's, Los Angeles, sale no. 217, 7–9 November 1977. The paintings included *Carmel Coast*, no. 243; *Springtime in Normandy*, no. 233; *Jade Beads*, no. 251; *La réponse difficile*, no. 323; and *Bowling on the Riviera*, no. 365.

168. Berry, "A Painter of California," 332–34, 336–37.

169. "Death Takes Guy Rose Today," *Pasadena Star News*, 17 November 1925.

PLATES

IN FRANCE

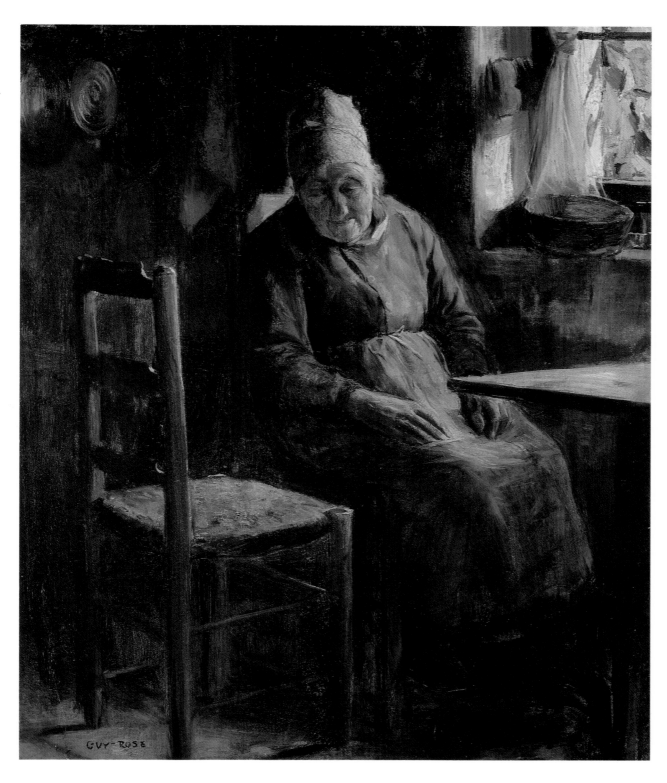

La Mère Pichaud, ca. 1890. Oil on canvas, 18 x 16 in. Private collection.

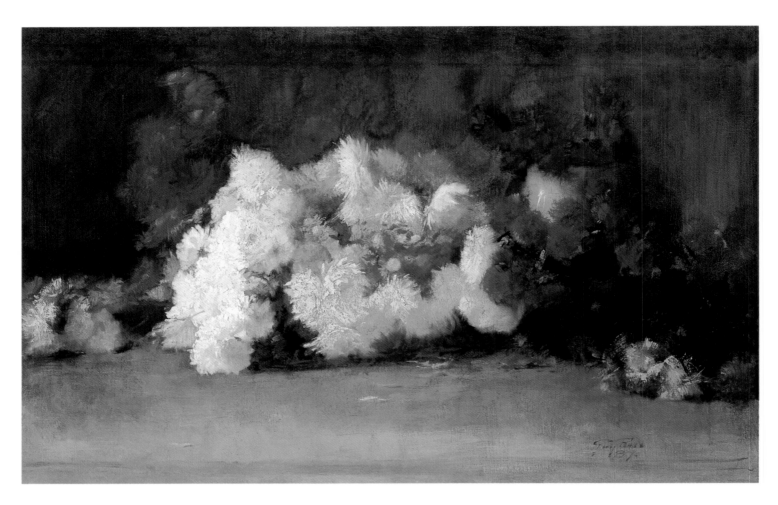

Chrysanthemums, 1887. Oil on canvas, 23 x 36 in. Private collection.

Plums, 1889. Oil on canvas, 12¾ x 21½ in. Rose Family Collection.

Tamarisk Trees in Early Sunlight, n.d. Oil on canvas, 24 x 29 in. Dr. James Zidell Collection.

October Morning. Oil on canvas, 24 x 29 in. Private collection.

Provincial Olive Orchard. Oil on canvas, 15 x 18 in. Joan Irvine Smith.

Late Afternoon Giverny, ca. 1910. Oil on canvas, 23¾ x 28¾ in. San Diego Museum of Art, Museum Purchase.

Blossoms and Wallflowers. Oil on canvas, 21 x 24 in. Mr. and Mrs. Thomas B. Stiles II.

The Old Church at Cagnes. Oil on canvas, 24 x 20 in. Courtesy Trotter Galleries, Carmel.

Springtime in Normandy. Oil on canvas, 24 x 29 in. Private collection.

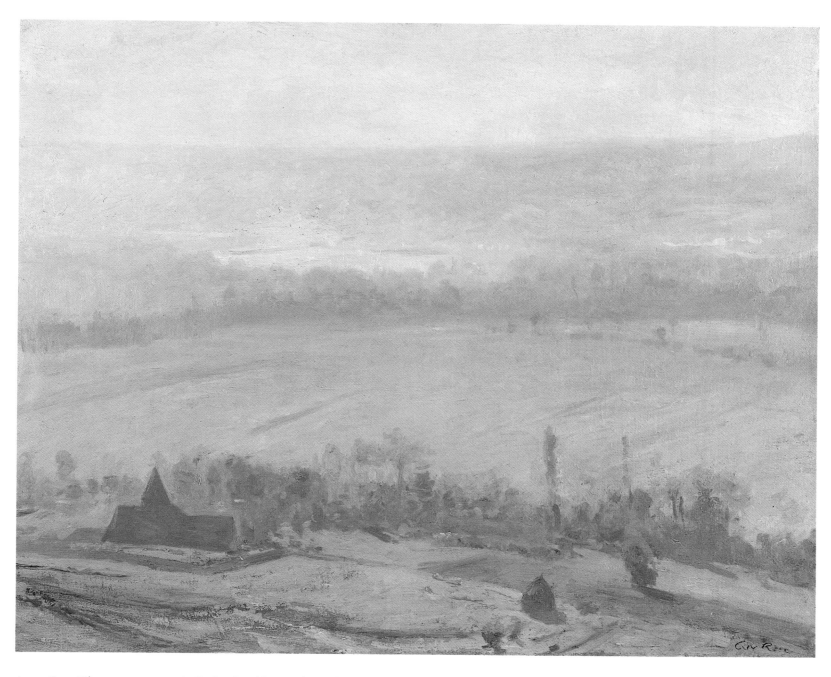

August Noon. Oil on canvas, 24 x 29 in. Paul and Kathleen Bagley Collection.

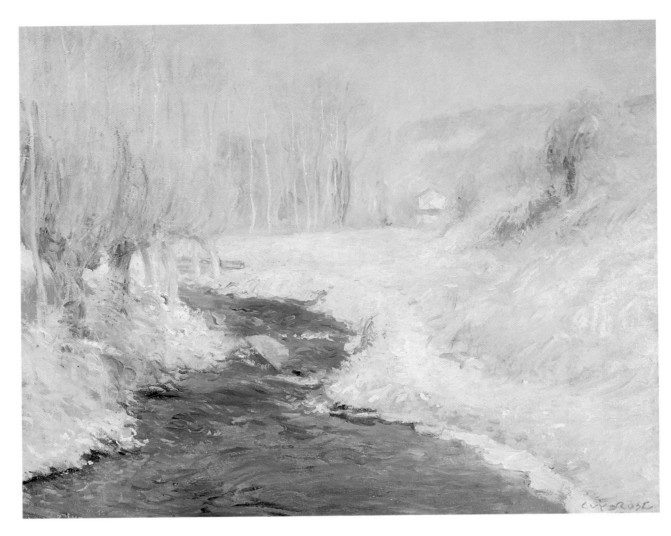

Hiver (Winter). Oil on canvas, 24 x 29 in. Rose Family Collection.

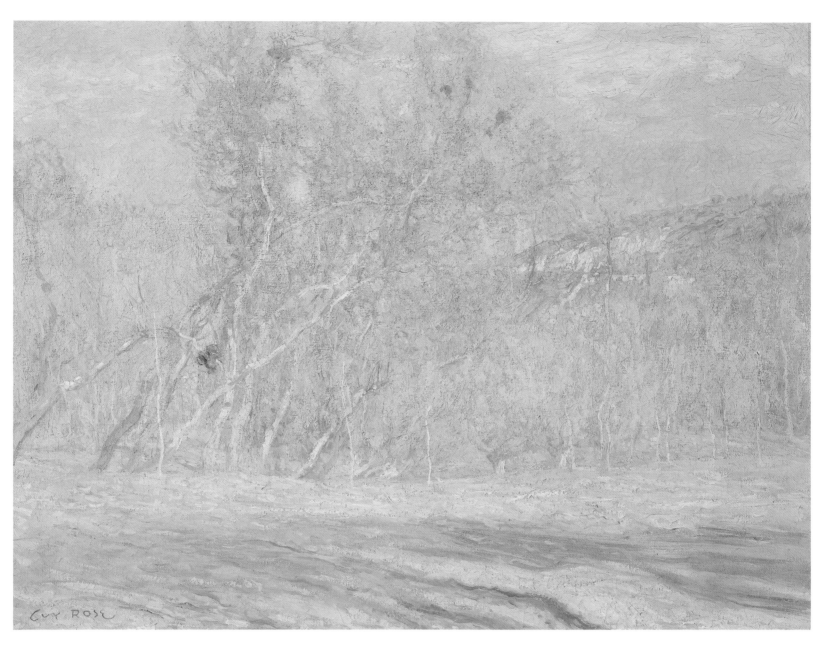

Printemps (Spring). Oil on canvas, 24 x 29 in. Rose Family Collection.

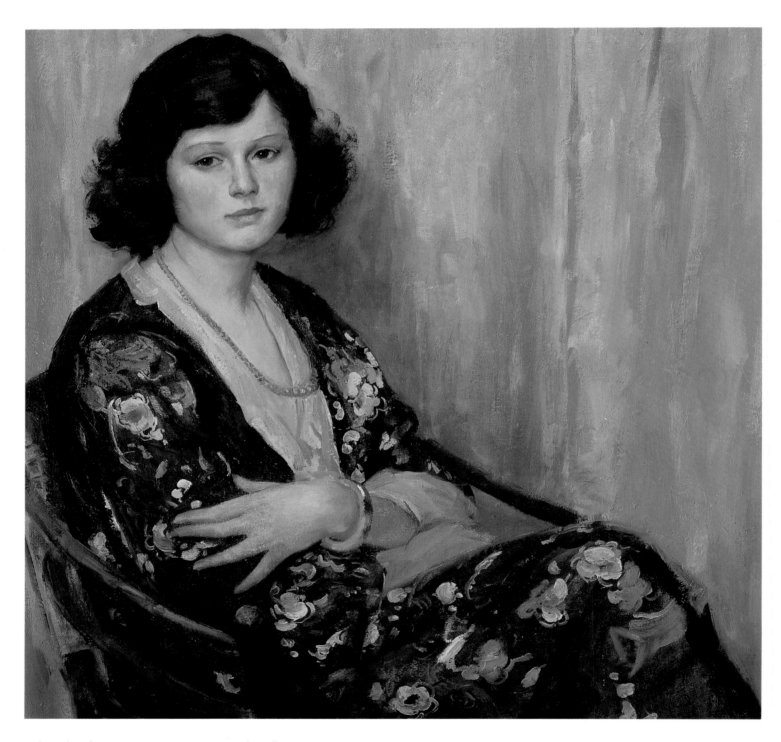

Jade Beads. Oil on canvas, 24 x 24 in. Rose Family Collection.

The Lavalier. Oil on canvas, 30 x 24 in. Rose Family Collection.

Morning Mist, n.d. Oil on canvas, 24 x 29 in. George Stern Fine Arts, Los Angeles, California.

Morning Mist (Late Spring), n.d. Oil on canvas, 24 x 29 in. Private collection.

French Farm, n.d. Oil on canvas, 24 x 29 in. Rose Family Collection.

Miss C. Oil on canvas, 11¼ x 8¼ in. Rose Family Collection.

The Model. Oil on canvas, 24 x 20 in. The Buck Collection.

Standing Nude, n.d. Oil on canvas, 28 x 15 in. The Buck Collection.

GUY ROSE AND THE
LOS ANGELES ART COMMUNITY

Guy Rose

AND THE LOS ANGELES ART COMMUNITY, 1914–1925

Jean Stern

GUY ROSE WAS BORN IN SAN GABRIEL, a small town approximately ten miles west of Los Angeles. Rose grew up on Sunny Slope, the family ranch, and attended Los Angeles High School, graduating in 1884. He left to study in San Francisco in 1885, went to Paris in 1888 to continue his studies, and, except for occasional visits home, he remained either in New York or in France until his return to Los Angeles in 1914. From 1914 until his stroke in 1921, he remained in California, painting throughout the state. He died in Pasadena, in 1925.

During the twenty-six years between 1888, the year Rose left for Paris, and 1914, the year of his permanent return, California underwent a series of remarkable transformations, social, economic and artistic. The transitions parallel in many ways the transformation that Rose experienced in France: from conventional to cosmopolitan; from academic to Impressionist. Rose was not the same artist when he returned and California was not the same region he had left.

California once had a large number of native inhabitants. Although European contact occurred in the mid-1500s, it was not until the late 1700s that California experienced an influx of Spanish colonizers. The Spanish flavor stayed with the Mexican era into the early 1800s. Soon thereafter, in spite of restrictive measures, Americans began to enter the region. The Americanization of California accelerated in the mid-1800s, the greatest catalyst being the Gold Rush of 1849, leading almost immediately to statehood the following year.

From the onset, San Francisco was the social and intellectual center of California. In the mid-nineteenth century, the port of San Francisco was the debarkation point for miners, merchants, bankers, and immigrants, all seeking to benefit from the gold fields, and it was the embarkation point for the tremendous quantity of gold that was generated from the mines.

In the 1860s and 1870s, at the time that Impressionism flowered in France, California was yet a distant, isolated region, hazardous and time-consuming to reach. The initial transcontinental railroad, the Union Pacific, was completed in 1869 with its western terminus at San Francisco. Prior to the completion of the Union Pacific, the only approaches to California were overland by horse and wagon through hostile territory, or by ship from Panama or around South America. The pre-canal Panamanian route necessitated docking on the Atlantic side, crossing the isthmus to the Pacific side, and boarding another ship to continue to California.

San Francisco grew from the ensuing trades and businesses that accompanied the effects of the Gold Rush and soon developed an artistic community. The direction and quality of artistic and cultural matters tend to be determined by the patrons who support those activities. Patronage in mid-nineteenth-century San Francisco demanded art that mirrored European canons, especially current French modes. The dominant style in France, and indeed in upper-class America, was a derivative of the French Beaux-Arts or Salon style. Paintings of this type were frequently large, pretentious historical and figural compositions, well suited for the grandiose homes of the San Francisco elite.

By the 1880s, the ascendancy of the French Barbizon style, enhanced in America by the influence of the later Hudson River school painters, affected an entire generation of Northern California landscape painters. California Barbizon works, by artists such as William Keith (1839–1911), Jules Mersfelder (1865–1937), and Julian Rix (1851–1903), were characteristically dark, moody pastorals, set in forest glades, often with figures tending small flocks of cattle or sheep.

Radiating from San Francisco, the railroads steadily edged south toward the emerging cities of Santa Barbara, Los Angeles, and San Diego. In 1876, the Southern Pacific completed a route between San Francisco and Los Angeles. In 1885 the Santa Fe opened a railway from Los Angeles through the southwest to Chicago. This route was not subject to winter closures as was the Union Pacific railway that traversed the Rocky Mountains. The installation of the Santa Fe track resulted in cheap and quick availability of transportation into Southern California. With a commercially viable link connecting the developing agricultural areas of Southern California to markets in the East, Los Angeles experienced a land boom. Within a few years, the population of Los Angeles increased from about 10,000 to over 100,000 with the arrival of large-scale agricultural and industrial activity.

With the growth of population of the early 1880s, Los Angeles began to attract professional artists. By the late 1880s, several artists were already permanent residents. Among the most prominent were John Gutzon Borglum (1867–1941) and his wife, Elizabeth Putnam Borglum (1848–1922), Elmer Wachtel (1864–1929), and John Bond Francisco (1863–1931).

John Gutzon Borglum trained in Los Angeles and San Francisco and painted large narrative works in the Barbizon style depicting California in the accepted conventions of the day. One such series of his paintings dealt with stagecoaches. Borglum would later turn to sculpture and be best known for

Elmer Wachtel (1864–1929), *Santa Paula Valley,* ca. 1903. Oil on canvas, 30 x 40 in. The Irvine Museum, Irvine, California.

the monumental presidential portraits carved on Mount Rushmore.

His wife, Elizabeth Borglum, first came to Los Angeles in 1881. She was known as Elizabeth Jaynes Putnam, or Mrs. J. W. Putnam before she married Borglum in 1889. She likewise worked in the Tonalist-Barbizon esthetic. She had studied art in San Francisco, with William Keith in 1885, and J. Foxcraft Cole (1837–1892) in 1887, both of whom were well entrenched in the Tonalist-Barbizon style. She and Gutzon sketched throughout Southern California, painting landscape and pastoral scenes.

Elmer Wachtel was at first very much a Tonalist, showing moody and poetic landscapes in dark tones. As he progressed, he accepted much of the Impressionist aesthetic and significantly brightened his palette. Many of his mature works show a more decorative and lyrical style, very reminiscent of Arthur Mathews (1860–1945), the San Franicsco landscape and figure painter who influenced a generation of Northern California painters, although Wachtel did not include figures in his compositions.

J. Bond Francisco arrived in Los Angeles in 1887. Munich trained, he produced landscapes and western genre subjects in a Barbizon palette that brightened with time with elements from Impressionism.

In 1885, when Rose left Los Angeles to study at the California School of Design in San Francisco, Impressionism was largely an unknown style in California. Of the three artists with whom Rose studied in San Francisco—Virgil Williams (1830–1886), Warren E. Rollins (1861–1962), and Emil Carlsen (1853–1932)—it was the latter who made the more demonstrable impression on the pupil. Williams was the director of the

School of Design. He was decidedly academic in his training and style. A product of Paris and Rome, his works are principally figural subjects, often in classical landscapes. They are well drawn and exhibit a high level of technical virtuosity and craftsmanship. Rose could not have studied with Williams long, since the teacher died within the first year of Rose's enrollment at the school. Rollins was himself a recent student of Williams and served as assistant director at the school. Rollins would later establish himself as a successful western painter, living and working in Taos and Santa Fe.

Emil Carlsen had the most influence on the young Rose. Carlsen also was academic in training, by way of the Danish Royal Academy in Copenhagen, but his specialty was the still life. The majority of student paintings by Rose, dated between 1886 and 1888, are still lifes. These works are highly crafted, elegantly composed paintings, showing a keen eye for detail and a sure hand for drawing. By no means Impressionist efforts, these somber paintings show great care in the application of paint and brush. As art students are usually a reflection of their favorite teacher, Rose, in his emulation of Carlsen, would likely be classified as an "academic-realist," evoking both the classical master of still-life painting Jean-Baptiste-Siméon Chardin (1699–1779) and the definitive realist Henri Fantin-Latour (1836–1904).

Rose continued his studies in Paris, taking classes at the Académie Julian, from 1888 to 1889. Rose's still lifes from this period differ from his San Francisco pieces in that they show a greater degree of craftsmanship, with convincing treatment of surface textures and light. Additionally, Rose turns to more sophisticated brushwork, preferring glazes and showing areas of smooth, glasslike surfaces.

Carmel Dunes, n.d. Oil on canvas, 24 x 29 in. Los Angeles County Museum of Art, Gift of Mr. and Mrs. Reese H. Taylor.

Realist, and more so romantic-realist, best describes Rose's oeuvre associated with his Paris exhibition days. His entries in the Salon of 1890, *La ménagère (The Housewife)* and *Le lutin (The Elf)*, and for 1891, *La fin de la journée (The End of the Day)* and *Les ramasseuses de pommes de terre (The Potato Gatherers)* emphasize the nobility of farm life and are firmly in the tradition of French realism.

Realism was a philosophical, literary, and artistic movement whose goal was to give a truthful, objective, and impartial representation of the real world, based on meticulous observation of contemporary life. In painting it is best illustrated by the French artists Gustave Courbet (1819–1877) and Jean-François Millet (1814–1875). Their work was first and foremost concerned with nature and dealt with life in rural France.

Coming in the mid-1800s, at the height of the consequences of the Industrial Revolution, with its attendant mass urbanization, environmental pollution, and social transformations, realism harkened to the idyllic life of the immediate past, to a time real or imagined when people were in harmony with nature and its bounty. It was a movement to democratize art, in step with other midcentury demands for social and political democracy. Declaring that art must have relevance to contemporary society, the realists refused to paint moralistic or heroic models from the past and instead directed their thoughts to themes that acclaimed people and events in more commonplace circumstances and in their own time.

One noteworthy group of romantic-realist painters focused on the French landscape. They imbued their works with an active brushstroke and a dramatic sense of light, most often energizing their compositions with vivid end-of-the-day sky effects. These artists, notably Théodore Rousseau (1812–1867) and Narcisse Diaz de la Peña (1807–1876), lived and painted in the village of Barbizon, thus giving a name to this aspect of realism, romantic model of nature and people coupled with dramatic lighting. The Barbizon style found a quick and willing group of followers in late-nineteenth-century Europe and America.

Yet, at the same time that Rose was competing in Salon exhibitions and echoing traditional subject matter and technique, he was curious about the "radical fringe" of French art: Impressionism. Between 1890 and 1891, he was in Giverny on at least two occasions, where he came in contact with Claude Monet.

The 1890s saw the first encroachment of Impressionism in California. The English-born William Lees Judson (1842–1928) came to Los Angeles in 1893 in search of a healthful climate. Judson lived in the Arroyo Seco, a wooded valley that runs between Los Angeles and Pasadena that was home to the area's artists and intellectuals. He taught at the Los Angeles School of Art and Design and began to paint landscapes in the Impressionist style. In 1896 he joined the faculty of the University of Southern California and in 1901 founded and was the first dean of its School of Fine Arts. An originator of the Craftsman movement in Southern California, he also worked in stained glass and other arts and crafts.

Benjamin C. Brown (1865–1942) came to Los Angeles to visit and sketch as early as 1886, settling as a permanent resident in 1896. After finding few patrons for his portraits, Brown turned to painting landscapes in a daring, vigorously impressionistic style. An outspoken proponent of his art, Brown pursued a long and active career as one of California's boldest Impressionists.

With the turn of the century, when Impressionism had only recently become an accepted American style, Southern California experienced an influx of young artists, most of whom had been trained in that style and had never known any other. The period from 1900 to 1915 marks the flowering of California Impressionism. The Panama-Pacific International Exposition of 1915, in San Francisco, was both the last great Impressionist show in America and the first major Impressionist exhibition in California. The exposition brought to California the major figures of American Impressionism. William Merritt Chase (1849–1916), Childe Hassam (1859–1935), Edmund Tarbell (1862–1938), and Edward Redfield (1869-1965), among others, were given individual galleries in which to hang their works. The Grand Prize went to Frederick Frieseke (1874–1939), Rose's friend and neighbor in Giverny, and the Medal of Honor to Willard Metcalf (1858–1925), a consummate Impressionist. The impact of the exposition on the California painters was tremendous and immediate.

Nineteen fifteen also marks the beginning of San Diego's professional artist community. In competition with San Francisco, San Diego likewise marked the opening of the Panama Canal with an exposition, the Panama-California Exposition, held in the newly constructed Balboa Park. Only one exposition could use the designation "International" and San Francisco's bid for the title was successful. Both expositions were extended for the following year, creating a rich source of confusion for scholars and trivia aficionados. In 1916, the "International" designation was in turn awarded to San Diego and

Franz A. Bischoff (1864–1929), *Arroyo Seco Bridge,* ca. 1915. Oil on canvas, 30 x 40 in. The Irvine Museum, Irvine, California.

the appellations were "Panama-Pacific Exposition" for San Francisco, and "Panama-California International Exposition" for San Diego.

Much has been offered about the desirability of the Southern California climate, with its generous number of sunny days, as motivation for the advent of Impressionism in the southern part of the state. Likewise, the southward migration caused by the San Francisco earthquake of April 1906 was significant. If both factors exerted considerable influence, however, the chief motivation was surely economic opportunity. Los Angeles, at the time not having an ingrained artistic establishment, became the alternative metropolitan center that absorbed the infusion of young artists in California in the late nineteenth century.

Among the important artists who came to Southern California in the first ten years of the twentieth century, one can count the cream of the California style: Granville Redmond (1871–1935), Hanson D. Puthuff (1875–1972), Marion Kavanagh Wachtel (1876–1954), William Wendt (1865–1946), Franz A. Bischoff (1864–1929), Jack Wilkinson Smith (1873–1949), George Gardner Symons (1862–1930), Jean Mannheim (1863–1945), and Maurice Braun (1877–1941). In addition, Edgar Payne (1883–1947) and Elsie Palmer Payne (1884–1971) were making frequent visits to Los Angeles and Laguna Beach, and, by 1914, with the return of Guy Rose and the arrival of Donna Schuster (1883–1953), the stage was set for one of the most remarkable and distinctive schools of regional American art.

The Roses arrived in Los Angeles sometime in October 1914, initially living with Guy's sister Daisy Montgomery, on Orange Street in Los Angeles. In January 1916 the Roses listed their address as 30 North Chapel Street, Alhambra, a small community favored by artists in the San Gabriel Valley. The next year, they moved to Pasadena, where they remained for only one year at the time. When Guy suffered his stroke, on 2 February 1921, they were living in Pasadena, at 303 North Fair Oaks Boulevard. In 1923, they settled into the house at 676 La Loma Road. It was there that Guy died, on 17 November 1925. Ethel continued to live at La Loma Road for many years thereafter.

Rose's prominence as an artist had preceded him to Los Angeles. Indeed, his status as an known Impressionist, a friend of Claude Monet, with a long list of exhibitions and awards in prestigious exhibitions in both Europe and in the United States, made him a figure of near-reverence to other members of the Los Angeles art community. Had it been any other important artist who chose to live in Los Angeles, the attention would have been considerable, but this was a Native Son, who had returned in triumph to the outstretched arms of a devoted following.

Almost immediately upon his return to Los Angeles, Rose was asked to serve on the board of governors of the Los Angeles Museum of History, Science and Art, the grand old institution in Exposition Park which housed the art museum until a separate art museum was built on Wilshire Boulevard in the early 1960s. Rose accepted the post and served until 1922.

Soon after his arrival, Rose accepted the position of instructor at the Stickney Memorial School of Art, in Pasadena. The Stickney School had its genesis in the Shakespeare Club, a

Guy Rose, *Arroyo Seco*. Oil on canvas, 23½ x 28½ in. The Fieldstone Collection.

Alson Skinner Clark (1876–1949), *Medora on the Terrace,* 1920. Oil on canvas, 36 x 46 in. Private collection.

women's reading club founded in 1888 in a building offered rent-free by Miss Susan Stickney. In 1899 a wing was added for special exhibitions and called the Stickney Memorial Art Hall. It was a fashionable space for well-attended art lectures and exhibitions. The concept continued with great popularity until 1912, when the hall was turned into a permanent art school, with Channel P. Townsley (1867–1921) an able administrator and well-regarded Impressionist painter in his own right, as director, and Jean Mannheim as instructor. In 1914, it underwent reorganization and Guy Rose replaced Mannheim as instructor.

Rose continued as instructor at Stickney until 1918, when he became director of the school. The previous director, Channel P. Townsley, moved on to become director of the newly founded Otis Art Institute in Los Angeles. Rose's old friend from France, Alson S. Clark (1876–1949), arrived in Pasadena in 1920, and accepted the position of instructor at the school.

Clark was a Chicago artist who had studied with William Merritt Chase before continuing his education in Paris. A confirmed Impressionist, Clark established himself in Paris and earned a distinguished reputation as an artist. He had met Rose through a mutual friend, Frederick Frieseke, who lived in Giverny and had been a neighbor of Rose. The three artists were among a small group who exhibited together in New York as the Giverny Group, in 1910. Clark visited California in 1919. He had suffered temporary hearing loss in one ear as a result of his activities in the U.S. Navy during World War I, and his doctor recommended a stay in a warm climate. Clark loved California and opted to settle permanently in Pasadena.

The Stickney Memorial School of Art cannot be considered on a par with the other Los Angeles area art schools of the time, notably the Art Students League of Los Angeles, founded by Hanson D. Puthuff in 1906, or the Otis Art Institute, formed in 1918. At the time that Rose was director, the Stickney School offered only a costume class, with painting and drawing from the costume model; a life class, with drawing and painting from a nude model; and a children's class, offered on Saturday mornings. Moreover, the school did not grade pupils or insist on a "time limit" for work.

Rose's affiliation with the Stickney School was ideal. It gave him a distinguished association with the Pasadena art community, both as a socially prominent member and as an esteemed artist, a connection surely not lost on the well-to-do art patrons of that city. Its less than rigorous schedule allowed him ample time for planning and participating in numerous exhibitions of his work. Furthermore, it allowed him great liberty to travel and paint throughout California.

In 1915 Rose participated for the first time in the annual exhibition of the California Art Club. Formed in 1909, the California Art Club was the largest and most influential art organization in Los Angeles. Nearly every professional artist in Southern California was a member of this club. William Wendt, perhaps the most important landscape painter of the plein-air style, became its president in 1911, a post he held for six years. In 1913 the club moved its annual exhibition site to the newly opened Los Angeles Museum of History, Science and Art. Rose sent one or two entries every year until 1922.

The singular benefits of having a nationally known artist living in the neighborhood were explicitly understood by the local art museum. The Los Angeles Museum of History, Science and Art invited Rose to mount a solo show of his works in February 1916. The show, numbering twenty-one paintings, included several figure studies, as well as landscapes from

111

William Wendt (1865–1946), *Vibrant Coast (Dana Point),* ca. 1903. Oil on canvas, 24 x 36 in. The Irvine Museum, Irvine, California.

France, particularly Giverny, and Laguna Beach. Rose held further solo shows at the museum in 1918 and 1919.

In the summer of 1918 a group of Southern California artists formed the Laguna Beach Art Association. These artists, including Mabel Alvarez (1891–1985), Charles Percy Austin (1883–1948), Franz A. Bischoff, Frank Cuprien (1871–1948), Anna A. Hills (1882–1930), Edgar A. Payne, Elsie Palmer Payne, Hanson D. Puthuff, Granville Redmond, Jack Wilkinson Smith, and William Wendt, were also for the most part members of the California Art Club.

Laguna Beach had become a favorite summer painting locale for many Los Angeles artists and several had opened studios there. Edgar Payne, who had painted there seasonally since 1911 and recognized the need for a mutual exhibition space, convened a group of friends who organized the first exhibition. It was an immediate success and Payne was elected president of the association.

At first, exhibitions were juried and changed monthly. Rose was welcomed into the group, although he was not one of the founders and he did not exhibit in the first show of July 1918. His entries were in August and September 1918, May and June 1919, and June, July, and August 1922.

In 1920 the Los Angeles Museum of History, Science and Art began an annual series of exhibitions entitled *The Painters and Sculptors of Southern California* (not to be confused with the Painters and Sculptors Club, started in 1923). Rose participated each year, his last one being the Fourth Annual, in 1923. *In Arcadia,* one of his two entries for the Second Annual, in 1921,

won the William Preston Harrison Prize, the highest award in the exhibition, judged regardless of subject or medium.

Rose was held in the highest regard by his peers. The list of articles and reviews praising his work is predictably long, but one of the most interesting essays was written in jest and published in the *Los Angeles Times,* on 14 January 1923, under the pseudonym "Benjamin Blue." Benjamin Blue was in fact Luvena B. Vysekal (1873–1954), a fellow artist who authored a series of these humorous essays she termed "Counterfeit Presentments." Please keep in mind that the Rose Parade has absolutely nothing to do with Guy Rose.

Over Pasadena way, there lives a painter who is honored by his fellow citizens each New Year's Day in a most appropriate Manner.

So few communities really know how to pay tribute to their artists that Pasadena deserves credit for the pretty little innovation. Each New Year's Day, they gather billions of posies and strew them along the path this Native Son will tread the coming year.

This stupendous, spectacular, gigantic, elaborate and artisic tournament each New Year's Day in his name should serve as an incentive to other communities (Friends of American Art please take notice) on how to treat their favorite artist.

It's a wonderful thing to be a Native Son of California! It's a wonderful thing to be an artist! The combination of the two is an achievement worthy of all the traffic blocking it on occasions. Next time I am cast in the role of an artist, I'm going to see to it that I am born in California.

As the recipient of this overwhelming adulation, his modesty is amazing. But after all, if your fellow citizens do your boasting for you, and your neighboring city calls you on advisory committees, and your club bids you serve on art juries, and the newspapers quote you and reproduce your paintings every other Sunday, and the art dealers run after you, and the exhibitors invite you, and patrons buy you, it's a trifling matter to be becomingly modest.

Only recently, I bought and read a book about this fellow-painter and his works. It was gratifying to think that anyone had shown the good judgment to publish a book about one of us while he yet lived among you.

This fortunate son of California is no wayward child. His delineations of his native hills and plains, the sea and sky that embrace them, are as full of love and tenderness as a most exacting parent could hope, and every mother's son who loves her

Guy Rose *(rear, center)* with several members of the Laguna Beach Art Association, ca. 1916, including artists Theodore Modra *(rear, left)*, Maurice Braun *(standing, right)*, Donna Schuster *(front)*, and William Swift Daniell *(front, right)*. Photograph courtesy of Charlotte Braun White, from Maurice Braun's scrapbook.

feels such a thrill of pride, that even we adopted children, who stand to one side and join in the chorus of "We Love You, California," do so with no spark of envy, we put real feeling into our part of the song. We realize Californians can't help boosting their own crop.

And he? Well, all the honors that Paris heaped upon him couldn't keep him long away from his own. No doubt about its being a perfect affinity.

Vive le Californien!

In addition to his museum and artists' clubs exhibitions, Rose maintained his relationships with commercial art dealers, an expediency that gained him added exposure and an outlet to sell his work. Upon his return to Los Angeles, Rose relied on the popularity of his French paintings for his initial exhibitions. In time, he showed more and more of his California subjects, using an occasional French painting for variety.

His arrangement with the Macbeth Gallery in New York City, established upon his return to the United States in 1911, was continued after his arrival in Los Angeles. His show of April 1917 consisted of nine paintings, mostly French subjects. Rose sent a few more works for display in 1918 but soon thereafter, the relationship with Macbeth seemed to have been terminated.

Rose's first Los Angeles art dealer was Steckel Gallery, but he showed there only once, in February 1915. The show, numbering twenty works, were mostly French landscapes and figure paintings. Two months later, in March 1915, he opened a show at the Elizabeth Battey Gallery in Pasadena. This was to become his principal California art dealer until he suffered his stroke on 2 February 1921, and stopped painting. Elizabeth Battey showed Rose in January, and April 1917, February 1918, and April–May 1920, and a special joint exhibition of Guy's and Ethel's works in April 1921.

Rose's brief association with a group called Ten Painters Club of California occurred in 1919. The club was in fact a promotional device by the Los Angeles art dealer John F. Kanst, in hopes of combining the best artists of Los Angeles into one significant show. No doubt patterned and named after the successful Ten American Painters (1898) of New York, the California group was composed of R. Clarkson Colman (1884–1945), Maurice Braun, Benjamin C. Brown, Edgar Payne, Guy Rose, Hanson D. Puthuff, Jack Wilkinson Smith, Elmer Wachtel, Marion K. Wachtel, and William Wendt. The exhibition was held in April 1919, and later, in August, Rose had a solo show at the Kanst Gallery.

In March 1920 Rose began his association with the Cannell and Chaffin Gallery in Los Angeles. The gallery showed Rose in a one-person exhibition, and later, in October, he was included in a group show. Cannell and Chaffin held another group show in July 1921 that included works by Rose.

Rose's most fruitful association with an art gallery came in September 1921, when he showed nine paintings at the newly opened Stendahl Galleries, in the Ambassador Hotel in Los

John Frost (1890–1937), *The Pool at Sundown*, 1923. Oil on panel, 24 x 28 in. The Irvine Museum, Irvine, California.

Angeles. The gallery was owned by Earl Stendahl, and it became the most powerful art gallery in Los Angeles, representing the cream of Southern California's artists, including Franz A. Bischoff, Alson S. Clark, Jack Wilkinson Smith, and William Wendt. The business relationship between Stendahl and the Roses grew to a warm friendship that continued for many years after Guy Rose's death.

The Stendahl Galleries held several shows for Rose. In October 1922 Stendahl held a massive solo show of sixty-five paintings. It marked the end of Rose's painting career owing to the effects of his stroke. To accompany the exhibition, Stendahl published a small book with numerous illustrations of Rose's paintings. The now rare book contains a preface in appreciation of the artist, written by Antony Anderson, art critic of the *Los Angeles Times*, and a biographical sketch, written by Earl Stendahl. The book is dedicated to Emil Carlsen.

After Rose's death, on 17 November 1925 Earl Stendahl and Ethel Rose carefully catalogued the estate of paintings left by the artist and opened the *Guy Rose Memorial Exhibition* at the Stendahl Galleries in February–March 1926. The show, accompanied by a book which also is now rare, traveled to the Peyton Boswell Gallery in San Diego. Stendahl managed the Guy Rose estate for many years, maintaining a close friendship and business relationship with Ethel Rose.

The extent of Rose's influence on the California art community is difficult to gauge. His teaching activity at the Stickney School was limited to what has at times been described as "dilettante" students. The closest "follower" of the artist might well be John Frost (1890–1937), who was greatly influenced by Rose.

Frost was the son of Arthur Burdett Frost (1851–1928), a well-known American illustrator and an intimate friend of Guy Rose. Rose and A. B. Frost were lifelong fishing buddies and collaborated on numerous articles and books on fly-fishing. Young Frost studied art at the Académie Julian and took lessons from Richard E. Miller (1875–1943) in Paris from 1906 to 1908. It was in France that Frost contracted tuberculosis, a disease that would limit him all of his tragically short life.

Frost remained friends with Miller, visiting him often at his home in Giverny. On those occasions, he would visit and paint with Rose. Eventually, Frost became friends with Clark and Frieseke, as well as artists who made up the closely knit American community in Giverny.

In 1919 Frost moved to Pasadena, where it was thought the dry climate would ease the effects of his tuberculosis. There he rejoined Rose and Clark and the three of them would frequently get together at each other's homes.

John Frost's paintings are scarce. He spent a good part of his short life in sanitariums. The few extant paintings show that he worked in the traditional, Monet-inspired type of French Impressionism, characterized by a strong sense of light, elegant brushstrokes, and use of soft, harmoniously balanced color, all of which also characterize Guy Rose's paintings. At times, the similarities between the two artists are striking, even to the extent that in some cases paintings appear to be by the same hand.

Guy Rose was admired and respected not only as a Native Son who went into the world, made a name for himself, and returned home a famous artist, but more so as a significant Impressionist painter who mastered the style, wore the aegis, and proudly kept the faith of French Impressionism. Upon his return, he found a large group of younger artists who were likewise interested in Impressionism but were also facing the turning of the tide toward modernism. He embodied the fulfillment of the Impressionist ideal, an ideal that had met its time a generation earlier. His death, in 1925, might have been interpreted as an omen pointing to the culmination of the period of Impressionism in California, for his life closely parallels the development and decline of the style. He was, in effect, the hero of California Impressionism and his life followed a heroic path. He studied art when the style was young; he matured when the style reached its zenith; he lived and worked at the center of the style; he met and befriended the pivotal figure; and he returned to his homeland late in his life. As it is, his paintings are clearly the archetype of the style and no exhibition or collection can be complete without an example of his work. For these reasons, Guy Rose and California Impressionism are synonymous and forever linked.

The Sycamores, Pasadena, ca. 1918. Oil on canvas, 19¾ x 24 in. Laguna Art Museum, Gift of Mrs. Ethel Rose, Laguna Beach, California.

GUY ROSE AND THE LOS ANGELES ART COMMUNITY, 1914–1925

Carmel Seascape. Oil on canvas, 21 x 24 in. The Irvine Museum, Irvine, California.

PLATES

IN CALIFORNIA

Palms. Oil on canvas, 18 x 15 in. Private collection.

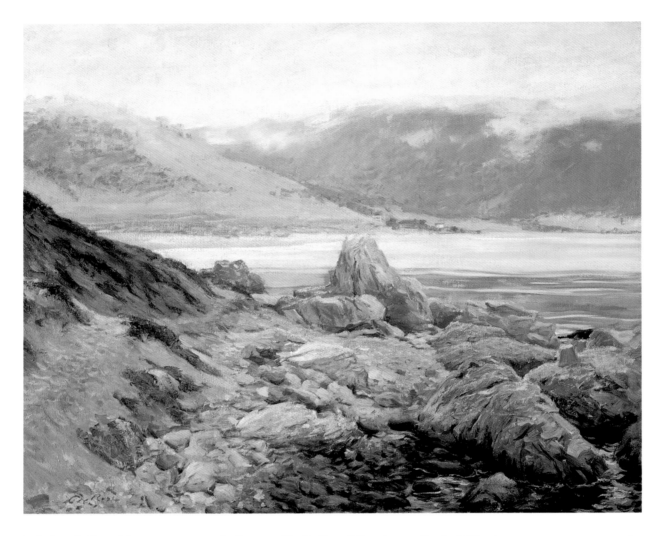

Path along the Shore. Oil on canvas, 24 x 29 in. Courtesy The Redfern Gallery, Laguna Beach, California.

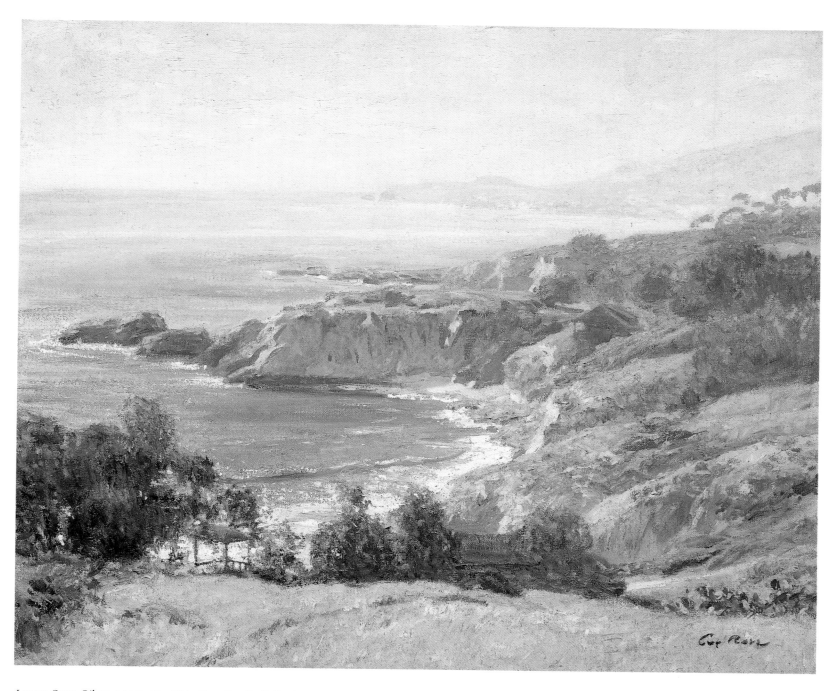

Laguna Coast. Oil on canvas, 24 x 29 in. Rose Family Collection.

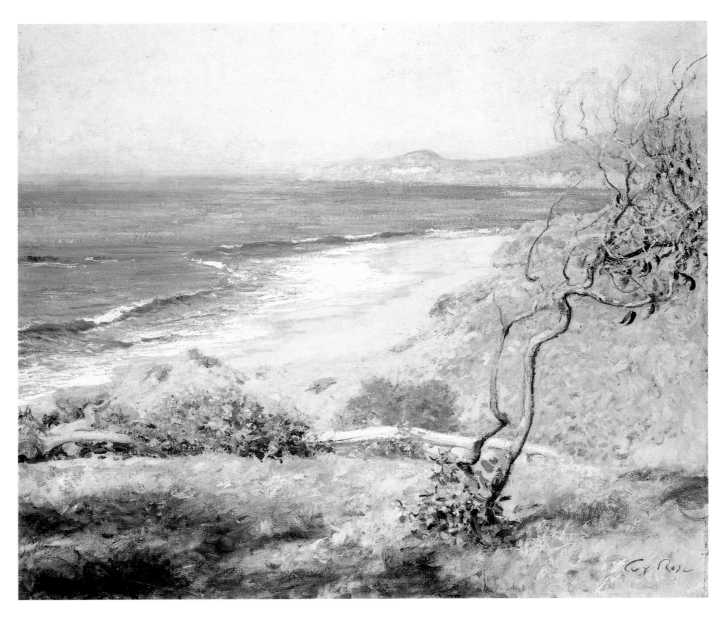

Laguna Shores. Oil on canvas, 21 x 24 in. Mr. and Mrs. Thomas B. Stiles II.

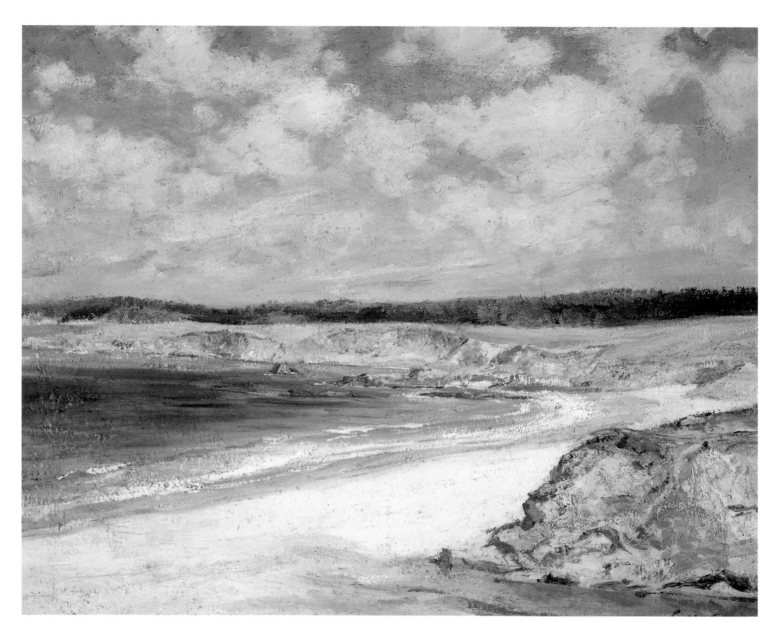

Carmel Beach. Oil on canvas, 15 x 18 in. Joan Irvine Smith Fine Arts, Inc.

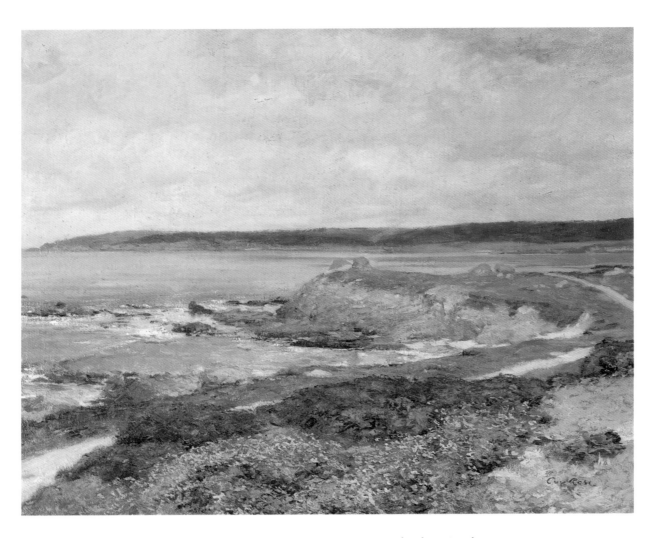

A Grey Day Carmel. Oil on canvas, 24 x 29 in. William A. Karges Fine Arts, Carmel and Los Angeles.

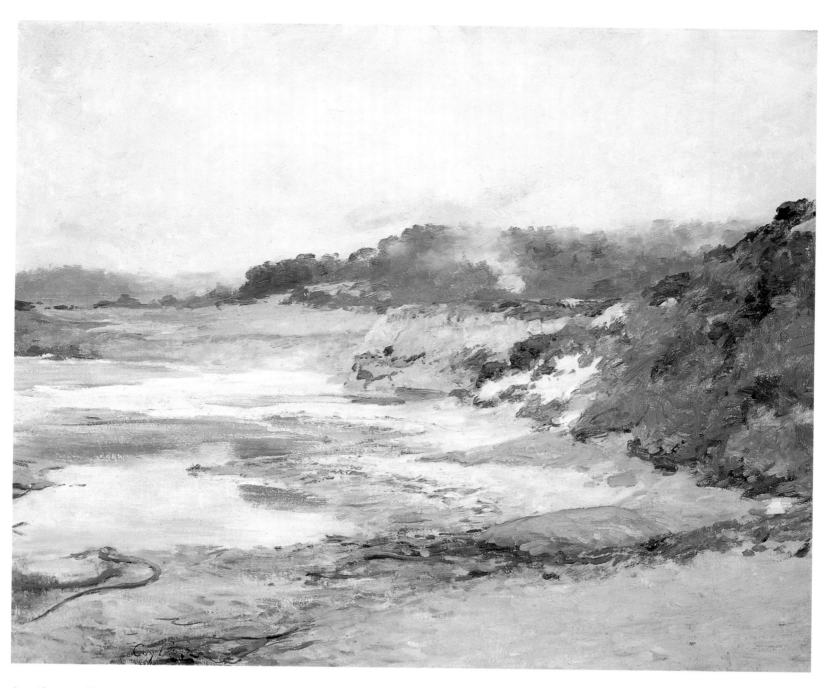

Grey Afternoon. Oil on canvas, 24 x 29 in. Rose Family Collection.

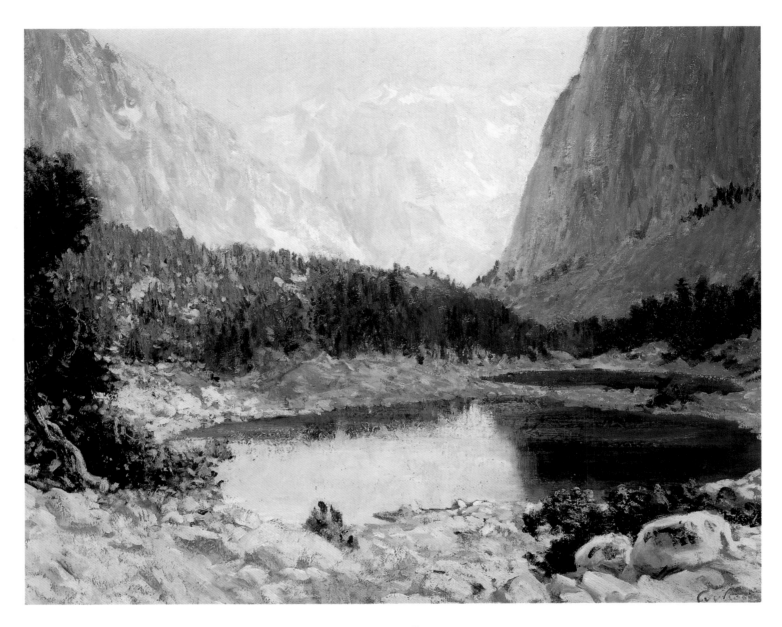

Twin Lakes, High Sierra. Oil on canvas, 23½ x 28¾ in. Mr. and Mrs. Allen Kovac Collection.

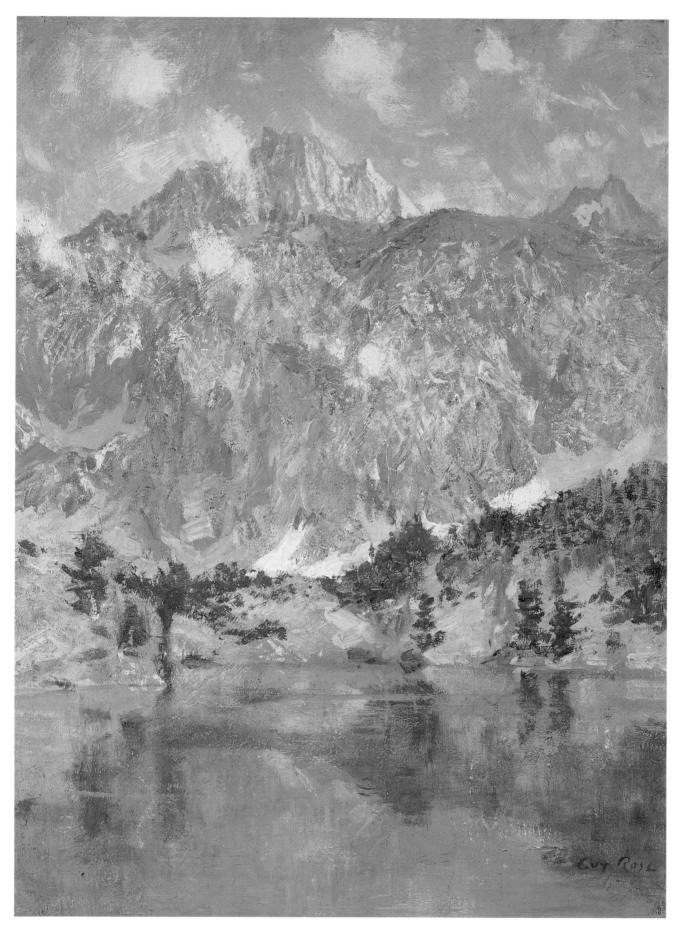

In the Sierra. Oil on canvas, 24 x 17 in. Private collection.

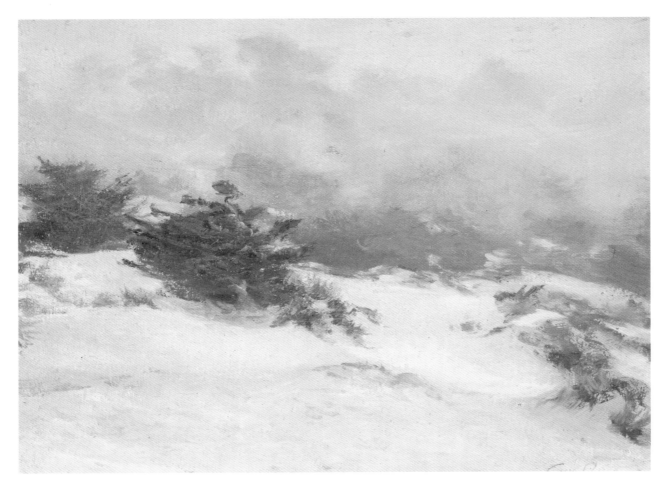

Misty Dunes, Carmel. Oil on canvas, 10 x 13¾ in. Anne and Howard Cusic Collection.

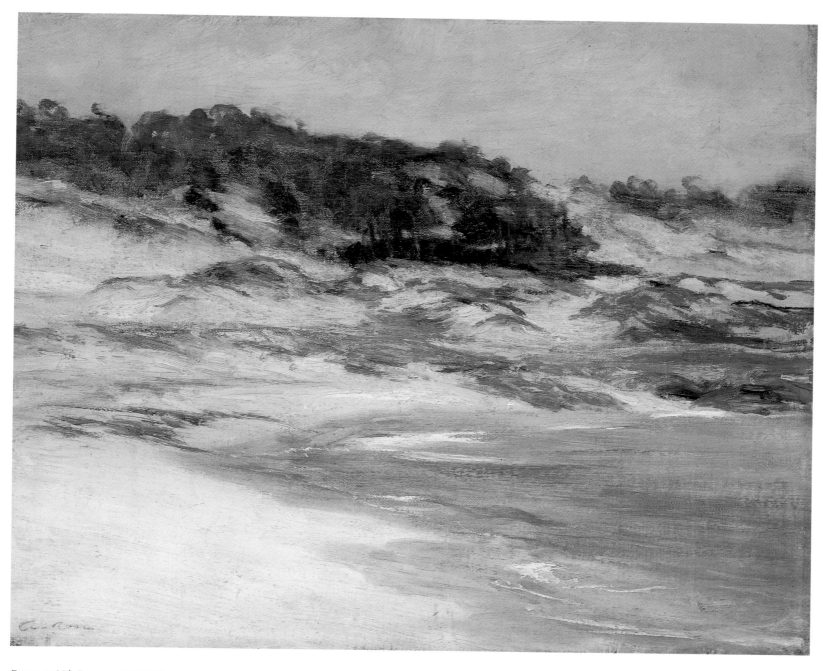

Dunes, 17 Mile Drive, ca. 1918. Oil on canvas, 15 x 18 in. Mr. and Mrs. E. Forrest Nance Collection.

Incoming Tide, ca. 1917. Oil on canvas, 24 x 29 in. Joan Irvine Smith.

Laguna. Oil on canvas, 24 x 29 in. Private collection.

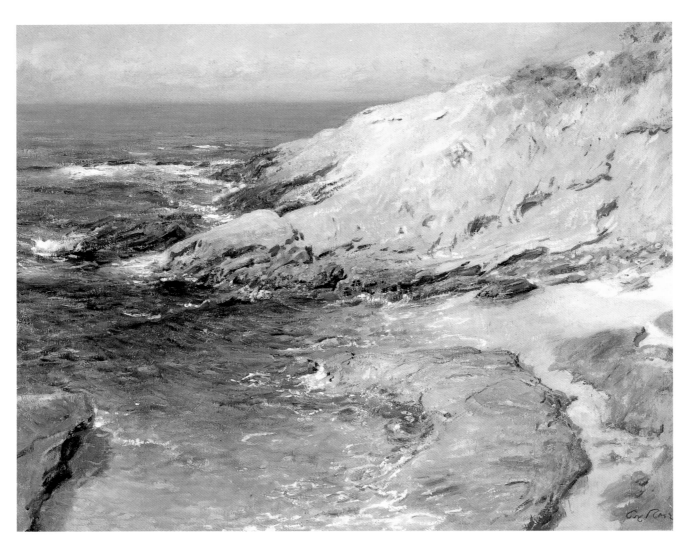

View of Wood's Cove, Rockledge, n.d. Oil on canvas, 24 x 29 in. Joan Irvine Smith Fine Atrs, Inc.

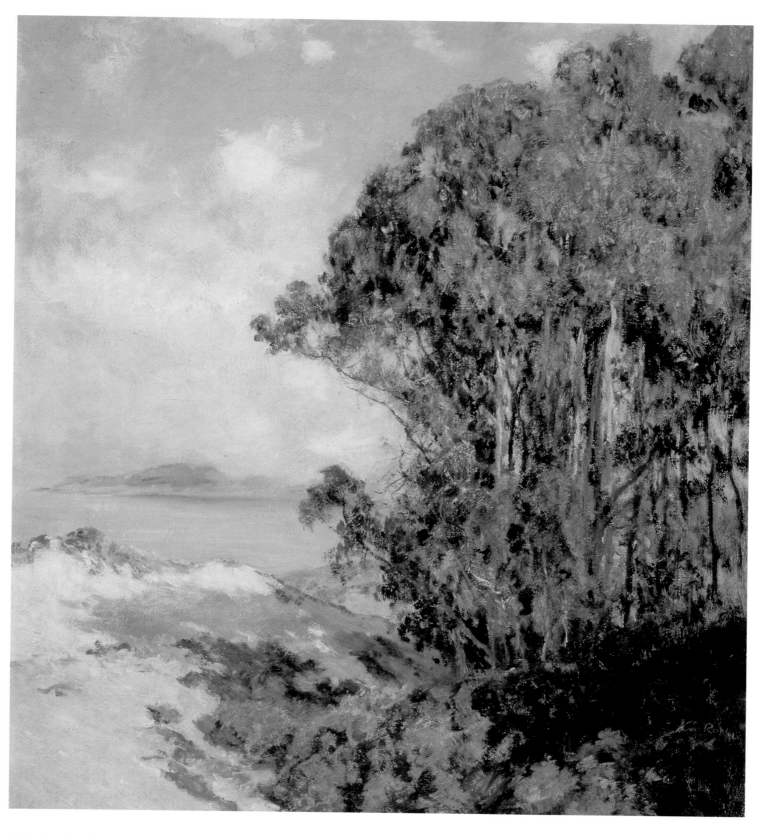

Lifting Fog, Carmel. Oil on canvas, 24 x 20 in. Rose Family Collection.

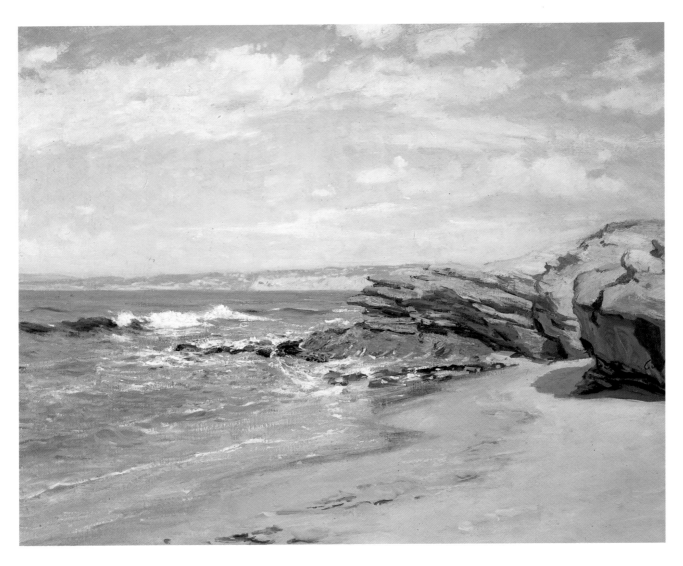

La Jolla Beach, n.d. Oil on canvas, 21 x 24 in. Joan Irvine Smith Fine Arts, Inc.

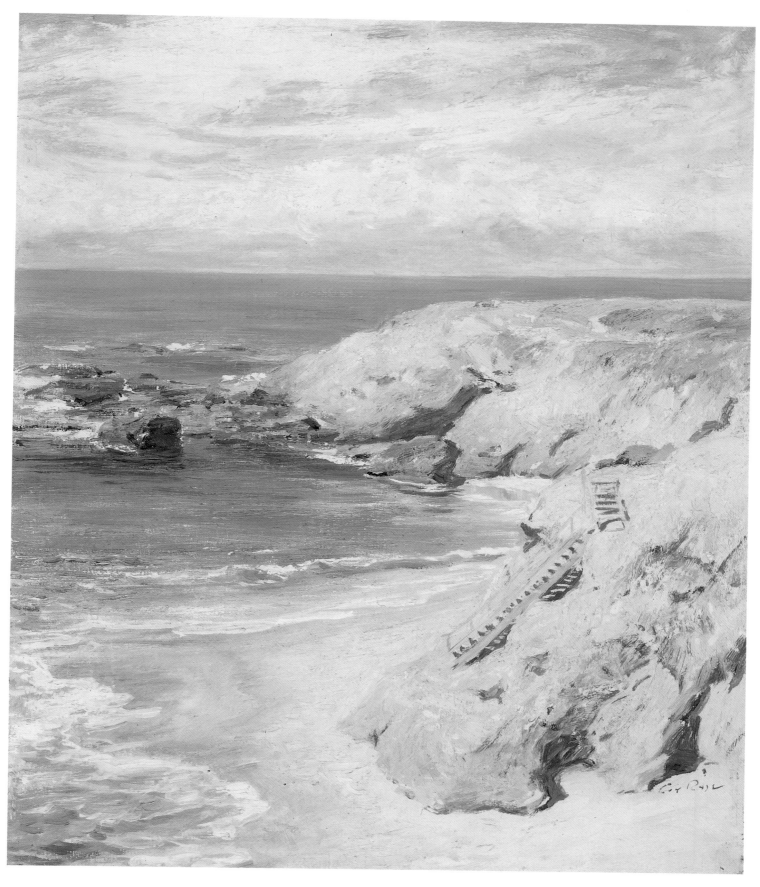

La Jolla Cove, n.d. Oil on canvas, 18 x 15 in. Private collection.

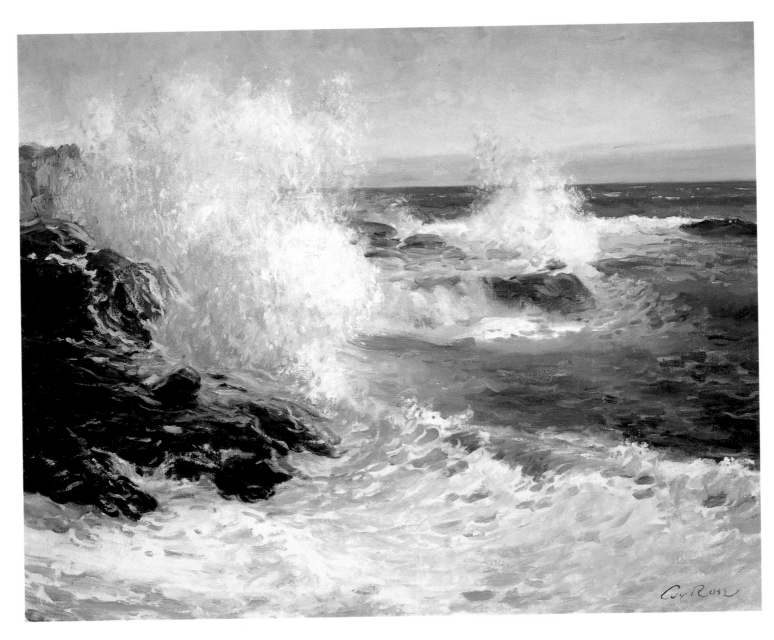

The Sea. Oil on canvas, 24 x 29 in. Private collection.

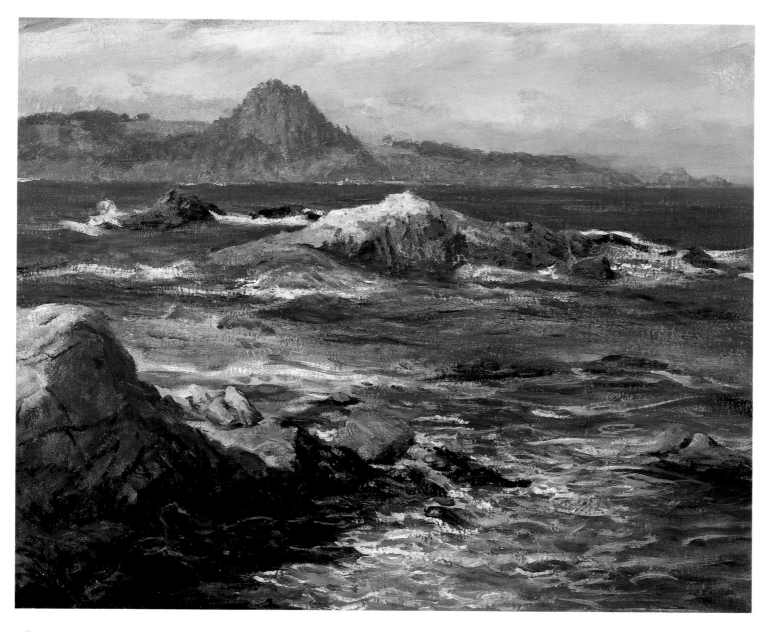

Off Mission Point (Point Lobos). Oil on canvas, 24 x 29 in. Private collection.

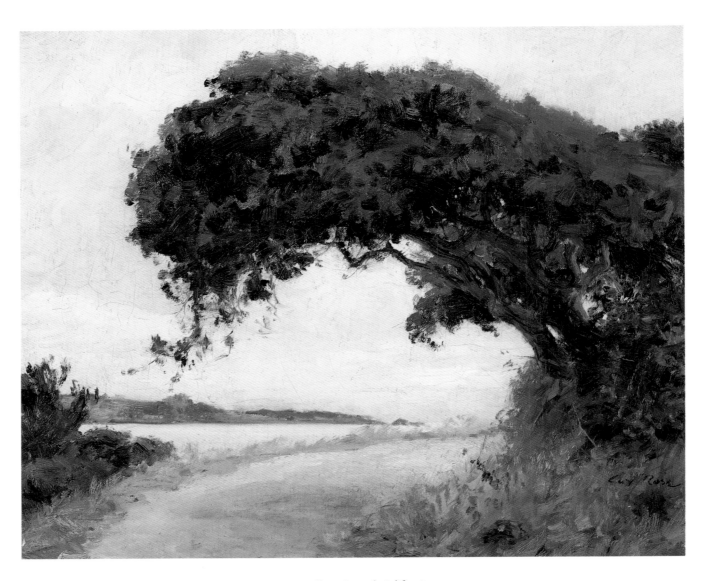

Point Lobos, Oak Tree. Oil on canvas, 15 x 18 in. Masterpiece Gallery, Carmel, California.

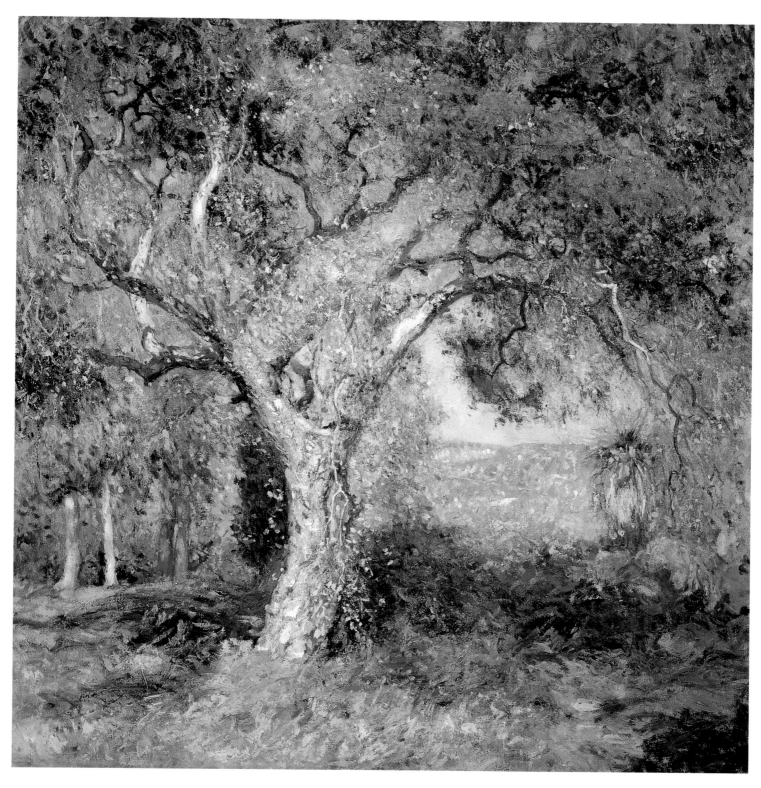

The Oak. Oil on canvas, 30 x 28 in. Thomas Gianetto Collection.

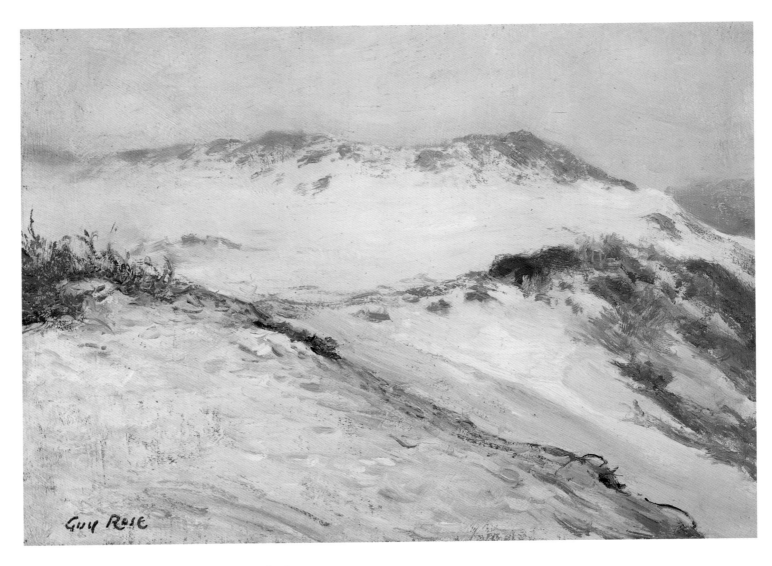

Carmel Dunes. Oil on canvas, 10 x 13½ in. Private collection.

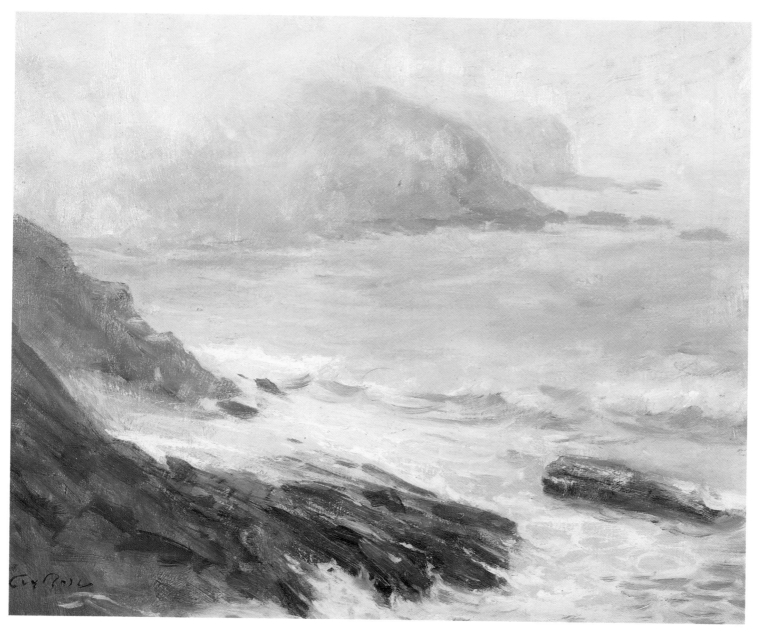

Coastline. Oil on canvas, 15 x 18 in. Dr. James Zidell Collection.

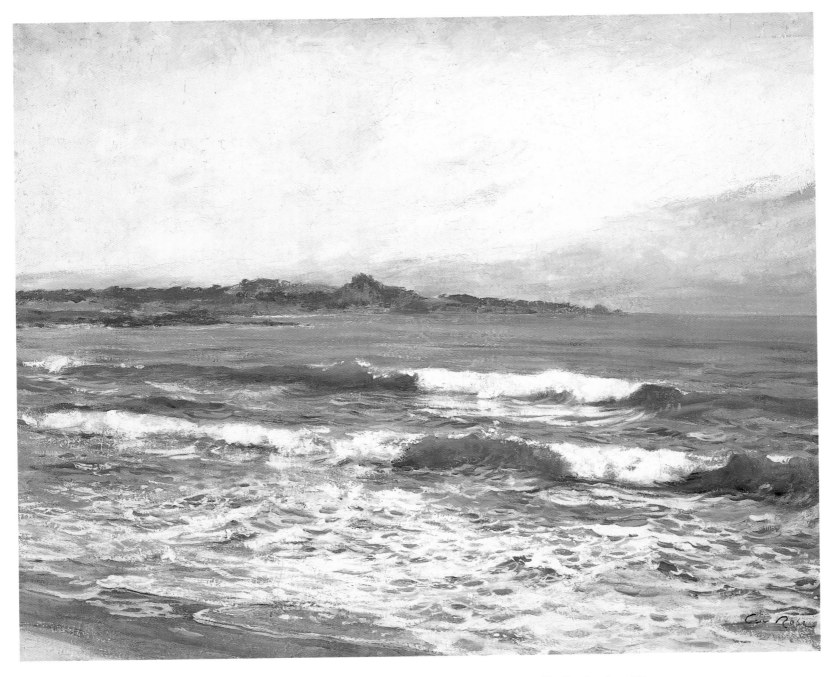

Mission Point. Oil on canvas, 24 x 29 in. Formerly Collection of Walter Nelson-Rees and James Coran. Destroyed by fire, October 1991.

GUY ROSE:

CHRONOLOGY AND BIBLIOGRAPHY

CHRONOLOGY

Marian Yoshiki-Kovinick

1867

3 March, born the seventh child
of Leonard John (1827–1899) and
Amanda Jones Rose (1834–1905) in
San Gabriel, Calif.

1876

Accidently shot in face during hunting
trip with brothers; begins to sketch
and use watercolors and oils.

c. 1878

Studies art with Mrs. Cordelia
Penniman Bradfield (director of art
department for Los Angeles schools)
during school years.

1884

Graduates from Los Angeles High
School.

1885–88

Attends California School of Design,
San Francisco; studies with Virgil
Williams, Emil Carlsen, and Warren
E. Rollins.

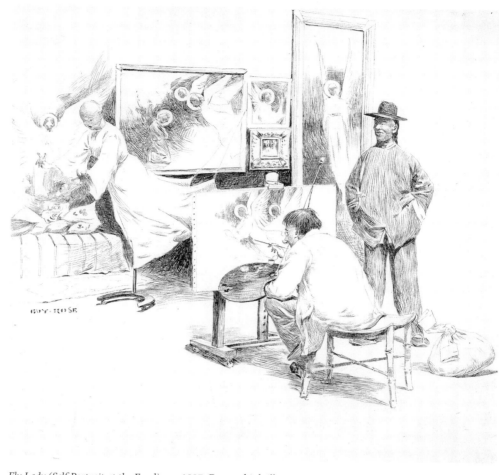

Fly Lady (Self-Portrait at the Easel), ca. 1887. Pen and ink illustration on paper. Rose Family Collection.

1886

Wins honorable mention in oil painting
and drawing at School of Design.

1887

Wins Avery Gold Medal in oil painting at School of Design.

1888

21 June, contributes *Retired Nook* to James T. Harwood Auction
in Salt Lake City.

20 August, joins James T. Harwood in Ogden, Utah, for trip to
New York City and Europe.

29 August, sails to England aboard the *Trave* for Paris with
fellow School of Design students Harwood, Eric Pape, and
Frederick Marvin; travels to Paris.

12 September, enrolls at the Académie Julian, where he studies
with Jean-Joseph Benjamin-Constant, Jean-Paul Laurens, Jules
Lefebvre, and Lucien Doucet.

1888–89

Resides at 50 rue d'Assas with Harwood.

Attends Léon Bonnat's anatomy lectures at the École des
Beaux-Arts.

Wins *concours* (student award) twice for drawing at the
Académie Julian.

Wins scholarship at Académie Delacluse.

Meets fellow students Frank Vincent and Frederick Melville
DuMond at Académie Julian (Frank and Guy were to remain
lifelong friends).

April–May, goes to French countryside with fellow Julian
student Ernest Peixotto.

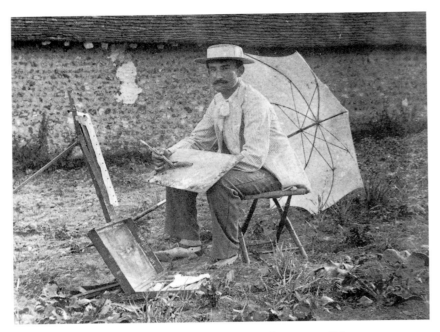

Guy Rose painting at Giverny, France, 1890. Photograph courtesy of the Rose Family Collection.

1890

Resides at rue du Faubourg Saint-Honoré in Paris.

April, exhibits 2 paintings at Paris Salon: *La ménagère (The Housewife); Le lutin (The Elf).*

April, travels to Italy and returns to Paris via Switzerland.

July–January 1891, stays with mother and sisters at Hôtel Baudy, Giverny.

1891

Resides at boulevard des Batignolles, Paris.

April, exhibits 1 painting at Spring Exhibition of San Francisco Art Association: *Portrait* (loaned by Mabel Rose)

April, exhibits 2 paintings at Paris Salon: *La fin de la journée (The End of the Day)* and *Les ramasseuses de pommes de terre (The Potato Gatherers).*

May–July, stays at Hôtel Baudy, Giverny.

Fall, returns to California.

October, exhibits 11 paintings at Sanborn, Vail & Company, Los Angeles, including *The End of the Day; The Potato Gatherers; La ménagère; First Communion; Still Life* (lemons, brass, and earthenware); and two paintings of a church in Normandy.

1892

Resides at 939 Eighth Avenue, New York.

April, exhibits 3 paintings at Spring Exhibition of San Francisco Art Association: *October; Onions; November* (loaned by M. E. McCormick).

1893

January–February, exhibits 2 paintings at Boston Art Club: *Church at Giverny, France; Frosty Morning.*

February, serves on jury for California Building at World's Columbian Exposition, Chicago.

April–May, exhibits 3 paintings at 15th Annual Exhibition, Society of American Artists, New York: *Early Summer Morning; Flight into Egypt; November Morning.*

May–October, exhibits 3 paintings at World's Columbian Exposition: *La ménagère* (now called *Food for the Laborers*); *The End of the Day; The Potato Gatherers.*

1894

January, exhibits at Union League Club, New York: *November Twilight* (loaned by F. V. DuMond).

Spring, returns to Paris; resides at Vercengé Tovix.

Travels for *Harper's Weekly* to Italy; during trip meets Ethel Boardman (1872–1946).

March–May, stays at Hôtel Baudy, Giverny.

April, exhibits 2 paintings at Paris Salon: *St. Joseph demandent asile pour la vierge (St. Joseph Asking Shelter for Mary); La teigne (The Moth).*

Summer, travels for *Harper's* to Greece and Venice; suffers illness later to be diagnosed as lead poisoning.

5 August, loses paintings in fire of DuMond's studio in New York.

November, exhibits 4 paintings at Los Angeles Art Association Loan Exhibition.

Library in the L. J. Rose Family home at Fourth and Grand Streets, Los Angeles. Photograph courtesy of the Rose Family Collection.

Guy Rose, New York, 1892. Photograph courtesy of the Rose Family Collection.

1895

3 January, marries Ethel Boardman in Paris.

January, exhibits 1 painting at Union League Club, New York: *The Flight into Egypt.*

February, returns to Los Angeles for 6 months before going to New York.

April–June, exhibits 1 painting at Los Angeles Art Association Loan Exhibition: *Portrait of Mrs. Guy Rose.*

Exhibits 2 paintings at Cotton States and International Exposition, Atlanta, Ga. (wins medal): *Flight into Egypt; The Moth.*

September–June 1898, teaches portraiture and drawing at Pratt Institute, Brooklyn.

1896

Resides at 62 Washington Square, New York.

March, exhibits 2 paintings at Providence Art Club: *Giverny Willows; Late Spring Afternoon.*

March–April, exhibits 1 painting at 71st Annual Exhibition, National Academy of Design, New York: *Early Spring Morning.*

April, exhibits 4 paintings at 18th Annual Exhibition, Society of American Artists, New York: *The Moth; The Annunciation; Moonlight Study; The Garden.*

April, exhibits 1 painting at Paris Salon: *St. Joseph Asking Shelter for Mary.*

Summer, conducts outdoor sketching class at Fallsburgh, N.Y. (five weeks); later goes to Maine.

September, exhibits 1 painting at 13th Annual Exhibition, St. Louis Exposition and Music Hall Association: *The Garden.*

December–January 1897, exhibits 1 painting at Pennsylvania Academy of the Fine Arts: *The Moth.*

Venetian Fruit Peddler, 1894. Pen and ink on paper, 6 x 4 in. Rose Family Collection.

1897

January–March, exhibits 3 paintings at Pennsylvania Academy of the Fine Arts: *Joseph Asking Shelter for Mary; Evening; Wash Woman.*

March–April, exhibits 3 paintings at 19th Annual Exhibition, Society of American Artists, New York: *Sheep Pasture; Wash Woman; Joseph Asking Shelter for Mary.*

May, retreats to Smithtown, on north shore of Long Island.

November–January 1898, exhibits 1 painting at 2d Annual International Exhibition, Carnegie Institute, Pittsburgh: *The Moth.*

In the Studio. Oil on canvas, 24 x 18 in. Private collection.

Guy Rose in his Paris studio. Photograph courtesy of Rose Family Collection.

1898

March–April, exhibits 1 painting at 20th Annual Exhibition, Society of American Artists, New York: *Evening*.

September–October, exhibits 1 painting at 15th Annual Exhibition, St. Louis Exposition and Music Hall Association: *The Moth*.

October, exhibits 2 paintings at Annual Exhibition of American Paintings and Sculpture, The Art Institute of Chicago: *Evening; July Afternoon*.

1899

January–February, exhibits 1 painting at Boston Art Club: *The Moth*.

March, returns to France and stays at Hôtel Baudy, Giverny.

Supplies fashion drawings for *Harper's Bazar*.

March, exhibits 1 painting at Annual Exhibition, Providence Art Club: *The Moth*.

1900

Resides in Paris; spends winter in Briska, Algeria. Paints three known paintings: *The Algerian Market; An Algerian Divorcee; Portrait of an Algerian*.

April, exhibits 1 painting at Paris Salon: *L'annunciation*.

1901

Exhibits 2 paintings at Pan-American Exposition, Buffalo, N.Y. (bronze medal): *The Moth; Flight into Egypt*.

1902

Resides in Paris.

October, exhibits 1 painting at 45th Annual Exhibition, San Francisco Art Association: *July Afternoon*.

1904

Buys stone cottage on sente des Grosses Eaux in Giverny; remodels it into a studio-home.

Exhibits 1 painting at Home Club Exhibition, East Oakland, Calif.: *The Potato Gatherers*.

1909

January–March, exhibits 1 painting at 105th Annual Exhibition, Pennsylvania Academy of the Fine Arts: *November Twilight*.

May, exhibits 1 painting at Paris Salon: *Le petit déjeuner*.

1910

January–March, exhibits 2 paintings at 106th Annual Exhibition, Pennsylvania Academy of the Fine Arts: *November; The Green Parasol*.

March, exhibits 4 paintings at Rhode Island School of Design, Providence: *Borders of the Seine; Winter Scene; The Valley; Printemps*.

March–April, exhibits 1 painting at 85th Annual Exhibition, National Academy of Design, New York: *November Twilight*.

May–September, exhibits 2 paintings at 5th Annual Exhibition of Selected Paintings of American Artists, Buffalo Fine Arts Academy, N.Y.: *November; The Green Parasol*.

September–November, exhibits 2 paintings at 5th Annual Exhibition of Selected Paintings of American Artists, City Museum, St. Louis: *November; The Green Parasol.*

December–January 1911, exhibits with the Giverny Group at Madison Gallery, New York.

1911

January–March, exhibits 2 paintings at 109th Annual Exhibition, Pennsylvania Academy of the Fine Arts: *The Pool; November.*

February, exhibits at Galerie de Vamber, American Salon, Paris (movement to create an American Salon in Paris and the United States).

February–March, exhibits 1 painting at Macbeth Galleries, New York: *The Church, Giverny.*

March–April, exhibits 1 painting at 86th Annual Exhibition, National Academy of Design, New York: *November.*

Fall, exhibits 1 painting at Annual Exhibition of American Paintings and Sculpture, The Art Institute of Chicago: *November Twilight.*

December–January 1912, exhibits 1 painting at Winter Exhibition, National Academy of Design, New York: *September Morning.*

1912

April–June, exhibits 1 painting at 16th Annual International Exhibition, Carnegie Institute, Pittsburgh: *October Morning.*

December, plans to return to the United States before 15 December.

1913

Resides at 62 Washington Square, New York.

January–March, exhibits 2 paintings at 107th Annual Exhibition, Pennsylvania Academy of the Fine Arts: *September Morn; Chapel of Notre Dame de Grace.*

March–April, exhibits 2 paintings at 88th Annual Exhibition, National Academy of Design, New York: *The Chinese Room— A Portrait; October Morning.*

April, exhibits 2 paintings at Macbeth Gallery, New York: *November Morning; A Normandy Farm.*

Guy Rose trout fishing in France. Photograph courtesy of the Rose Family Collection.

1913–14

Summers, holds outdoor sketching classes at Narragansett, Rhode Island.

1914

January, visits the Frank DuMonds in Lyme, Conn.

March, exhibits 1 painting at Salmagundi Club, New York: *Melting Snow.*

March–April, exhibits 1 painting at 89th Annual Exhibition, National Academy of Design, New York: *The Bridge.*

October, returns to Los Angeles.

1915–18

Teaches at Stickney Memorial School of Art, Pasadena.

1915–22

Serves on board of governors of Los Angeles Museum of History, Science and Art.

1915

Resides at 1220 Orange, Los Angeles.

February, exhibits 20 paintings at Steckel Gallery, Los Angeles: *The Pacific; Model Resting* (now known as *By the Fireside*); *Tea; In a Boat* (now known as *On the River*); *The Green Parasol; In the Summer House; The Old Garden; Blue House; Autumn Mists; Cathedral of Tours; The Distant Town; On the Rocks; Sunny*

146

Window; Petit bleu (now known as *The Difficult Reply*); and several studies of the sea at La Jolla.

February–December, exhibits 2 paintings at Panama-Pacific International Exposition, San Francisco (silver medal): *November Twilight; The Backwater.*

March, exhibits 17 paintings at Elizabeth Battey Gallery, Pasadena, including *Tea; October Morning, Giverny; Boating; The Green Parasol; Shifting Shadows; The Sheik's Daughter; Almond Tree, Toulon; Hot Afternoon* (now known as *Warm Afternoon*); *Moonlight; Portrait of Mrs. Guy Rose.*

October, exhibits 2 paintings at 6th Annual Exhibition, California Art Club, Los Angeles: *Harmony Valley; Hot Afternoon.*

1 9 1 5 – 1 6

Exhibits 1 painting at Panama-California International Exposition, San Diego (gold medal): *Lucretia Del Valle as Señora Josefa Yorba.*

1 9 1 6

January, resides at 30 North Chapel Street, Alhambra.

Serves as 1st vice president of Fine Art League of Los Angeles.

February, first one-person exhibition of 21 paintings at Los Angeles Museum of History, Science and Art, including *The Green Mirror; La grosse pierre; November Twilight; Morning Mist; The Distant Town; The Cliffs; Rising Mist; Washington Arch, New York; Laguna Rocks, Low Tide; Near Arch Beach; Black Rock*

March–April, organizes and juries 1st Annual Exhibition of Contemporary Painters at the Los Angeles Museum of History, Science and Art. Exhibits *The Old Bridge.*

June–September, exhibits 1 painting in Summer Exhibition, Los Angeles Museum of History, Science and Art: *Misty Morning, La Jolla.*

July–August, exhibits 5 paintings at Art Institute of Chicago.

Summer, spends seven weeks painting and sketching in High Sierra.

September, moves to 371 Arroyo Terrace, Pasadena.

October, exhibits 3 paintings at 7th Annual Exhibition, California Art Club, Los Angeles: *The Bridge on Convict Lake; A Sierra Meadow; In Old Narragansett.*

November, holds one-person exhibition of 21 paintings at Friday Morning Club, Los Angeles, including *The Shore Line; Afternoon; Sun on Cliffs; Foggy Morning; Lifting Fog; Afternoon Tea; Moonrise; The Seine Valley; White Day; The Old Bridge; Notre Dame de Grace.*

1 9 1 7

January, exhibits 17 paintings at Battey Gallery, Pasadena, including *Evening Shadow* (desert)*; The Lifting Fog; The Bay at La Jolla; Near Arch Beach; Foggy Morning; The Bridge at Convict Lake; The Blue Pool; Brewing Storm; Early Morning; Old Live Oak; Sunset Glow; Twin Lakes.*

April, exhibits 3 paintings at Spring Exhibition, California Art Club, Los Angeles: *The Summer Sea* (2d prize, Clarence A. Black Award)*; Foggy Morning; Notre Dame de Grace.*

April, exhibits 19 paintings at Battey Gallery, Pasadena, including *White Roses; The Seine Valley; The Old Summer House, Laguna Beach; The Cliffs at La Jolla; Bridge at Vernon* (moonlight)*; Bridge at Vernon* (gray mists)*; Low Tide at Honfleur* (early hour, afternoon)*; Low Tide at Honfleur* (one hour earlier).

5 April, exhibits 1 painting at Macbeth Gallery, New York: *Square in Tours.*

25 April, exhibits 9 paintings at Macbeth Gallery, New York: *Girl with Rouge Stick; Church at Giverny; Olive Trees; November; Bridge over River; Church* (Honfleur)*; Hayfield; Wickford; Normandy Farm.*

April–May, exhibits 5 paintings at Pasadena Music and Art Association: *The Blue Pool; The Old Bridge; The Bridge at Vernon; The Beach, La Jolla; The Shore Line.*

May, exhibits 20 paintings at Shakespeare Club, Pasadena Music and Art Association, including *Sierra Shadows; The Blue Pool* (High Sierra)*; The Old Bridge; The Beach, La Jolla; The Shoreline; Notre Dame de Grace; Foggy Morning.*

June, exhibits 2 paintings at Macbeth Gallery, New York: *November Touraine; Notre Dame de Salert, Honfleur.*

October, exhibits 2 paintings at 8th Annual Exhibition, California Art Club, Los Angeles: *Incoming Tide; The Light House.*

1 9 1 8

Resides at 284 South Madison, Pasadena.

February, exhibits 2 paintings at Macbeth Gallery, New York: *Windswept Trees; Laguna Eucalyptus.*

February, exhibits 6 paintings at Battey Gallery, Pasadena: *Sierra Madre; Windswept Trees, Laguna; Green Is the Water There; Foggy Morning; Abalone Bay; Arroyo Seco.*

March, holds one-person exhibition of 18 paintings at Los Angeles Museum of History, Science and Art: *The Leading Lady; La réponse difficile; Windswept Trees; The Old Oak; Incoming Tide; The Old Garden; The Old Bridge; The Sierra Madres; The Valley of the Seine; Rainy Morning; San Gabriel Mission; Arroyo Seco; The Blue Pool; The Light House; November Morning; Late Afternoon; Off Shore; The Distant Town.*

April, exhibits 2 paintings at Spring Exhibition, California Art Club, Los Angeles: *The Mermaid; Windswept Trees.*

June, accepts directorship of Stickney Memorial School of Art, Pasadena; through 1921, and moves to school.

June, exhibits 7 paintings at Gift Shop Gallery, Pasadena: *October Morning; Mexican Market* (San Gabriel); *Annandale; Dove Spring; The Sierra Madres; Under the Olives; Lifting Mists.*

Spends summer in Carmel, Calif.

26 August, visits the Frank DuMonds in Lyme, Conn.

August and September, exhibits at Laguna Beach Art Association Gallery.

October, exhibits 2 paintings at 9th Annual Exhibition, California Art Club, Los Angeles: *Across the Bay; Carmel Shore.*

December, exhibits 2 paintings at California Liberty Fair, Los Angeles: *Autumn Morning; The Point.*

1 9 1 9

Moves to 300 Lincoln Avenue, Pasadena (Stickney Memorial School of Art).

March, exhibits Carmel paintings at O'Hara and Livermore Gallery, Pasadena.

Exhibits 1 painting with Artists of Southern California, at The Woman's Club of Hollywood: *Point Lobos.*

April, exhibits 2 paintings at Spring Exhibition, California Art Club, Los Angeles: *A Sierra Trout Stream* (1st prize, Clarence A. Black Prize); *On the Divan.*

April–May, exhibits 1 painting with Ten Painters Club of California at Kanst Art Gallery, Los Angeles: *Off Point Lobos.*

May, holds one-person exhibition of 16 paintings at Los Angeles Museum of History, Science and Art: *Eagle Rock; Martin's Point; Church at Giverny; Green Water; Windswept Pine; Carmel Valley; Monterey Pine; Mission de Carmel; A Sierra Mountain Trout Stream; Point Lobos; Across the Bay; Headland; Portrait; Marguerite; Annandale; Monterey Cypress.*

May, exhibits Carmel paintings at Gift Shop Gallery, Pasadena.

May and June, exhibits 1 painting at Laguna Art Association Gallery: *The Stairway to the Beach.*

June, exhibits 14 paintings at Friday Morning Club, Los Angeles, including *Monterey Cypress; Springtime; Church at Giverny; A Sierra Mountain Trout Stream; Point Lobos; Annandale.*

August, holds one-person exhibition of 9 paintings at Kanst Gallery, Los Angeles: *Off Point Lobos; Martin's Point; October Morning; Woman Sewing; Girl by the Fireplace; Carmel Pine; Green Water; Portrait; Model Resting.*

Spends summer in Carmel.

1 9 2 0

March, holds one-person exhibition of 22 paintings (mostly Carmel and Palm Canyon views) at Cannell and Chaffin Galleries, Los Angeles, including *November Morning; Lifting Fog; San Gabriel Mission; Carmel Pine; Bertha; Sunlight Waves.*

April–May, exhibits 20 paintings at Battey Gallery, Pasadena, including *A View from Arroyo Terrace; Lifting Fog; Afternoon Sunshine; Mission Point; The Point of Rocks; Winter in France; Notre Dame de Grace.*

April–May, exhibits 1 painting at 1st Annual Painters and Sculptors of Southern California Exhibition, Los Angeles Museum of History, Science and Art: *Mission Point.*

May, exhibits 20 paintings at Friday Morning Club, Los Angeles.

Spends summer in Carmel.

July, exhibits 2 paintings at Carmel Arts and Crafts exhibition: *The Beach; The Point.*

September, exhibits at California State Fair, Sacramento (Landscape Prize).

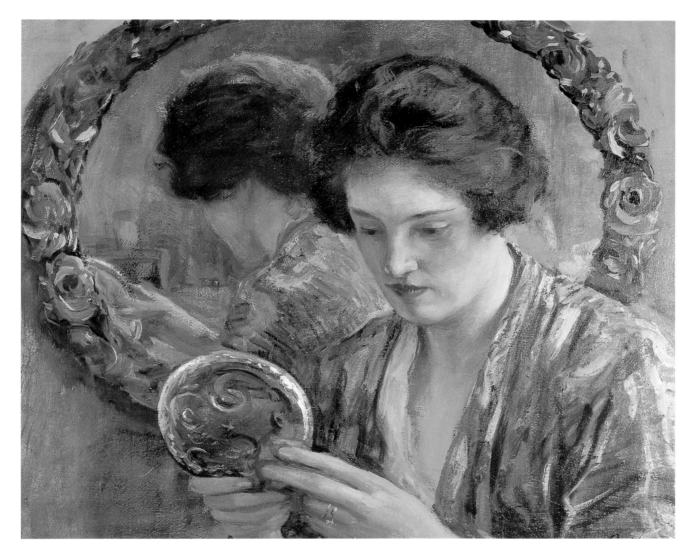

Marion. Oil on canvas, 15 x 18 in. Private collection.

September, exhibits at Stendahl Galleries, Los Angeles, including *Lucretia del Valle as Señora Josefa Yorba; The Blue Pool; Windswept Trees, Laguna; Monterey Bay; View from Arroyo Terrace; The Sierra Madres; Moving Mists at Point Lobos.*

October, exhibits 3 paintings at 11th Annual Exhibition, California Art Club, Los Angeles: *Incoming Fog, Point Lobos; Lifting Fog; Mission Point.*

October–November, exhibits 1 painting with twenty-four Southern California artists at Cannell and Chaffin Galleries, Los Angeles: *Summer Day.*

1921

Moves to 303 North Fair Oaks Boulevard, Pasadena (Stickney Memorial School of Art).

2 February, suffers debilitating stroke.

April, exhibits 7 paintings in two-person exhibition with Ethel at Battey Gallery, Pasadena: *View from Arroyo Terrace; Lifting Fog; Afternoon Sunshine; Mission Point; The Point of Rocks; Winter in France; Notre Dame de Grace.*

April–May, exhibits 2 paintings at 2d Annual Painters and Sculptors of Southern California Exhibition, Los Angeles Museum of History, Science and Art: *In Arcadia* (William Preston Harrison Prize, for the most meritorious work of art regardless of subject or medium); *The Model.*

May, exhibits 20 paintings at Friday Morning Club, Los Angeles, including *The Model.*

June, exhibits 1 painting at Cannell and Chaffin Galleries, Los Angeles: *Carmel Coast.*

September, exhibits 9 paintings at Stendahl Galleries, Los Angeles: *Portrait of Lucretia del Valle; Afternoon Sunshine; Mission Point; Windswept Trees, Laguna; Monterey Bay; View from Arroyo Terrace; Moving Mists; The Sierra Madres; The Blue Pool.*

December, exhibits 3 paintings at 12th Annual Exhibition, California Art Club, Los Angeles: *Morning, Laguna Beach; The Sea; Portrait of Miss C.*

1922

Los Angeles Museum of History, Science and Art purchases *Carmel Coast* for permanent collection.

April–May, exhibits 1 painting at 3d Annual Painters and Sculptors of Southern California Exhibition, Los Angeles Museum of History, Science and Art: *Tours Cathedral.*

June, exhibits at Laguna Beach Art Association Gallery.

July, exhibits 1 painting at Laguna Beach Art Association Gallery: *Carmel Coast.*

August, exhibits 1 painting at Laguna Beach Art Association Gallery: *Morning Mists, Point Lobos.*

October, one-person exhibition of 65 paintings at Stendahl Galleries, Los Angeles, including *Tours Cathedral; Normandy Twilight; Marion; On the Honfleur Jetty; A Warm Afternoon; Moonlight Carmel; A Grey Day; November Mists; The Green Parasol; The Blue Kimono; Laguna Trees; Incoming Tide; Indian Tobacco Trees; San Gabriel Mission; A Sierra Mountain Trout Stream.*

December, exhibits 1 painting at 13th Annual Exhibition, California Art Club, Los Angeles: *November Twilight* (honorable mention).

1922–23

Exhibits 1 painting at Western Painters Exhibition (traveled): *The Sea.*

1923

Moves to 676 La Loma Road, Pasadena.

March–April, exhibits 1 painting at 98th Annual Exhibition, National Academy of Design, New York: *Rock and Sea, Point Lobos.*

May–June, exhibits 1 painting at 4th Annual Painters and Sculptors of Southern California Exhibition, Los Angeles Museum of History, Science and Art: *Sublimity.*

May, exhibits 20 paintings at opening exhibition of Stendahl's Maryland Gallery, Pasadena: *November Twilight; Arroyo Seco; The Honfleur Jetty; Carmel Shore; The Blue House; La Jolla Coast; Low Tide, Honfleur; The Tithe Farm; Eucalypti, Laguna; Modjeska's Cabin; Normandy Farm; Early Morning; The Distant Town; Summertime; Grey Afternoon; Blue House in Winter; Marion; August Noon, Seine Valley; Fig Trees, Mediterranean; Girl of the Summer House*

September–October, exhibition of paintings from permanent collection, Los Angeles Museum of History, Science and Art: *Carmel Coast.*

Guy Rose's paintbox. 8 x 9¾ in. Photograph courtesy of the Rose Family Collection.

1923–24

Exhibits 1 painting at Western Painters Exhibition (traveled); *Sunset Glow.*

January, holds one-person exhibition of 17 paintings at Stendahl Galleries, Los Angeles, including *Sublimity; Modjeska's Cabin; Laguna Trees; Summer House; The La Jolla Coast; On the Honfleur Jetty; Tamarisk Trees with Figures.*

March–April, exhibits 3 paintings at Pasadena Art Institute: In Arcadia; *The Monterey Forest; The Sea.*

April, exhibits 4 paintings at Pasadena Society of Artists: *The Blue House; In the Canadian Rockies; Portrait of a Singer; Fisherman's Cove.*

Exhibits with American Federation of Arts Traveling Exhibition.

May–June, exhibits 2 paintings at 1st Exhibition of Painters of the West, Biltmore Salon, Los Angeles: *The Sea; The Monterey Forest.*

September–October, exhibits 3 paintings with Traveling Exhibition of Impressionist Paintings by Western Artists assembled by the Oakland Art Gallery, and the Los Angeles Museum of History, Science and Art: *Late Afternoon; Tamarisk Trees; Sunset Glow.*

November, exhibits 1 painting at Stendahl Galleries, Los Angeles: *Misty Morn.*

December, exhibits 5 paintings at Pasadena Art Institue: *At Annandale; Low Tide, Honfleur; Carmel Dunes; A Normandy Farm; Sunset Glow.*

1925

January, featured in *International Studio,* "Painter of California," by Rose V. S. Berry, including reproductions of *The Sea; Carmel Coast; Live Oak; Off Point Lobos; Monterey Cypress; Moonlight, Carmel.*

January, exhibits 2 paintings at 1st Bidding Sale, Stendahl Galleries, Los Angeles: *A Gray Day; The Beet Farm.*

June, exhibits 1 painting at Stendahl Galleries in Oxnard Civic Center: *Morning Mists.*

August, exhibits at Pasadena Art Institute.

September, exhibits at California State Fair, Sacramento.

October, exhibits at Pasadena Art Institute.

17 November, dies in Pasadena.

November–January 1926, 1 painting exhibited at 1st Pan-American Exhibition of Paintings, Los Angeles Museum of History, Science and Art: *California.*

1926

February–March, 133 paintings exhibited in memorial exhibition held at Stendahl Galleries, Los Angeles.

November, 3 paintings exhibited with William Wendt, Ebell Club, Los Angeles: *Mojave Desert; Twilight, Laguna Beach; The Loire at Tours.*

SELECTED BIBLIOGRAPHY

ARCHIVAL SOURCES

Archives of American Art, Smithsonian Institution: Philip Leslie Hale Papers; Ferdinand Perret Papers; Earl Stendahl Papers; Mabel Woodward Papers; Macbeth Gallery Papers; Joseph Moure Papers (unfilmed).

Frank C. Havens' World Famed Collection of Valuable Paintings by Great Ancient and Modern Masters. Auction brochure, 1917. Copy in Oakland Public Library, Oakland, Calif.

Harwood, James Taylor. *A Basket of Chips.* Memoirs, typescript copy in the James T. Harwood Papers, Special Collections, The Marriott Library, University of Utah.

———. Letters to Harriet Richards [later Harriet Richards Harwood], 1888–90. Numerous references to Guy Rose. Private collection.

Inventory of American Art. National Museum of American Art, Smithsonian Institution, Washington, D.C.

Los Angeles County Museum of Natural History Exhibition Scrapbooks, 1914–17.

Registre pour inscrire les voyageurs, 1887–99, Hôtel Baudy, Giverny, France. Department of Prints, Drawings, and Photographs, Philadelphia Museum of Art, Philadelphia.

Rose Family Collection. Letters, photographs, and unpublished articles in the private collection of descendants of Guy Rose.

San Francisco Art Association Collection, School Committee Meetings/Awards Minute Book, 1873–1905, San Francisco Art Institute.

BOOKS AND EXHIBITION CATALOGUES

Anderson, Antony, and Earl Stendahl. *Guy Rose: Paintings of France and America.* Exhibition catalogue. Los Angeles: Stendahl Galleries, 1922.

Anderson, Antony, and Peyton Boswell. *Catalogue of the Guy Rose Memorial.* Exhibition catalogue. Los Angeles: Stendahl Galleries, 1926.

Anderson, Antony, et al. *Art in California: A Survey of American Art with Special Reference to California Painting, Sculpture, and Architecture Past and Present Particularly As Those Arts Were Represented at the Panama-Pacific International Exposition.* San Francisco: R. L. Bernier, 1916.

Berry, Rose V. S. *The Dream City: Its Art in Story and Symbolism* (San Francisco: Walter N. Brunt, 1915.

Carr, Carolyn Kinder, Robert W. Rydell, et al. *Revisiting the White City: American Art at the 1893 World's Fair.* Exhibition catalogue. Washington, D.C.: National Museum of American Art and National Portrait Gallery, Smithsonian Institution, 1993.

Catalogue of the Department of Fine Arts, Panama-Pacific International Exposition. Exhibition catalogue. San Francisco: The Wahlgreen Company, 1915.

Catalogue of the Exhibition of Fine Arts, Pan-American Exposition. Exhibition catalogue. Buffalo, N.Y.: David Gray, 1901.

Catalogue of the Fifth Annual Exhibition of Selected Paintings by American Artists. Exhibition catalogue. Buffalo, N.Y.: The Buffalo Fine Arts Academy, 1910.

Catalogue of Paintings by Guy Rose. Exhibition catalogue. Los Angeles: Los Angeles Museum of History, Science and Art, 1919.

Dominik, Janet. *Early Artists in Laguna Beach: The Impressionists.* Exhibition catalogue. Laguna Beach, Calif.: The Laguna Art Museum, 1986.

Exhibition of Paintings by Guy Rose. Exhibition catalogue. Los Angeles: Los Angeles Museum of History, Science and Art, 1918.

Exhibition of Paintings from the Museum's Permanent Collection: Exhibition catalogue. Los Angeles: Los Angeles Museum of History, Science and Art, 1923.

Fehrer, Catherine. "List of Students Enrolled at the Julian Academy." *The Julian Academy, Paris.* Exhibition catalogue. New York: Shepard Gallery, 1989.

Final Report of the California World's Fair Commission, Including a Description of All Exhibits from the State of California, Collected and Maintained under Legislative Enactments, at the World's Columbian Exposition, Chicago, 1893. Sacramento, Calif.: A. J. Johnston, State Printer, 1894.

Fort, Ilene Susan. "The Cosmopolitan Guy Rose." In *California Light, 1900–1930.* William H. Gerdts, Patricia Trenton, et al. Exhibition catalogue. Laguna Beach, Calif.: Laguna Art Museum, 1990.

Gerdts, William H. *American Impressionism.* New York: Abbeville Press, 1984.

———. *Lasting Impressions: American Painters in France, 1865–1915.* Exhibition catalogue. Chicago: Terra Foundation for the Arts, 1992.

———. *Monet's Giverny: An Impressionist Colony.* New York: Abbeville Press, 1993.

———. "Southern California." In vol. 3 of *Art Across America: Two Centuries of Regional Painting, 1710–1920.* New York: Abbeville Press, 1990.

Gerdts, William H., Patricia Trenton et al. *California Light, 1900–1930*. Exhibition catalogue. Laguna Beach, Calif.: Laguna Art Museum, 1990.

Hitchcock, Ripley. *The Art of the World, Illustrated in the Paintings, Statuary, and Architecture of the World's Columbian Exposition.* 5 vols. New York: D. Appleton, 1894.

Hughes, Edan Milton. *Artists in California, 1786–1940*. San Francisco: Hughes Publishing Company, 1986.

Impressionistic Paintings by Western Artists Assembled by Oakland Art Gallery: September 17–October 14, 1924. Exhibition catalogue. Los Angeles: Los Angeles Museum of History, Science and Art, 1924.

Jones, Harvey L., John Caldwell, and Terry St. John. *Impressionism: The California View*. Exhibition catalogue. Oakland, Calif.: The Oakland Museum, 1981.

Jones, Harvey L., Janet Blake Dominik, and Jean Stern. *Selections from the Irvine Museum*. Exhibition catalogue. Irvine, Calif.: The Irvine Museum, 1992.

Jones, Harvey L., Paul C. Mills, and Nancy Dustin Wall Moure. *A Time and Place: From the Ries Collection of California Painting*. Oakland, California: The Oakland Museum, 1990.

Joyes, Claire. "Giverny's Meeting House, the Hôtel Baudy." In *Americans in Brittany and Normandy, 1860–1910.* Edited by David Sellin. Exhibition catalogue. Phoenix: Phoenix Art Museum, 1982.

"Leonard John Rose, Jr." Entry in *Historical and Biographical Record of Southern California*. Edited by J. M. Guinn. Chicago: Chapman Publishing Company, 1905.

Loan Collection of Paintings by American Artists. Exhibition catalogue. New York: Union League Club, 1894.

Masterworks of California Impressionism: The Morton H. Fleischer Collection. Phoenix: FFCA Publishing, 1986.

Moure, Nancy. *Loners, Mavericks, and Dreamers: Art in Los Angeles before 1900*. Exhibition catalogue. Laguna Beach, Calif.: Laguna Art Museum, 1993.

———. *Painting and Sculpture in Los Angeles, 1900–1945*. Los Angeles: Los Angeles County Museum of Art, 1980.

———. *Publications in Southern California Art, 1, 2, and 3*. Los Angeles: Dustin Publications, 1984.

Myers, William A. *Ranches to Residences: The Story of Sunny Slope Water Company, 1895–1995*. Pasadena, Calif.: Sunny Slope Water Company, 1994.

Nelson-Rees, Walter, and James Coran. *If Pictures Could Talk: Stories about California Paintings in Our Collection*. Oakland: WIM, 1989.

Orr-Cahall, Christina, ed. *The Art of California: Selected Works from the Collection of the Oakland Museum*. Oakland, Calif.: The Oakland Museum Art Department and Chronicle Books, 1984.

Paintings: Guy Rose–Paul Sample. Exhibition catalogue. Santa Barbara, Calif.: Faulkner Memorial Art Gallery, Free Public Library, 1934.

Paintings by Guy Rose. Exhibition catalogue. Los Angeles: Los Angeles Museum of History, Science and Art, 1916.

Sellin, David. *Americans in Brittany and Normandy, 1860–1910*. Exhibition catalogue. Phoenix: Phoenix Art Museum, 1982.

Smith, Sarah Bixby. *Adobe Days: Being the Truthful Narrative of the Events in the Life of a California Girl on a Sheep Ranch and in El Pueblo de Nuestra Señora de Los Angeles While It Was Yet a Small and Humble Town; Together with an Account of How Three Young Men from Maine in 1853 Drove Sheep & Cattle across the Plains, Mountains, & Deserts from Illinois to the Pacific Coast and the Strange Prophecy of Admiral Thatcher about San Pedro Harbor.* Los Angeles: Jake Zeitlin, 1931.

South, Will. *James Taylor Harwood, 1860–1940*. Salt Lake City: The Utah Museum of Fine Arts, 1987.

South, Will, Iona M. Chelette, and Katherine Plake Hough. *California Grandeur and Genre*. Palm Springs, Calif.: Palm Springs Desert Museum, 1991.

ARTICLES

"American Salon Admired in Paris." *New York Times*, 19 February 1911.

Anderson, Antony. "Art and Artists: Guy Rose Again." *Los Angeles Times*, 21 February 1915.

———. "Art and Artists: Guy Rose, Impressionist." *Los Angeles Times*, 7 January 1917.

———. "Art and Artists: Guy Rose's California." *Los Angeles Times*, 10 April 1921.

———. "Art and Artists: Guy Rose's Impressions." *Los Angeles Times*, 8 April 1917.

———. "Art and Artists: Important Works at Woman's Club." *Los Angeles Times*, 14 November 1926.

———. "Art and Artists: Landscapes by Guy Rose." *Los Angeles Times*, 8 June 1919.

———. "Art and Artists: Landscapes by Guy Rose." *Los Angeles Times*, 15 May 1921.

———. "Art and Artists: Light and Air." *Los Angeles Times*, 19 November 1916.

———. "Art and Artists: Paintings by Guy Rose." *Los Angeles Times*, 14 February 1915.

———. "Art and Artists: Paintings by Guy Rose." *Los Angeles Times*, 20 February 1916.

———. "Art and Artists: Pictures by Guy Rose." *Los Angeles Times*, 10 August 1919.

———. "Art and Artists: Pictures by Guy Rose." *Los Angeles Times*, 25 September 1921.

———. "Art and Artists: Pictures of Guy Rose." *Los Angeles Times*, 1 October 1922.

———. "Art and Artists: Pictures by Rose Now at Stendahl's." *Los Angeles Times*, 27 January 1924.

———. "Art and Artists: Pictures by Rose Now on Exhibition." *Los Angeles Times*, 25 January 1925.

———. "Art and Artists: Unusual Pictures at Stendahl Gallery." *Los Angeles Times*, 2 November 1924.

———. "Guy Rose." *Laguna Life* 9, no. 457 (13 October 1922): 1–3.

———. "Guy Rose in Pasadena." *Los Angeles Times*, 21 March 1915.

———. "In the Realm of Art: Guy Rose's Impressions." *Los Angeles Times*, 31 March 1918.

———. "In the Realm of Art: Pictures by Guy Rose." *Los Angeles Times*, 24 February 1918.

———. "In the Realm of Art: Pictures by Guy Rose." *Los Angeles Times*, 30 June 1918.

———. "Portrait of Miss Del Valle." *Los Angeles Times*, 13 June 1915.

———. "Two Newcomers." *Los Angeles Times*, 27 December 1914.

"Art for the Fair: The Paintings to Be Sent to the State Building." *San Francisco Chronicle*, 18 February 1893.

"Art in Los Angeles: The Exhibit Now in the Chamber of Commerce." *Los Angeles Express*, 15 June 1895.

"Art Notes." *Carmel Pine Cone*, 5 May 1921; 21 July 1921.

Art Notes: Published in the Interest of American Art and the Macbeth Gallery 48 (April 1913): 761.

"Artistic Career of Guy Rose Remembered." *South Coast News* (Laguna Beach, Calif.), 4 December 1931.

"Artists Known Here Exhibit in Pasadena." *Carmel Pine Cone*, 5 April 1924.

Berry, Rose V. S. "A Painter of California." *International Studio* 80 (January 1925): 332–34, 336–37.

"Brave Woman Has Passed: Death of Widow of the Late Leonard J. Rose." *Los Angeles Daily Times*, 23 May 1905.

C., E. M. "Comment on Art Progress: The Art Gallery at the Chamber of Commerce." *Los Angeles Herald*, 11 November 1894.

"Carmel Art Exhibition." *Carmel Pine Cone*, 9 September 1920.

"Death Ends Art Career of Guy Rose: World-Famous Painter Is Victim of Long Illness at Pasadena Home." *Los Angeles Daily Times*, 18 November 1925.

"The Dead Pioneer: Life-Work of the Late L. J. Rose." *Los Angeles Times*, 21 May 1899.

"Death Takes Guy Rose Today: Nationally Known Artist Was Invalid Here for Past Five Years." *Pasadena Star-News*, 17 November 1925.

"Debts Were Heavy: L. J. Rose Was Despondent and Killed Himself." *Los Angeles Daily Times*, 18 May 1899.

Dominik, Janet. "Guy Rose—American Impressionist." *Antiques and Fine Art* (December 1986): 36–41.

"The Estate of the Late Senator Rose: Mortgaged for Practically Its Full Value." (Los Angeles) *Evening Express*, 18 May 1899.

"Exhibition of Guy Rose's Pictures at the Ambassador." *Laguna Life*, 30 September 1921.

"Five Painters at Maryland Galleries." *Los Angeles Times*, 27 May 1923.

"Five Painters at the Maryland Galleries." *Pasadena Evening Post*, 30 May 1923.

"Five Exhibitors at the Maryland Hotel." *Los Angeles Times*, 10 June 1923.

Fort, Ilene Susan. "The Figure Paintings of Guy Rose." *Art of California* 4, no. 1 (January 1991): 46–50.

Hogue, S. Fred. "Guy Rose." *Los Angeles Times*, 7 March 1926.

Hunt, Edwin Arthur. "The Wright Criterion." *Out West Magazine* 43, no. 4 (April 1916): 160–61.

"In Studios and Galleries." *California Southland* (October 1919): 18.

Lack-Krombach, Beatric de. "Art." *Los Angeles Graphic* (16 February 1915): 54.

"Loan Exhibit: Paintings at the Art Association Rooms." *Los Angeles Express*, 20 April 1895.

Monroe, Harriet. "The Giverny Colony." *Chicago Tribune*, 28 May 1911.

"Mr. and Mrs. Guy Rose Return." *Los Angeles Herald*, 8 February 1895.

"Oakland Sees Interesting Art Group." *San Francisco Chronicle*, 31 August 1930.

"Pine Needles." *Carmel Pine Cone*, 1 August 1918; 24 July 1919; 23 October 1919; 7 October 1920.

Pratt Institute Monthly 5 (October 1896): 22; 5 (December 1896): 106; 5 (June 1897): 322.

"Prominently Identified with This Section: Hon. L. J. Rose Came Here in 1800 and Has Been Connected with Many Great Enterprises." (Los Angeles) *Evening Express*, 17 May 1899.

"Recent Purchases." *Bulletin of the Los Angeles Museum of History, Science and Art* 3, no. 4 (July 1922): cover and 93.

"Reveal Guy Rose Martyr to Art." *Los Angeles Evening Herald*, 18 November 1925.

Rose, Ethel. "Among the Pines at Carmel-by-the-Sea." *California Southland* 7 (October–November 1919): 18.

———. "An Afternoon Call in Algeria." Unpublished, copy courtesy of the Rose Family Collection.

———. "Camping in Algeria." Unpublished, copy courtesy of the Rose Family Collection.

———. "The Chocolate Lady." Unpublished, copy courtesy of the Rose Family Collection.

———. "Shooting in France [Normandy]." *Scribner's Magazine* 49 (March 1911): 399–409. Illustrated by Guy Rose and Arthur B. Frost, Sr.

———. "Trout Fishing in Normandy." *Scribner's Magazine* 54 (October 1913): 455–70. Illustrated by Guy Rose and Arthur B. Frost, Sr.

———. "Coarse Fishing in Normandy." *Scribner's Magazine* 72 (September 1922): 281–92. Illustrated by Guy Rose and Arthur B. Frost, Sr.

———. "Giverny." *For Art's Sake* 1 (8 November 1923): 4.

———. "Honor to a Great Artist of France." Journal article ca. 1920 in the Rose Family Scrapbooks.

———. [Title obscured; re: First Annual Exhibition of Contemporary American Painters]. *The Graphic* (26 February 1916), in the Los Angeles County Museum of Natural History Scrapbook for 1915–17.

Rose, Guy. "At Giverny." *Pratt Institute Monthly* 6 (December 1897): 81.

"The School of the Music and Art Association." *California Southland* (February–March 1920): 18.

"Shocking Suicide This Morning of Hon. L. J. Rose: He Grew Weary of His Grievous Burden of Indebtedness." (Los Angeles) *Evening Express*, 17 May 1899.

Sloane, C. F. "Guy Rose's Work: A Review of the Young Artist's Career." *Los Angeles Herald*, 4 October 1891.

———. "Mr. Rose's Paintings." *Los Angeles Herald*, 13 October 1891.

Stern, Jean. "California Impressionism Chosen for Corporate Offices in Arizona." *Western Art Digest* 12, no. 5 (November–December 1985): 72–80.

———. "The Laguna Beach School: California Impressionism, 1900–1930." *Western Art Digest* 13, no. 5 (September–October 1986): 112–15.

Stevens, Otheman. "Guy Rose Canvases in Notable Display." *Los Angeles Examiner*, 18 August 1931.

South, Will. "Americans in Paris." *Southwest Art* 17, no. 6 (November 1987): 48–53.

———. "The Painterly Pen [Guy Rose as Illustrator]." *Antiques & Fine Art* 9, no. 3 (March–April 1992): 120.

"Summer Exhibitions." *Bulletin of the Art Institute of Chicago* (October 1916): 204.

"Sunny Slope: Estate of L. J. Rose." *Los Angeles Herald*, 1 January 1876.

Ussher, B. D. "California Art Exhibit." *Holly Leaves* (26 April 1919).

Winchell, Anna Cora. "Artists and Their Work." *San Francisco Chronicle*, 21 October 1917.

INDEX

Page numbers in *italics* refer to illustrations.

157

158